The Photographic Arts

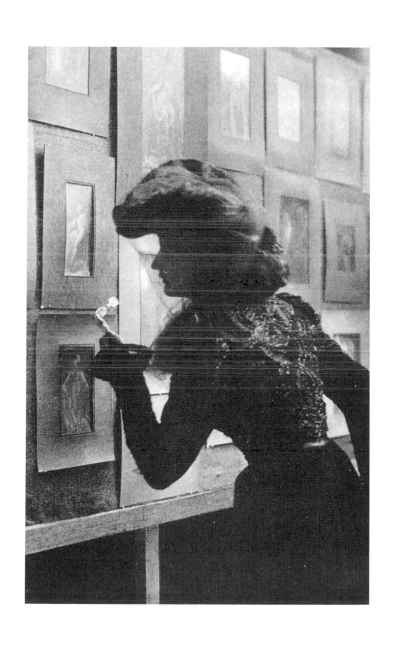

John Wood

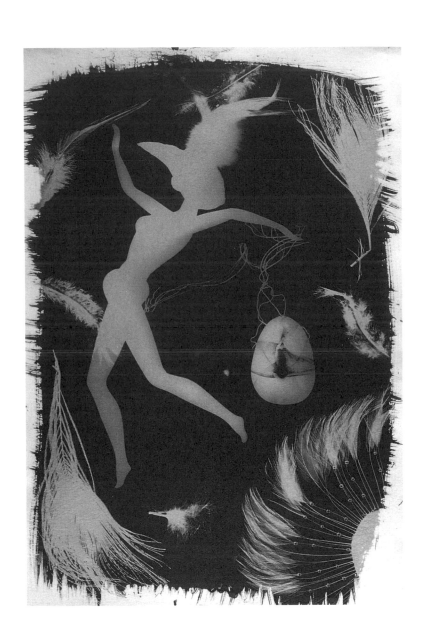

The Photographic Arts

UNIVERSITY OF IOWA PRESS IOWA CITY

University of Iowa Press,
Iowa City 52242
Copyright © 1997
by John Wood
All rights reserved
Printed in Singapore

Design by Richard Hendel

Printed on acid-free paper

Library of Congress
Cataloging-in-Publication Data
Wood, John, 1947–
 The photographic arts / by John Wood.
 p. cm.
 Includes bibliographical references.
 ISBN 0-87745-573-2
 1. Photography—United States—History.
 2. Daguerreotype—United States—History. I. Title.
TR23.W66 1997
770'.973—dc20 96-32933
 CIP

02 01 00 99 98 97 C 5 4 3 2 1

for HEINZ K. HENISCH, *who has never ceased to dance*

Contents

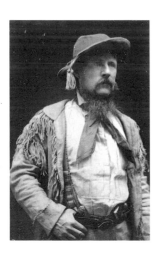

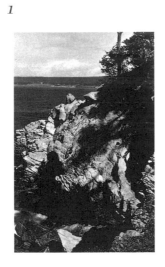

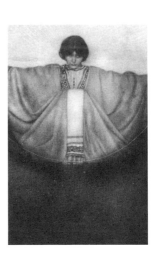

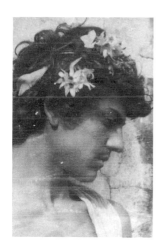
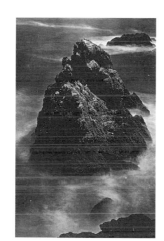
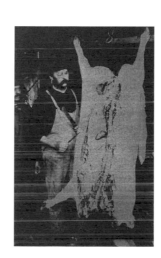
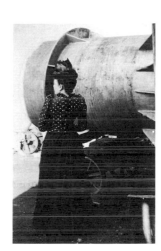

Preface and Acknowledgments

Were I to subtitle this collection of essays I would probably call them *Essays in Revision* because each is an attempt to re-see certain images and to revise what had previously been said or thought about them. I want to emphasize, however, that these are simple attempts to look again at certain groups of photographs and draw a few new but, again, simple conclusions. I have complained in more than one book about so-called revisionist approaches because I usually find them, for all their seeming radicalism, predictable and fueled by current ideological fashion. I would not, therefore, want anyone to think my modest collection of second looks and simple revisions was written from that "bold revisionist standpoint" dust jackets delight in proclaiming.

Rather ordinary but important matters have been overlooked in many areas of the photographic arts, especially in the Western daguerreotype, the American autochrome, the actual *art* of the cyanotype, the American Symbolist photograph, in European Pictorialism, and in the contemporary daguerreotype. Except for the cyanotype, each of these is a subject I have addressed in one form or another and later realized was a subject that demanded my own re-vision as well as my revision. Though these are factual essays, they are in many respects personal essays, too. I am not gazing down upon my fellow photohistorians from lofty heights to point out what *they* needed to re-see. These essays are about what I needed to re-see. They do attempt to address topics within the photographic arts that have in my opinion been too often neglected.

I have not, however, limited myself to a narrow discussion of the one hundred and three photographs I chose to illustrate. In fact, the first essay, which is about the Western daguerreotype and is the longest of the six, has less to say about daguerreotypes than anything I have ever written on that subject. What it attempts to discover is the actual look of the world of those daguerreotypes in the words of the gold miners themselves. My approach may bother some readers, but I would suggest that photography in a vacuum is finally as meaningless as any other art placed in a vacuum. Photography is vital; it is about life and living, even if the lives are done, because photography is finally and most importantly about us. Could a documentary photograph from the American Civil War be about us? Absolutely; it is a cautionary tale. Is an advertising photograph from the 1920s about us? Of course, because we read it differently today than it was read in its time and so it is about the modern eye and modern notions of art.

I don't want to suggest that this is only an assortment of contemporary readings of old pictures. It *is* theoretical but also factual. There are a few facts here stated for the first time, and there are some historic and important images published here for the first time. But I would like to think that if this volume has any

real merit, it lies not within its facts but its conjectures. Photography is one of the greatest delights of my life because of what it makes me think about, and I hope readers will find some of those thoughts worth having been shared. That, too, is an aspect of why I feel these essays, though scholarly, are also personal.

As I said, they are attempts to address topics that have been neglected. Though the daguerreotype has certainly come into its own in the last few years, it had long languished as photography's Cinderella overshadowed by all of her less brilliant sisters in a kind of no-man's-land between the museum and the flea market. Fortunately this situation has changed and the daguerreotype is increasingly seen in its proper position as one of photography's greatest achievements and as a significant artistic medium of the nineteenth century.

Though scholars such as Therese Thau Heyman, Peter Palmquist, and Matthew Isenburg have made a serious study of the daguerreotypes of the American West, it is an area that I personally have neglected in spite of having produced four books on the daguerreotype. The first essay, therefore, attempts to address no one's oversight but my own, yet from a different vantage point than my highly competent colleagues have used. And the last essay, which also deals with the daguerreotype, addresses another of my oversights. I have often written on the contemporary daguerreotype but failed to discuss the powerful and important work of Jerry Spagnoli.

The autochrome and the cyanotype are as striking and beautiful in their own way as the daguerreotype is in its. Each has a unique and haunting beauty, and though both were immensely popular and many of photography's greatest masters made use of them, they, curiously enough, have been critically neglected. Apart from the publications of the Musée Albert Kahn and my own *Art of the Autochrome*, little has been written on the autochrome since its demise, and nothing on the subject of the American autochrome and Fred Payne Clatworthy, probably the greatest American master of the process. Larry Schaaf's brilliant and beautiful *Sun Gardens*, a study of Anna Atkins' cyanotypes, is the only historical study devoted to the lovely process. The cyanotype needs and deserves an entire book devoted to it, a complete artistic and historical survey, and I hope that someone will eventually produce such a study. In the meantime I offer a modest survey and a more concentrated look at the work of an inspired modern cyanotypist who has crafted both a new vision and a vocabulary for the cyanotype.

Though Symbolism has been the subject of renewed attention in the last five years, American Symbolism has not been discussed, nor has the primary myth to which most Symbolist photographs seem to refer. And related to that subject is a somewhat similar essay discussing European Pictorialism, which in this country has been neglected in favor of our own Pictorialists or those Europeans who got Alfred Stieglitz's stamp of approval by being included in *Camera Work*. The *Camera Work* photographers have ended up in the history books, and deservingly so; however, many of those who only appeared in the equally lavish Ger-

man journal *Kunst in der Photographie,* or the less lavish but still elegant *Photographische Rundschau,* or in the Photo-Club de Paris's four sumptuous *Exposition d'Art Photographique* catalogues of 1894–1897 or its 1903–1908 *Revue de Photographie,* or in any number of similar publications have been forgotten. Many of these neglected masters also deserve our attention and a place in photography's history.

I am particularly grateful, as usual, to Charles East, my brilliant editor and good friend, and to those who were kind enough to allow me to reproduce images from their collections. Matthew Isenburg, the foremost authority on the daguerreotype and the leading collector of them; Greg French, America's other premier collector of the daguerreotype; and John McWilliams, the well-known expert on daguerreotypes of the American West, all allowed me to publish images from their fine collections never previously published. Marc and Mona Klarman as well as Keith Davis, the fine arts director of Hallmark and curator of the Hallmark Collection, also generously allowed me to publish important daguerreotypes from their collections. Larry Gottheim, one of the country's foremost collectors of cyanotypes, allowed me to select whatever I wished from his collection, none of which had previously been published. George Eastman House and various collectors of the work of John Metoyer were kind enough to allow me to use images from their collections.

I owe a debt of immense gratitude to Mark Jacobs, the leading authority on Fred Payne Clatworthy. He offered me complete access to his collection, which contains Clatworthy's personal collection of nearly a thousand autochromes, his correspondence with the *National Geographic,* and many of his personal papers. He was also kind enough to contact Barbara Clatworthy Gish, daughter of the photographer, and she provided me with invaluable assistance in identifying and providing additional information about the autochromes I wanted to use.

I used images from my own collection to illustrate the essays on Symbolism and European Pictorialism, for several reasons. In all of my books I have tried primarily to reproduce images that have not previously been seen, and so I did not want to use those same standard Symbolist images that are reproduced again and again in book after book. I became passionate about Symbolist photography following Janet E. Buerger's 1984 Eastman House exhibition *The Last Decade: The Emergence of Art Photography in the 1890s.* I can still vividly recall a lecture/slide presentation she gave that was one of the most brilliant I had ever heard and one of the most visually stimulating I have ever seen. She inspired me to begin studying this field, a field virtually impossible to study without actually collecting its images unless one has the good fortune to be in Rochester, Antwerp, Hamburg, or one of those cities where the work can be seen firsthand. I tried to acquire work typical of an artist's Symbolist or pictorial period but which existed only in a very limited number of prints—a holdover, I suppose, from my passion for daguerreotypes and autochromes, but at least it did allow

me to view many images apart from the standard ones. Since none of these prints have previously been seen or published, it seemed appropriate to use them; illustrations not cited as being from a particular collection are, therefore, from my own.

The gravures of course, especially those from *Camera Work*, of which I use but one because they are so well known, do exist in other collections, but it was easier to use my own, especially in the case of the rarer items. There are only two other copies of *Kunst in der Photographie* in the United States, both in institutions, and four in institutions outside the U.S.; the only other copy in private hands is in Germany. Two U.S. institutions have copies of the 1897 London *Kodak Portfolio*, the tight binding of which, unfortunately, makes copying images difficult without breaking the spine. Consequently many important things in that volume have never been reproduced, including three magnificent George Davison images. Binding also makes copying from the 1894 Photo-Club de Paris *Première Exposition d'Art Photographique* a great difficulty as well. So, even had I chosen to appear more modest and request all these images from institutions, there are still several I would not have been able to use.

All of which brings me to Gray Little, my colleague at McNeese, a highly talented, artistic photographer in his own right who was kind enough to turn his talent to mere copy work, as he had done for me in *The Art of the Autochrome*, and produce the copy prints, many of which were quite problematical to make. I am deeply in his debt.

Finally I should acknowledge the very great man to whom this book is dedicated, Heinz Henisch, an inspiration to me, the finest scholar photohistory has produced, and a giant of compassion and humanity.

The Photographic Arts

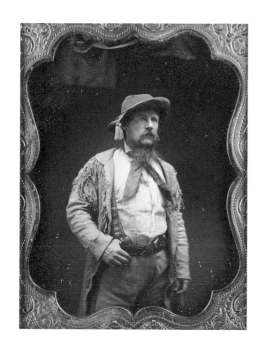

American Destiny or Manifest Mythology

Some Historical Considerations of the Western Image

For years I have argued that too often the daguerreotype is viewed exclusively as a historical artifact, important only for its factual content, and that it should be considered within the pictorial tradition of Western art and nineteenth-century art in particular. There is no other way, I maintained, to deal with the fact that these very first photographs, in some cases images made within the first months of photography's existence, exhibit such formal sophistication and possess such seemingly innate artistic qualities. We have to ask from where their form is derived, and we have to wonder how such clear masterpieces of photographic composition were possible prior to photography and a tradition of such imagery —*unless* we recognize that photography sprang from the same forms and tradition. Nineteenth-century science allowed this new art to spring, like Athena, full-blown into life — and as wise and mature at birth as it would ever be. There was no "primitive" stage of photography, nothing that resembled cave drawings or aboriginal glyphs. Photography simply appeared at a moment when both the Western pictorial vision and the camera's eye coincided, a time at which painters and photographers were producing similar kinds of compositions.

All this I still believe to be true, still believe is the best way to approach the daguerreotype; however, I think it is also true that the photographic historian must read the art of the daguerreotype as a reflection of its moment in the nineteenth century. The art — which is crafted from the look in the eye, the turn of the head, the dress of the sitter or the look of the scene, the content of the landscape, the sweep of the sky, and so forth — suggests certain things, certain things that demand us to ask why those things and not something else. And no Ameri-

can daguerreotypes so demand these questions to be answered as do those that captured the California Gold Rush and the Westward movement.

We usually think of the exploration and conquest of the American West either as a glorious moment in our history, a time when there was still a frontier to test our spirit, or a pretty bloody business we'd prefer to forget about — or possibly never forget, to hold sacred as a memorial to the past and as a warning to the future. How then does one read the Western daguerreotype? What do those images of miners, frontiersmen, and pioneers say? What do they mean? And is what they *say* the same thing as what they *mean*? These are a few of the central questions the Western image poses.

No discussion of the American West and the Westward movement, whether related to intellectual, social, economic, or even photographic history, is intellectually credible that does not immediately deal with the white man's near extermination of the country's native people. In his annual message of January 1851 Governor Peter Burnett, the first governor of California, said, "That a war of extermination will continue to be waged between the two races, until the Indian races become extinct, must be expected." The fact that he followed that statement with "While we cannot anticipate this result but with painful regret, the inevitable destiny of the race is beyond the power or wisdom of man to avert"[1] in no way mitigates the horror of what he said, of actually seeing the word "extermination" in print. And Burnett's use of it is not unique in the literature of this period, even — and this is what is most shocking — among generally sympathetic voices, voices like Henry Boller's.

Boller was a fur trader who lived for years among the Indians and left a long narrative of his experiences. He rather patronizingly considered them a people whose "wild nature and habits cannot be eradicated," yet still he used the word "monster" to describe the Reverend J. M. Chivington, colonel of the Colorado Volunteers, the man responsible for the infamous Sand Creek Massacre and the order to kill and scalp the children. Boller also commented that though "the Indian has been called a bloodthirsty savage, . . . a careful investigation will show that the whites have so far taken the lead in bloodthirsty atrocities of every kind."[2] However, in his chapter on "The Indian Question" he writes with the detachment of a participant in the Wannsee Conference that "A war of extermination is a far more gigantic affair than we can manage, to say nothing of the stigma such an undertaking would cast upon the Government in the eyes of the civilized world" (p. 433).

It would seem that slavery, America's other great shame, prepared the way for extermination. Though the enslavement of black people was far more pervasive, the Indians were sometimes enslaved as well. "Another variety of commerce across the Old Spanish Trail was the disreputable slave traffic in Indian women and children. . . . A continuous reservoir of Indian children to supply the New

Mexico market was found in the country along the trail to California. . . . Indian slaves brought from fifty dollars to two hundred dollars apiece in the New Mexico market."[3]

If a people can feel so superior to and so different from other human beings as to enslave them, then it is an easy step to the conclusion that still others are sub-human and, therefore, exterminatable if need be. Such illogic would seem to explain the Reverend Chivington's cruelty and attitudes like "The only good Indian is a dead Indian," but I fear it is too simplistic an explanation to deal with so complex a tragedy. History is seldom a simple matter of the battle between the angels of light and the angels of darkness.

Charles Bancroft's *Footprints of Time*, an immensely popular late-nineteenth-century U.S. history — it went through thirteen editions between 1874 and 1888 — unashamedly flatters the white American ego and speaks of "the instinctive love of liberty and intuitive statesmanship of the [American] people" and our "ready intelligence and quickness to comprehend the main features of every important situation."[4] But of the Indian he writes, "They were so inherently wild men that the conquered remnants usually withered and faded away under the process of civilization. . . . They are difficult to control, however, not recognizing, as civilized people do (except a small number who are far on the way to civilization), the obligations of treaties and pledges."[5] This, however, seems more of an explanation after the fact, a kind of rationalization for what had happened, than the expression of some long-held attitude.

One author has written that "In Protestant North America the Indian nations were deliberately stamped out . . . and it was generally believed that some inscrutable natural laws were at work by which the Indians automatically perished under the withering touch of civilization.[6] This was certainly Bancroft's position, but modern historians writing from a wider perspective have recognized that "Where the English plantation colonies destroyed, as soon as possible, the Indian cocoon around them, the French supported and sustained the Indian world in which they found themselves" and that "Spain, in general, was far more tolerant in making use of the Indian peoples, who were absorbed in large numbers into the population of Spanish colonies."[7]

However, it is not just the modern historian who has recognized this fact. The humorist Joseph Glover Baldwin, a minor American writer, though one admired by Lincoln, the author of a volume of Gold Rush memoirs, and eventually an associate justice of the California Supreme Court wrote, "The policy of Spain was to encourage marriages between her soldiers and the native women. And in this feature, in the happier turn for amalgamation of the S[panish] & F[rench] people with inferior races consists the difference between them & the Anglo-Saxons. The planting of an English colony is an extermination, sooner or later, of the Savages around it; while the colonists of Spain and France multiply and replen-

ish the earth by grafting French and Spanish upon the Native breed."[8] And there again in the middle of nineteenth-century America is that ominous word "extermination."

What was the difference in English attitudes and those of the French and Spanish? It has been pointed out that "The gulf between the Indian and white view of life was at its most unbridgeable in the region that became the United States, colonized by a people to whom diligent labor, thrift, Benjamin Franklin's admonition to 'Remember, that time is money,' became the highest virtues, and work was literally man's sacred calling. The colonies of Catholic Spain to the south and Catholic France to the north, while by no means less interested in reaping golden pesos or gross sous, were less devoted to the principle of absolute utilitarianism — measuring fields, woods, streams, people, and above all time, only by the yardstick of potential profit."[9] Obviously there was a serious cultural conflict between the Anglo-Saxon and the Indian view of what was important in life.

In reading the journals of the Forty-Niners, again and again one encounters the Indians being called lazy because they did not share the work ethic of the whites, and even more unfathomable to the whites, though often admiringly so, was their attitude toward sharing and their non-European notions of property. But such cultural differences in themselves surely could not have lead to extermination. We do not make a habit of romanticizing the objects of our hatred. The popularity of *The Last of the Mohicans*, the "Song of Hiawatha," and countless other Indians in poems, plays, and stories; the presence of an Indian on some circulating U.S. coin every year from 1854 to 1938 (the cent from 1859 until 1909, the nickel from 1913 to 1938, the one- and three-dollar gold coins from 1854 until they were no longer minted in 1889, the $2.50, $5.00, and $10.00 gold coins from 1907 and 1908 until they were no longer minted); and the omnipresence of Indians in nineteenth- and earlier twentieth-century advertising all must attest to some kind of affection, admiration, or nostalgia at least for the Indian. Even though especially terrible things were happening to the American Indian between 1854 and 1889, does it make sense to argue that if they were truly hated an image of an Indian would have been placed on the dollar, the nation's monetary unit? Could a similar thing be imagined during the Holocaust?

Prejudice, feelings of cultural superiority, ignorance of the native cultures, the Anglo-Saxon work ethic, and in some cases pure, sadistic cruelty — authentic evil — on the part of whites all contributed to the tragedy of the American Indians, but nothing so probably determined their fate as did greed for land. They had what we wanted, and we had the power to take it. Robert Frost's well-known poem "The Gift Outright," which begins "The land was ours before we were the land's," might better have been entitled "The Theft Outright." The very notion of the "land" being "ours" — or anyone's, for that matter — would have struck the Indian as a primitive, barbarous, and sacrilegious notion. The Indians were the land's caretaker, and they cared well for this continent for thousands of years,

raised great civilizations, made art, built beautiful buildings, and crafted the myths to give a meaning and a center to the People's lives.

We might ask how we have fared as caretakers. Gerald Hausman, writing in *Turtle Island Alphabet*, noted that "As we near the cycle of five hundred years since Columbus blundered into historical tragedy, many people want to know what happened, how did the land get ruined so fast, what did this nation do to hasten the destruction."[10]

Frost's term "Gift Outright" is, of course, suggestive of other catchy phrases, such as *Lebensraum*, or that earlier and more acceptable version of the same notion, *manifest destiny*. When John O'Sullivan, editor of the *Democratic Review*, coined the term in July of 1845 to refer to the then recent annexation of Texas, he had not come up with a new notion; the idea was already in place. He merely created the euphemism, the noble-sounding expression that greed could be cloaked in and cruelty rationalized by. Though there had been numerous earlier examples of white destiny in conflict with the Indian presence, the most famous was the Great Removal initiated by Andrew Jackson's shameful Indian Removal Bill of 1830. The United State Supreme Court even handed down a decision by Chief Justice John Marshall in favor of the Cherokees' right to their land and against the unconstitutional action being taken to remove them, but Jackson would not execute the decision of the court. Few actions by any American president ever produced the enormity of suffering caused by that bill. Though the history of the American settlers' dealings with the Indian in the previous centuries had not always been the most noble, something significant seemed to have changed in the quarter century from the Lewis and Clark Expedition to the Removal Bill.

Thomas Jefferson's *Instructions to Meriwether Lewis* with regard to the Indians were both kind and respectful:

In all your intercourse with the natives treat them in the most friendly & conciliatory manner which their own conduct will admit; allay all jealousies as to the object of your journey, satisfy them of it's [sic] innocence, make them acquainted with the position, extent, character, peaceable & commercial dispositions of the U.S. of our wish to be neighborly, friendly & useful to them. . . . if a few of their influential chiefs, within practicable distance, wish to visit us, arrange such a visit with him, and furnish them with authority to call on our officers, on their entering the U.S. to have them conveyed to this place at public expense. if any of them should wish to have some of their young people brought up with us, & taught such arts as may be useful to them, we will receive, instruct & take care of them. . . . carry with you some matter of the kine-pox, inform those of them with whom you may be of it' [sic] efficacy as a preservative from the small-pox; and instruct & incourage [sic] them in the use of it.[11]

But in a mere quarter of a century such kindly attitudes changed, and by the time the Cherokees were driven from their land in 1838 and 1839, land piracy clearly had the official blessing of the United States government. After that the Indian's fate was sealed. Wherever the white man chose to go on this continent, he could, and it was his—his land, his destiny.

That was the message that seemed to have been sent out, and the fearless look of confidence one sees again and again in the faces of those who went West (plates 1–3) [12] suggests that was the message they heard, but reading the actual words they left in diaries, journals, and letters home suggests an altogether different picture, suggests that the daguerreotypes lied, that what their pictures seem to say is not the truth. An entirely different picture of the Forty-Niners emerges in their own words from the one held in the popular imagination, one shaped by those powerful daguerreotypes (plates 4 – 6) and countless stories and legends about wild California and the Gold Rush.

What their journals say about the Indian, for example, is a particular case in point. Luzena Wilson, a female Forty-Niner, wrote, "Around us in every direction were groups of Indians sitting, standing, and on horseback, as many as two hundred in the camp. I had read and heard whole volumes of their bloody deeds, the massacre of harmless white men, torturing helpless women, carrying away captive innocent babies. I felt my children the most precious in the wide world, and I lived in an agony of dread that first night. The Indians were friendly, of course, and swapped ponies for whisky and tobacco." [13]

In fact, according to David Potter, who edited the journal of Vincent Geiger and Wakeman Bryarly, those more legendary than factual "accounts of the Gold Rush as a pageant usually show that the trek westward was dangerous, and they dramatize the skulking redskin; in fact, the mortalities were highest at the outset of the journey, and the Indian menace, from an actuarial standpoint, was negligible." [14]

The only completely hostile portrait I encountered was written not by an American but by a Frenchman, Étienne Derbec, a journalist who wrote a series of otherwise interesting and informative letters to the *Journal des Débats*, a Parisian newspaper. In a letter of October 27, 1850, he spoke of the Indians as "cruel" and "cunning as they are treacherous." "In Europe they imagine that the customs of the California Indians are somewhat less savage; . . . that is an error; they lead a savage existence in every respect that is most repulsive to civilized man." [15] For those who thought the Indians had "a civilization and morals," he explained that they "do not exist" (p. 154). They are "unprincipled," "without religion, without morals. . . . No moral bond unites them, and marriage is unknown to them" (p. 159). "Indian life [is] hideous" (p. 162) and "show[s] us to what abject state human nature can fall" (p. 161). Derbec, with a surprisingly narrow culinary sense for a Frenchman, is even shocked at what they eat. "Everything is eaten: the hide, stomach, intestines" (p. 156). "Everything that

lives . . . is good [food] to the Indians' stomach; toads, frogs, grasshoppers, moles, mice, rattlesnakes . . . ; they find nothing in nature unworthy of their stomachs" (p. 157). His discussion finally sounds like a caricature of "the savage." They eat "like famished wolves" (p. 156), "have repulsive faces," and often put bones through their noses (p. 154).

He concludes his attack with the actual reason for his hatred, the Indians' attitude toward property and his own memories of the revolutions of 1848. They "practice communism in its entirety, in its most rigorous application, for they adapt it to everything which exists without the least exception. Among them, *everything belongs to everyone* or to use the same words which are winning over so many ignorant people in our country to that sect, *nothing belongs to each*. It is this principle which encourages them to steal what they like" (p. 161). "And whatever they say about it, the communism of the innovators would end, after six thousand years of progress, by leading man back to the state of the brute, the state of the Indian, placing him, like these savages, under the exclusive dominion of the law of the stomach, making him today what he was the day after creation" (p. 162). Derbec must have forgotten that the day after our creation we were still in the Garden of Eden.

A more accurate picture of the California Indians comes from Alonzo Delano, whose *Life on the Plains and at the Diggings* records his time living among them as a merchant. "I was completely in their power and might have been killed or robbed at any moment; but while I was with them I am not aware that I lost the worth of a dollar, although I had five thousand dollars' worth of goods with me at one time. . . . I sometimes had occasion to be gone all day from home, but leaving my house and goods in the care of the chief or some of the old men I invariably found everything safe on my return. My confidence was never abused."[16]

"The Indians of California," Delano wrote, "are regarded as being treacherous, revengeful, and dishonest. This may be so to a certain extent, when judged by the customs and laws of civilization; but it should be qualified by the fact that they are governed by their own sense of propriety and justice, and are probably less likely to break the laws which they recognize as right than the whites to break theirs" (p. 273). Delano also noted, "It cannot be denied that there are evil-disposed Indians as well as white men; for human propensities are alike in all ages and climes" (p. 275). "I do not mean to appear as their apologist, but I do think their character is not well understood by the mass of people, and that their good will might be gained by conciliation, kindness, and justice" (p. 286).

"When I went among them," he wrote, "I was surrounded by numbers, with the utmost cordiality, and always invited to share their meals or to partake of their luxuries, and they never seemed weary in showing me little attentions. . . . a more jolly, laughter-loving, careless, and good-natured people do not exist. . . . To each other they were uniformly kind, and during the whole of my residence with them I never saw a quarrel or serious disagreement" (p. 256).

Delano's deeper knowledge of Indian culture clarifies many of Derbec's faulty assertions. "Marriage is unknown to them," Derbec wrote, obviously because it did not take the form of a ceremony he could recognize. Delano explains that marriage among them "resembles, in some respects, that of the Tartars. When a young man has fixed his affections on a girl, he makes a proposal to the parents, and with their consent, which is easily obtained, she goes out and hides. The lover then sets out in search, and if he finds her twice out of three times, she is his without further ceremony. But if he fails he is on probation for about three weeks, when he is allowed to make another trial, when, if he does not succeed, the matter is final. The simple result is, that if the girl likes him she hides where she is easily found, but if she disapproves of the match a dozen Indians cannot find her" (pp. 270–71).

As for their being "without religion, without morals," Henry Boller, who lived among them for years, wrote, "I have always considered the North American Indians a highly religious people. . . . They practice as well as preach. . . . their religion is essentially the same as that of more enlightened nations, differing only in the mode of its observance" (pp. 114, 116).

Delano, too, commented on their "communism" or sense of sharing, which he first observed after giving dinner to a child for helping him do some work. He noted how two of the boy's friends came up and ate from the plate as if it was theirs and with no objection from the child to whom he had given it. He wrote that he often tested this seemingly amazing, and to the white man, foreign sense of generosity; if two Indian boys came in to his store "I would give one of them a single cracker, . . . he would invariably break it in two and give half to his companion" (p. 261). Delano's narrative, however, ends on an ominous note. "Once in contact with whites, they learn their vices without understanding their virtues; and it will not be long before intemperance, disease, and feuds will end in their extermination or complete debasement" (p. 286).

Baldwin, whose *Flush Times of California* I quoted from earlier about the "planting of an English colony . . . sooner or later" leading to "extermination," clearly echoed Delano's unhappy sentiments. Baldwin also commented that before the whites arrived the "vices and crimes of a ripe or rotten Civilization were withheld" (p. 39); then came the padres who "converted the indians by platoons, sprinkling them with a mop — and treated them with kindness after they had subjugated them at once to Christianity and to their own service and authority" (p. 40).

Such attitudes toward the Indian were not merely those of literary men or people who lived intimately among them. In January of 1849 Alfred Doten, an eighteen-year-old sometimes cod fisherman and apprenticed carpenter from Plymouth, Massachusetts, read of a proposition offering to give free passage to California in return for a percentage of the individual's earning over the next

two years. In addition to keeping a journal Doten sent letters back home to his local newspaper, the *Plymouth Rock*. Two letters from 1855 deal with the Indians. The first opens with these lines from a poem entitled "The Indian Hunter":

> Oh, why does the white man follow my path,
> Like the hound on the Tiger's track,
> Does the flush on my dark cheek, waken his wrath,
> Does he covet the bow at my back?
>
>
>
> Then why should he come to the streams where none
> But the red skin dare to swim,
> Why, why should he wrong the hunter, one
> Who never did harm to him.[17]

In the second letter he writes, "But now, 'lo! the poor Indian,' a change had indeed come o'er the spirit of his dream; the tall trees fall fast before the axes of the ever encroaching 'pale faces;' towns and cities spring up rapidly in the very midst of his hunting grounds, and all the once clear and sparkling mountain streams are made thick and muddy by the incessant wash of the industrious miner. . . . Ever since the first settlement of America, ever since the landing of the Pilgrims, the Indians have been driven westward. . . . they have been ordered to 'move on' . . . step by step, on the weary trail. . . . Now . . . they are crowded back into the interior; slowly but surely the race of the red man is fading away, 'moving on' to be among the things that were" (I, 211). It is as if everyone who had even the slightest dealing with them realized what was happening, realized that they were vanishing.

In addition to the more sympathetic portrait of the Indian presented in the journals and letters of the Forty-Niners, a far more sensitive portrait of the miner emerges than the pistol-packing tough guy often seen in the daguerreotypes. Of course, it was the more intelligent, sensitive ones who wrote things down; however, I was amazed at the delicate sensibilities these honestly very tough guys recorded themselves and other miners as having, at how often they actually wept. Most of the miners were young when they arrived in California. George Dornin, who went from mining to daguerreotyping, recorded in his *Gold Rush Memories* that "Not since the days of the Crusades has such an uprising taken place, and like the Crusades, the pilgrims were (with rare exceptions) men — young men, or under middle age."[18] However, their journals all suggest that the long trip around South America and exposure to the brothels of Chile toughened and matured these New England boys, so that by the time they arrived in San Francisco they were certainly grown if they hadn't been when they left.

Those who took the overland route probably matured even more quickly, for their journals are filled with cholera, hunger, and death. After a few years of the

hard life of mining, they were all as mature as they would ever be. Alfred Doten was nineteen when he arrived in 1849; a few years later, on December 22, 1851, he recorded in his journal from Rich Gulch, Calaveras County, the tale of a murder. The murderers were caught and locked in a store, and then the dead man's partner arrived. Doten wrote, "But such a scene as this. Oh my God may I never look upon such another—Poor Dave—he begged us, prayed us, to let him shoot them. 'Oh, let me kill them with my own hands,' 'Alex was my last partner and I loved him as a brother'—.... Poor Dave. When he found we would not let him shoot the prisoners, he dropped his pistol and laying his head on Chinn's shoulder and cried like a baby. All he could say was 'Oh Jake! Alex! Alex! Alex!' The scene was indeed affecting and from very sympathy I cried too and many a rough hardy miner turned away from the scene to wipe away their tears which came rolling down their bronzed and manly cheeks" (I, 102). The murderers were soon executed.

George Dornin, writing a memoir of his experiences for his children years after the fact, was also unashamed to record his tears. He carried with him his "mother's daguerreotype, over which I cried often and bitterly, when suffering from that most distressing of all heart-diseases, 'home-sickness'" (p. 4). He also commented that he "frequently gave way to homesickness the most depressing." Once "I threw myself on the ground and cried as though my heart would break," he wrote, going on to write that "such feelings . . . were experienced by thousands in those early days" (pp. 31–32).

And Luzena Wilson, the female Forty-Niner, described the scene when schooners came in with mail from the East. "Sometimes the letters came; more often the poor fellows turned away with pale faces and sick disappointment in their hearts. Even the fortunate recipients of the precious sheets seemed often not less sad, for the closely written lines brought with their loving words a host of tender memories, and many a man whose daily life was one long battle faced with fortitude and courage, succumbed at the gentle touch of the home letters and wept like a woman. There was never a jeer at these sacred tears, for each man respected, nay, honored the feelings of his neighbor" (p. 17). The receipt of such a letter (plate 7, and also note the pistol on the table), like the showing off of a pan of gold at the local tent store (plate 8) or the recording of the actual mining machinery (plate 9), was a meaningful enough event to the recipient to be recorded in an expensive daguerreotype.

Doten was probably rather typical of the young New Englander come out West. He, as I said, had had a simple education, fished cod for a summer, and became an apprenticed carpenter. He couldn't afford passage to California on his own but went with a company to which he would pay a percentage of his earnings for a certain length of time. With this kind of ordinary background I doubt if his sensitivity was unique among the miners, and from the frankness of his journal

we can certainly tell that he was no delicate Puritan boy. In Chile on August 3, 1849, he wrote, "There are plenty of girls in Talcahuano and the principal business carried on is—F—ing" (I, 40). At Rich Gulch, Calaveras County, on April 12, 1852, he noted, "The stage arrived and left an American woman and four Chileno whores who are going up to Angel's camp to set up a whorehouse" (I, 110). On Sunday, May 30, he wrote, "There is a Chileno *hermaphrodite* camped near Brooks' store—" (I, 116).

And "On the Calaveras" on September 20, 1852, he recorded an interesting experience, from which he later erased some passages. "This forenoon two squaws came over from the rancheria" (which he defines elsewhere as the Indians' "towns [which] consist of a cluster of wigwams" [I, 212]) "and paid me quite a visit—... As is as usual she was accompanied by an old hag of a squaw—I gave her several presents and made myself pretty thick with her and after a while I got her [erasure] and took her into my tent and [erasure] was about to lay her altogether but the damned old bitch of a squaw came in as mad as a hatter and gave the young gal a devil of a blowing up—Nevertheless I still left my hand in her bosom and kissed her again right before the old woman. She didn't get cross at all but gave me a slap in the face and ran away laughing." Doten told the girl to come back later (I, 125–26).

Doten, therefore, appears rather as we might expect the legendary California gold miner to appear. And I do think he was typical, other than that he kept a near daily diary; however, unlike what we might think typical, he records that in August of 1853 he was reading Charles Dickens' *Nicholas Nickleby* (I, 159). In February of 1855 at Fort Grizzly he was reading Dickens' *Hard Times*, which he noted was "very appropriate to the times" (I, 206); and after suffering a cave-in that nearly killed him and left his legs and also his penis, he is particular to note, paralyzed for some time, he lay in bed reading Lord Byron (I, 246).

George Evans, a young middle-class man from Ohio who left a tragic but powerful journal of twenty-one months studded with disease and death, including finally his own, also records a considerable amount of reading and the fact that miners loaned each other books.[19] These young men who headed for the gold fields were not the caricatures from television that we have of illiterate, rude, ill-mannered, drunken, dirty miners. In fact, complaints about and embarrassment over lice were common in the diaries. They read, they thought, they felt deeply, and they talked about important matters. Doten even records that onboard ship they discussed the evils of slavery! On Sunday, April 15, 1849, he wrote, "The Captain, mates, Mr Caleb Bradford, and a few others, are on the quarter deck talking and holding a very spirited and animated discussion on the subject of slavery, equality, and the rights of man, and Universalism" (I, 9).

Surprising only in terms of the caricature we have of the miner is Doten's discussion of how deeply moved he was by the power and beauty of the California

landscape. On December 21, 1850, he wrote, "When I came back on my way to dinner, the veil [of mist] was lifted and again appeared the whole vast and magnificent scene of the San Joaquin valley with its undulating hills, beautiful rivers, and dark lines of timber . . . Is there a single human being on the face of the earth who could gaze on such a scene as this and say in his heart? 'There is no God!' – No! – " (I, 80).

This is not just an aesthetic reaction; it is the kind of deeply Romantic response we normally think reserved for poets. In fact, it sounds remarkably like a letter the great poet Thomas Gray sent to his friend Richard West about crossing the Alps: "Those [works] of Nature have astonished me beyond expressions. In our little journey up to the Grande Chartreuse, I do not remember to have gone ten paces without a exclamation, . . . not a precipice, not a torrent, not a cliff, but is pregnant with religion and poetry. There are certain scenes that would awe an atheist into belief."[20] And again, Doten is not unique; George Evans uses the word "beautiful" again and again in his descriptions, which are also highly romantic and poetic: "Standing on the top of a high hill, I could look down and see the clouds in the form of a beautiful wreath, almost entirely concealing the valley below me – magnificent, lovely picture, drawn by an artist never excelled" (p. 235).

A number of the Forty-Niners who kept journals wrote very well and very poetically. Reuben Shaw, a Boston carpenter who set off in '49 in hopes of bettering the lives of his wife and new baby, is a particularly good example. At times his writing is as brilliant as any prose being written by an American novelist of the time: "Our road was across a sage desert. As far as the eye could reach nothing could be seen but the blue sky and a wilderness of wild sage. The sun was excessively hot and there was not a breath of air in motion. A profound stillness hovered over the landscape and we seemed to travel in a world of sunshine, silence, and sage."[21] And some of the Forty-Niners actually did write poetry. Vincent Geiger records that while the "stock were grazing, and some few men reposing about camp," B. F. Washington, the organizer of the company Geiger was traveling with, read one of his "beautiful & feeling" poems, which, Geiger wrote, "I have taken the liberty to copy into my book." Though undistinguished as poetry, four of the eleven quatrains are particularly interesting for other reasons:

'Tis not because thy hills are green, thy valleys fair to see,
Thy forests clothed with varied tints & fill'd with harmony,
'Tis not because thy skies are bright as Italy's in hue,
Or on thy distant mountains rests a veil of shadowy blue, . . .

Upon Pacific's distant shores is heard a startling cry,
A sound that wakes the nations up as swift the tidings fly;
An El Dorado of untold wealth – a land whose soil is gold,
Full many a glittering dream of wealth to mortal eyes unfold.

O gold! how mighty is thy sway, how potent is thy rod!
Decrepid age & tender youth acknowledge thee a God;
At thy command the world is sway'd, as on the deep blue sea,
The Storm King rules the elements that roll so restlessly.

And see, the crowd is rushing now across the arid plain,
All urged by different passions on, yet most by thirst of gain;
And I, my home & native state, have left thy genial shade,
To throw my banner to the breeze where wealth, like dreams, is made.[22]

Luzena Wilson quickly disabuses us of any idea we might still have of the miners being rude, brutish, or ill-mannered. She and a husband she never even named sold their oxen for $600 and bought an interest in a hotel at which she cooked.[23] "It was a motley crowd," she wrote, "that gathered every day at my table but always at my coming the loud voices were hushed, the swearing ceased, the quarrels stopped, and deference and respect were as readily and as heartily tendered me as if I had been a queen. I was a queen. Any woman who had a womanly heart, who spoke a kindly, sympathetic word to the lonely, homesick men, was a queen, and lacked no honor which a subject could bestow. Women were scarce in those days. I lived six months in Sacramento and saw only two" (p. 15).

Like Wilson, Étienne Derbec also suggests that the miners were more civilized, or less rowdy, than we often think they were. "In Europe they think that the miners are addicted to drunkenness, gambling, debauchery, cutting each other's throats in order to steal: these are so many errors which I must destroy. . . . I have constantly found the morale of the miners admirable: sober, hard working, honest, disliking noise, . . . but I must add, a little sad and disappointed in their dreams of a fortune" (p. 142). He also noted in a letter of February 1850 that "Those people who expected, on setting foot in California, to find a disorganized and anarchical country were greatly mistaken. In no country are the laws better observed and crimes more rare. Theft and thieves are at present unknown. The terrible death penalty they must inflict upon the guilty restrains them perhaps; nevertheless, there is the greatest security and everyone has complete trust" (p. 78).

Doten wrote his father that he should "not suppose there is no law; Lynch law prevails here. . . . But yet this is the most civil country in the world, stealing is a rare thing, and murder is scarce, although every body goes 'armed to the teeth' at the mines" (I, 52). That look often carried over into the daguerreotype. "Californians were so anxious that their friends in civilized countries should see just how they looked in their mining dress, with their terrible revolver, the handle protruding menacingly from the holster, somehow twisted in front, when sitting for a daguerreotype to send to the States! They were proud of their curling mustaches and flowing beards; their bandit-looking sombreros; and our old friend

[the photographer] accumulated much oro en polvo and many yellow coins" (plate 10).[24]

Doten also records the miners' outrage at the very kind of brutishness that the popular imagination sees as a part of the Old West. On September 1, 1852, he wrote, "Two or three days ago at Camp Seco, over on the Mokelumne, two Mexicans took a little Italian girl of only six years of age and decoyed her up into the Chapparal nearby, where one of them tried to ravish her but as she was so small [erasure, but intent to rip with a knife can be made out] before he could accomplish his hellish intention he was surprised by a party of Americans — He made his escape but his compañero was taken prisoner — The miners were in the highest state of excitement about it and would have burned him alive but law prevailed and he was taken up to Mokelumne hill for trial" (I, 123).

Derbec claimed the miners were not "addicted to . . . debauchery," and they probably were not; however, there being so few women, so many men, and so much money, there was, consequently, a thriving sex industry in San Francisco even in 1849, but it, too, was not as we might have imagined it. Few writers were honest enough to leave firsthand records of it, though. Elisha Oscar Crosby, a lawyer and U.S. diplomat in South America, fortunately did. In the "Appendix: Anecdotal Scraps" to his *Memoirs: Reminiscences of California*, he wrote: "In 1849 a very noted cortezan [*sic*] of San Francisco established herself on the north side of Washington Street opposite the Plaza. There were very few of that class here then. She was among the pioneers in that calling and was known as the 'Countess.' She had six or eight young ladies, as they were called. Most of them beautiful girls. Some of them highly accomplished . . ."

The Countess was from New Orleans, and she issued "cards of invitation for one of her reception nights, beautifully engraved and embossed envelopes tied with white Satin ribbon. . . . These were addressed to the most distinguished gentlemen of the Community. . . . On presenting their cards at the door the gentlemen were admitted and by some means it was understood that a gratuity was to be left with the doorkeeper; generally not less than an ounce. . . . Other ladies as they were called were generally invited in from the few demimonde houses then in operation making quite a display of female beauty."[25] There was dancing, and then dinner followed. "The gentlemen were in full dress, with white kid gloves. There was no loud and boistrous [*sic*] mirth nor rude conversation or behavior." Some men would stay after dinner "for private enjoyment of a different character."

Crosby also comments that "when these girls appeared in the streets they were treated with the greatest respect and gallantry the same as would be extended to the most respectable women by men in general. This was during the winter of '49 – '50. Their regular business must have been profitable; six ounces was the price of a nights entertainment" (pp. 108 – 109). Gold traded at $16.00 an ounce at this time.[26] "Entertainment," therefore, was not cheap. "The first Chinese

courtezan [sic] who came to San Francisco was Ah Toy. She arrived I think in 1850 and was a very handsome Chinese girl. She was quite select in her associates was liberally patronized by the white men and made a great amount of money" (p. 109).

Crosby also records an amusing, "characteristic," and vaguely erotic story about a Judge Blackburn of Santa Cruz. A vaquero kept a woman from being gored and killed by a wild steer, but unfortunately the man knocked her down and she lost the child she was carrying. "The husband brought suit against the vaquerro [sic] for damages and during the trial of the case great stress was laid on the loss of the child. Blackburn after considering the case very solemnly gave his decision that the vaquero should put the woman in the same condition as he found her, and the complainant, the husband, should pay the costs of the prosecution" (p. 113).

The stereotypical miner was also supposed to dislike the Chinese, and real prejudice here did exist, but because of economics, not because of racism. They were welcome in the mines if they would become citizens and stop sending all their profit back to China. Though images of Chinese in the gold fields are exceedingly rare, they can occasionally be seen at the mines in their typical straw hats and native dress (plate 11). In his memoir *Three Years in California* J. D. Borthwick complained that "the Chinese formed a distinct class which enriched itself at the expense of the country . . . without contributing in a degree commensurate with their numbers to the prosperity of the community. . . . the Chinese, though they were no doubt, as far as China was concerned, both productive and consumptive, were considered by a very large party in California to be merely destructive as far as that country was interested."[27] And Doten, who seemed to comment on everything, remarked in May of 1852 that "There is considerable in the papers and much said about driving the Chinese out of the mines, except those who are willing to become naturalized citizens, as they are no benefit to the country at all, but rather a drain" (I, 111).

We also know that the Spanish were ill-treated during this time, but once again it is interesting to go back to the journals to read what contemporary reports had to say. Elisha Crosby, the lawyer and diplomat, argued that the Spanish Californians (plate 12)[28] were unjustly treated by the Federal government, that some of the decisions of the U.S. Supreme Court "were in utter violation of the Treaty with Mexico and the plainest justice," which he claimed "was in consequence of the clamor of demigogues [sic] here in California. I think these decisions were on a par with the Dred Scott decision which was rendered to comply with the demands of the slave owners" (p. 115). And Joseph Glover Baldwin, who was writing with his usual acerbic wit and who, as I mentioned earlier, became a justice of the California Supreme Court, commented that "our admirable Federal system is a little lame and imperfect in this thing of affording government to its provincial citizen, natives and acquired. Our forefathers seem to have

underrated the American genius for . . . taking other people's land. . . . The American people are always very well agreed as to taking the land of their neighbors; they are nearly always unanimous on that subject; but they always get to falling out about the division of the spoil" (p. 31).

All in all, then, the portrait of the miners and those westward pioneers that arises from their own words seems rather different from the dime novel depictions we have of them or from the view the daguerreotype presents. But nowhere was a mythology more manifest than on the frontier because nowhere was a mythology more needed. Our myths are the great structures we try to hang our own smaller lives upon in order to give meaning to them or make them bearable. In our myths we are heroic and larger than life; in our personal journals we weep with homesickness, worry about loss — the loss of money, virility, face — and are as human as everyone else. However, we do rise to our myths, and in doing so we find ourselves cloaked in our destiny. The confident Dragoon scout (plate 2) may not have been as heroic in real life as his portrait suggests he was, but finally he is his portrait, just as poor William McKnight (plate 10) was his. We make ourselves heroes if we choose to be. It is an existential act.

Alexander Pope tells us that "Happiness . . . 'Tis no where to be found, or ev'ry where," and it is the same with courage, heroism, or whatever. We make our own lives. We take on the mantle of Sir Gawain and proceed through the terrifying wilds to face the unknown at the Green Chapel, to face what we expect to be disaster. But like Gawain, if we are truly heroic, we look the part, we manifest the myths in our very bearing. George Baumford (plate 1), in Joseph Campbell's words, is clearly following his bliss. Perhaps it's an act; perhaps it's a mask. But these are the masks of who we are. Too often we think negatively of putting on our masks, as if they conceal some greater truth beneath them. Our masks are our archetypes, the forms of our culture and civilization; they are the true selves we become. Existentialism, the journey of the hero, and all quests are no more than the discovery of our own mask, that act of self-definition which then goes on to shape and define everything else that we do or do not do. The metaphors of psychology are useful, if they are seen as the stripping away of the *destructive* personae we sometimes assume, but to deny the value of all masks is to deny the meaning of myth. And though I argued that the daguerreotypes lied — and literally they did lie — finally they told a greater truth, which is what the truth of art always is. They revealed the mask, the self-image, that is within an individual's potential. The mythology was manifest on their very faces, and that mythology shaped their destinies.

Though I have written of Walt Whitman in connection with the daguerreotype before, it is necessary once more to return to him for he is our Homer, the collector of our myths, the one who gave them voice, the most vivid dreamer of our dream. Whitman's work is the American *Odyssey*, and he turns into poetry the voices of Alfred Doten, Luzena Wilson, George Dornin, and countless other

Americans on other journeys. In "Starting from Paumanok" Whitman wrote that starting from where he was born "Solitary, singing in the West, I strike up for a New World." And he continued:

With firm and regular step they wend, they never stop,
Successions of men, Americanos, a hundred millions,
One generation playing its part and passing on
Americanos! conquerors! marches humanitarian!
I will make a song for these States
And I will report all heroism from an American point of view
The greatness of Love and Democracy
And I will show that whatever happens to anybody it may be turn'd to
 beautiful results, . . .
. . . . the future of the States I harbinge glad and sublime,
And for the past I pronounce what the air holds of the red aborigines
Leaving natural breaths, sounds of rain and winds, calls as of birds and
 animals in the woods, syllabled to us for names,
Okonee, Koosa, Ottawa, Monongahela, Sauk, Natchez, Chattahoochee,
 Kaqueta, Oronoco,
Wabash, Miami, Saginaw, Chippewa, Oshkosh, Walla-Walla,
Leaving such to the States they melt, they depart, charging the water and
 the land with names.

And then Whitman asks us to see in his poems the actual myth of America: "immigrants continually coming and landing, . . . the backwoods village (plates 13 – 14). . . pastures and forests . . . cities, solid, vast, (plate 15). . . ploughmen ploughing . . . miners digging mines (plate 16)[29]. . . mechanics busy at their benches with tools — 800 from among them superior judges, philosophs, Presidents, emerge, drest in working dresses."[30] Here is our belief that out of the common man, even from the backwoods village, greatness can emerge, that out of such men can come the judges, the philosophers, and the leaders of a nation, all common men dressed in common clothes.

But when we look into their uncommon faces (plates 17 – 18), they speak to us as forcefully and as poignantly as anonymous Romans and Renaissance courtiers and eighteenth-century ladies speaking from their portrait busts, paintings, and drawings. The daguerreotype is no mute chronicle, and these long-dead men and women speak with the voice of history, a voice we still honor and incline our ears toward, even when we pay it no heed or conflate it with popular legend. And they speak with the voice of myth, that greater truth we often mistakenly take for literal reality. Within these contexts, I would argue, they speak in terms of two large Whitman-like categories with seemingly contradictory aspects: Transcendence and Immanence; Illusion and Fact. Whitman was more than just the poet of America's potential, of America's "open road," as he put it, a road which un-

fortunately led to dumps, used car lots, urban sprawl, and ugliness. But the fact that he may not have been a prophet does not deny that he was a visionary. And it is that visionary, that spiritual, side of Whitman that finally is the most informative about what we see in the daguerreotypes because here Whitman is not our Homer giving voice to the myth of who we thought we were; he is our Pythia, the oracle voice, addressing the mystery of what we are — and addressing it in as ordinary, natural, and American a voice as Whitman could write.

In his great poem *Song of Myself* (part 20) he said:

> I know I am deathless,
> I know this orbit of mine cannot be swept by a carpenter's compass, . . .
> My foothold is tenon'd and mortis'd in granite,
> I laugh at what you call dissolution,
> And I know the amplitude of time.

Certain daguerreotypes also seem to know the amplitude of time and are deathless — not merely because they are beautiful but because they possess a kind of power that pulls us back to them again and again. They have no subject but themselves. They are universal and self-contained. Even when they might be of a famous individual, they are finally not about the man, the particular person, or his time in our history. When we come to these daguerreotypes and stare into them, it is not the individual we see, but something universal, time-spanning, and transcendent. When we look into George Baumford's face, we know we are looking into the very eyes of confidence, strength, and certainty. We do not have to know anything about him to know that his portrait is a universal portrayal of a man assured of his destiny. We immediately understand such portraits because they contain the transcendent material of archetypes, and it is their transcendence that draws us back to them again and again.

This is not only the case with portraiture. Some landscapes (plate 19) also go beyond mere geography, beyond their place and the confines of a thin strip of time in the middle of the nineteenth century. They rise before our memories as places we have known, though we have never been there; they seem familiar but are foreign and probably so changed that were we to find them, we would not even know them. Once real, they are now only the landscape of the imagination.

"All truth waits in all things. / They neither hasten their delivery nor resist it, . . . / The insignificant is as big to me as any" (*Song of Myself*, part 30). The sages of India have told us that there is no difference in Brahman, the transcendent, and Atman, the immanent, that they are two aspects of the One. They tell us that we could see this were it not for the curtain of ego and illusion called *maya* that hangs before our eyes. And we are urged to see with deeper vision, to penetrate the illusion, to find the spiritual resonant in the temporal, the sublime in the mundane, to so penetrate our egos that when we look into others we rec-

ognize that we are looking into ourselves. Some photographs, images as seemingly mundane as a miner with his friends reading a letter from home (plate 7) evoke a feeling of such intimacy, of such connectedness spanning the years, that we do see through the blur of illusions and differences, and in them see ourselves.

And speaking of what things are and what we see, Whitman wrote that "the unseen is proved by the seen, / Till that becomes unseen and receives proof in its turn" (*Song of Myself*, part 3). These images are all illusions. Some of them are about illusion, the vaqueros who in reality are probably Texas Rangers in disguise (plate 12), for example. They are tricks of the camera's eye. Some are illusions by virtue of being purely photographic. The elegant image of *Four Miners* (plate 5) is not a portrait of men working. It is an illusion, a purely photographic composition — beautiful but not really about work or the life of the miner. If it is about anything, it is about photographic composition. Occasionally what seems an illusion isn't because we cannot understand the message or can only guess at it. The recipients of the image surely understood, but with the passing of a century and a half the message has turned illusory.

And other images at first seem pure fact, like well-armed, well-protected William McKnight, who died at thirty-five, or confidant George Baumford, who certainly knew where he was going, but in 1853 out on his ranch in Walla Walla would have never believed it was going to be Florence, Italy. These are created fictions, incomplete narratives; they are not those people at all but merely the illusions those long-gone individuals wanted to present. These are the most mysterious of images. They are pure *maya*, the strongest presentations of the ego, and finally the most impenetrable portraits of them all.

In the *Song of Myself* (part 31) Whitman also wrote, "I believe a leaf of grass is no less than the journey-work of the stars." What often seems only factual can rise to the level of symbol because documentation alone can possess the power of revelation. Too often what is called documentation is thought of as being nothing but the bland record of some *thing*, but documentation by virtue of its being *pure presentation* is also an attempt to get at the thing-in-itself, the noumenal which we can never know through the senses, that *thing* philosophers seek and which artists, even documentary ones, occasionally find and find sensory ways of expressing. It goes without saying that appearances are all we finally know, that we never really get to that *thing-in-itself* which Kant and the Transcendentalists pondered, but art in its complete reliance on the sensory and its submission to it seems at times to translate the physical into the mystical, phenomenon into noumenon. The noumenal may finally always lie hidden because we can never completely express what it is we experience in those greatest works of art or fully explain why they so affect us, even though we can see before us the objects out of which they are made and can fully explicate their craft. But art does allow us an approach, and even the most factual, the most documentary, of works often

surprisingly approaches the most transcendent of revelations, as in *The View of San Francisco* (plate 20). It is literally a cityscape of San Francisco, but it is also the traveler at the end of the open road.

The meaning of these California images finally, then, is the thing we see, the thing manifest in the physical presence of the sitters, in their immanence and factuality, which, of course, is true, but also a kind of a lie whose message of illusion and transcendence contains a truth beyond any fact, a truth that is the stuff of masks, myth, and the destiny of the individual.

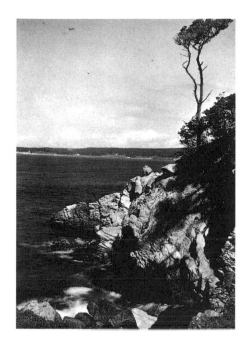

The American Autochrome

I n *The Art of the Autochrome* I argued that contrary to the accepted view we find in the standard histories of photography, the best autochromists were not those individuals we usually recognize as the best photographers of the first two decades of the twentieth century.[1] No one could doubt the craftsmanship, the artistry, and the brilliance of individuals like Alfred Stieglitz, Edward Steichen, A. L. Coburn, or Clarence White. Their paper prints are among the finest ever made, but that fact alone was not enough to assure that their autochromes would be equally crafted, artful, and brilliant. Steichen's usually were because he labored enough at the process actually to master it. But none of the other American photographers associated with the Photo-Secession labored with equal diligence. White's and Haviland's autochromes, for example, were never more than beginners' experiments, and after intense initial excitement but limited experimentation Coburn simply abandoned the process when he found he could not make it do certain things he wanted. The fabulous claims he and Stieglitz made in print about their own work and that of their friends and the repetition of those claims in subsequent photo-history books down through the years have distorted our understanding of the real history of the autochrome.

There were many great autochromists, especially Americans, but their names, unfortunately, have slipped from the history books. They were well known and highly recognized a mere seventy-five years ago, but try to find the names of Fred Payne Clatworthy, Helen Murdoch, Charles Martin, Franklin Price Knott, Clarissa Hovey, or Edwin Wisherd in books on the history of photography. Or even try to find more than a passing reference to the autochrome, the most luminous and beautiful of all color processes.

It is important to look at these autochromes again and reassess the work of

their makers not merely to correct the slights of photographic history but to better see *our* actual history. The autochrome gives us the first photographs of ourselves in color. When we look into an autochrome, we are not just looking into the past as we do when we look into any other old photograph; we are looking into a past as vibrantly as it can be recalled by the still camera. The autochrome catches the actual colors of the first decades of this century and gives us back our grandparents and our great-grandparents as clearly as the snapshots that we take of our children. Looking at American autochromes is like looking through an American family album. Though we recognize it is all past and the people are all gone, the colors seem to insist the present upon us, to insist an immediacy that makes the past seem not really so long ago, not so distant, not so different.

Shortly after the Lumière brothers' public announcement and presentation of the autochrome process in Paris, Stieglitz, who was America's premier photographer, wrote, "Soon the world will be color-mad, and Lumière will be responsible. . . . The Lumières . . . have given the world a process which in history will rank with the startling and wonderful inventions of those two other Frenchmen, Daguerre and Nièpce."[2]

Coburn wrote Stieglitz to exclaim, "I [too] have the color fever badly and have a number of things that I am simply in raptures over."[3] A few weeks later he gave an interview in which he stated, "It's just the greatest thing that's ever happened to photography."[4] And Steichen, who with Stieglitz was probably the most-respected American artistic photographer of the time, declared, "I have no medium that can give me colour of such wonderful luminosity as the Autochrome plate. One must go to stained glass for such colour resonance, as the palette and canvas are a dull and lifeless medium in comparison."[5]

During the first year and a half of the autochrome's existence on the market, there were some two hundred articles published on it in photographic journals alone; that's an average of nearly three articles per week for seventy-five weeks! All this excitement resulted from the fact that on June 10, 1907, Auguste and Louis Lumière had demonstrated their autochrome color process at the Photo-Club de Paris. They not only had developed a way of making color photographs but had gone into commercial production of the plates and were able to make them available to photographers, who now had what they had dreamed of for generations, true color photography. One contemporary report declared, "It is the greatest discovery in photography since Daguerre made his first daguerreotype. It is to photography what the discovery of perpetual motion would be to mechanics."[6]

The Lumières' technique was based on the fundamentals of color theory. All colors are modifications of the colors of the spectrum. There are three primary colors — blue, yellow, and red — which in mixtures will produce all the other colors. Each color has as its opposite a corresponding complement, which when placed beside it makes it more brilliant. The complement of blue, for example, is

orange; the complement of yellow is violet; and the complement of red is green. A given color will absorb the rays of its complement, but the rays of other colors will pass through it. Understanding these fundamentals, the Lumières pulverized transparent potato starch, passed it through a sieve to isolate grains between ten and fifteen thousandths of a millimeter in diameter, and then dyed these microscopic grains red-orange, green, and violet, the complements of the primaries. They were mixed and evenly spread over a glass plate coated with a sticky varnish. An extremely fine powder of charcoal dust was next spread over the plate to fill in any gaps in the color grains. This coating was then carefully flattened under a high pressure rolling process, thereby producing a tricolored mosaic screen. On every square inch of that screen were about four million individual microscopic screens of red-orange, green, and violet. The plate was then varnished and covered with a panchromatic silver bromide emulsion. The plate was reversed in the camera so that the rays from the lens would strike the colored grains before striking the film. The starch grains acted as tiny filters, absorbing their complements and letting the other colors pass through. The developed autochrome plate then would be a negative of the complementary colors. The image would be reversed and a second development would then turn the negative to a positive.

Photographers found the process, as complicated as it might sound, extraordinarily simple to handle. The plate was put into an ordinary camera, exposed twenty times longer than usual, and developed in a way any photographer could learn in a few minutes. The procedure produced a single glass print, a kind of photographic monotype. There was no traditional negative and so additional prints could not be made. This black glass print was also impossible to see without being held to the light, projected, or placed in a special viewer called a diascope that allowed light to strike the plate and cast an image onto a mirror. But what one saw when light did strike! There is such a luminosity and lushness of color that one thinks of Seurat or the Impressionists, who had realized that the eye mixes color better than the hand.

Mixing any two of the three primary colors will produce the complementary; however, those primaries need not be mixed, merely juxtaposed, as the Impressionists had realized, to produce the complement, and this juxtaposition, interestingly enough, is more luminous, more intense than had the two colors been mixed. Though a five- by seven-inch autochrome plate was made up of 140 million colored points, those individual grains, obviously, unlike the dots of a pointillist painting, could not be seen. However, an even distribution of the dyed grains was not possible, and there was always a one in three chance that grains of the same color would be adjacent. In a square inch, therefore, there is a probability that there would be thirty-three dots of twelve or more grains, and these dots *were* visible to the naked eye! They produced by accident that very effect the Impressionists sought to achieve, a shimmering world of suggestions, of haze and

nuance, a world of juxtaposed colors blended and mixed by the eye itself. And it is for this reason that the autochrome has continued to interest and fascinate viewers generations after its demise. Its colors are unlike the colors one sees in any other kind of photograph, and so it has a strange charm. It is like some lovely hybrid thing — part photograph and part painting.

Dixon Scott was one of the first critics to write about the autochrome. In an interview with Coburn he wrote, "These little transparencies . . . were indeed more beautiful than many famous pictures; and as I looked at them I thought rather sadly of certain earnest friends of mine toiling in dull studios . . . , studying perspective in chilly schools, going out . . . with unresponsive pigments and stubborn, primitive tools, gallantly, unsuccessfully striving to make their stiff hands transcribe the lush splendors their eyes so longingly discerned."[7]

Scott was not alone in such conclusions. Franklin Price Knott, one of the finest of American autochromists, wrote, "For years I was a painter of miniatures. Faces, beautiful and dull, ugly and interesting, passed before my brush. Then came the magic of autochromes. . . . I laid down my brushes and took up the color plates."[8] Coburn's "color fever" was certainly in the air. For some it burned longer and brighter than others. Many of those photographers, like Coburn, who first took up the process with such enthusiasm abandoned it after a year or less. Autochromes, though beautiful, were cumbersome, fragile, hard to see, difficult to display, and finally were more difficult to control than initial experiments had led many photographers to believe. The literature of the time certainly bears witness to this fact. Photographers are constantly complaining about colors not coming out right, clouding, frilling, and so forth. As in any other art, one had first to *master* the craft. Finally the best autochromists, naturally, were those who worked the longest and hardest at making autochromes. Their labor produced the needed expertise. To become truly a great autochromist, one had to devote one's self to the technique to the near exclusion of photography's other processes. Those photographers who did that or at least who worked at it with some diligence for more than a few years all produced impressive bodies of work; however, even those who worked with less enthusiasm produced some exceptionally beautiful plates because the autochrome process itself was, like the daguerreotype process, in many ways aesthetically self-contained. A novice with a knowledge of the rudiments of the process would most likely produce beautiful work if he or she had an eye for composition and a sense of color. The process was not foolproof, but the odds were that better than one out of every two plates would be successful — and those were the odds one of the autochrome's most discerning and critical masters gave himself.[9] In reality, of course, the odds for producing an acceptable and even beautiful plate were considerably better.

One of the major problems with the study of the history of photography is that our aesthetic conclusions are often clouded by the categories we have placed certain photographers in. For example, in early twentieth-century photography

we all know that there are several "major artists" we take quite seriously, photographers such as Stieglitz, Steichen, Coburn, White, Seeley, and so forth. Then there are the "lesser artists" we recognize as having been quite good but whose vision or craft was simply not the equal of the major figures, fine photographers like Paul Anderson and Laura Gilpin. There are also "professional photographers," like Arnold Genthe and Clara Sipprell, whose work was sometimes purely artistic but which always exhibited, even when made merely for money, artistry and superb craftsmanship; excellent "amateur photographers," such as Charles Zoller or B. J. Whitcomb; and finally there are the "commercial photographers," men and women like Fred Payne Clatworthy, Helen Murdoch, Franklin Price Knott, or Charles Martin who went out and took pictures for a living. A work by a "major artist" by definition, then, should be superior to a similar work by a "lesser artist." And words like "professional" or "commercial," which immediately signal a concern not with the muses but with money, warn us to expect little in the way of art. These snobbish distinctions, problematical under even the best of circumstances, break down completely with the autochrome because they are not verified by the eye. In order to *see* the history of the autochrome, we have to forget the way we have been taught to think. Clarence White was a great photographer, but most of his autochromes are bad because he did not work at the process enough to master it, whereas Arnold Genthe — brilliant, yet by no means a Clarence White — produced countless masterpieces in autochrome, beautiful things that are clearly the finest color work in American Pictorialism. His advantage over White was simply that he had made probably at least a thousand autochromes, if not more, as opposed to the fewer than twenty that White appears to have made. When we deal with the autochrome, our hierarchies of expected artfulness, excellence, and quality nearly always must be reversed.

The greatest masters of the American autochrome were those photographers, like Genthe, Clatworthy, Murdoch, Knott, Martin, Paul Guillumette, George Holt, Clifton Adams, Maynard Williams, and others who, with the exception of Genthe, are not remembered within the pages of books on the history of photography but within the pages of the *National Geographic*. The art historical hierarchies of masters, major artists, minor artists, and so forth, are often inappropriate to photohistorical studies because the history of photography is littered with more brilliant anonymity than any other field. There are many anonymous masterpieces,[10] and there are whole bodies of beautiful work by photographers who, for all we know of them, might as well have been anonymous — H. Bosse, whose dramatic cyanotype views along the Mississippi only came to light in 1990; E. J. Bellocq, whose now famous photographs of the prostitutes of New Orleans' Storyville were virtually unknown until the late 1960s, nearly sixty years after their making; Mike Disfarmer, a professional photographer of Heber Springs, Arkansas, who in the 1940s captured the world of Walker Evans with an eye as acute as

August Sander's; as well as whole bodies of work by once famous but now forgotten photographers, like Otto Scharf, Eduard Arning, Maurice Bucquet, or Edouard Hannon. Their work is as powerful as that of any of their contemporaries, but it is never written about today and, therefore, never comes up for auction and, therefore, lacking economic value, never gets taken seriously for its artistic value. Yet the work of such photographers can be seen in issue after issue of serious turn-of-the-century journals, such as *Kunst in der Photographie*, the *Photographische Rundschau*, and the *Revue de photographie*.

When preconceptions of who is major and who is minor are abandoned, new things can then be seen, books have to be rewritten, and we are "like some watcher of the skies / When a new planet swims into his ken"; we truly are left in dumbed silence looking "at each other with a wild surmise," as Keats put it. I know of no better way to describe the effect of seeing a group of Fred Payne Clatworthy's autochromes. There was no one else like him in the history of the American autochrome; he was our Jules Gervais-Courtellemont.[11] Clatworthy, like Gervais-Courtellemont, perfected his art with countless experimentation. He did not make a few autochromes, a few hundred, or even a few thousand, but more than ten thousand![12]

Clatworthy was born in 1875 and bought his first camera at the age of thirteen in 1888. He began making cyanotypes and was soon selling them. In 1898 with his camera and glass plates he headed West from Chicago. At the Grand Canyon he made photographs that he sold on the Sante Fe Limited. The advertising manager was taken with his work enough to encourage him to go to California to photograph and offered him a free trip. This was the beginning of Clatworthy's extensive work with railroads — the Santa Fe, the Burlington, Denver and Rio Grande, Northern Pacific, Southern Pacific, and Union Pacific. He continued his traveling and photographing but wrote that "it was not until the advent of the color plate in the early nineteen hundreds (the Lumière Autochrome imported from France) that the real traveling began." Clatworthy became devoted to the autochrome process. "For true rendition of color and pastel effects, it has never been excelled," he wrote in 1948 and lamented that "Shades of purple could be reproduced not possible in present day processes."

Clatworthy traveled around the world the equivalent of twenty-five times, "always in search of pictures." With the development of the autochrome he felt compelled to rephotograph all his work from the Southwest. "Everything in the Southwest, most colorful of all countries, had to be done over in color." He was also the first to make color pictures in Hawaii, New Zealand, and Mexico and the first to photograph many of the national parks in autochrome. Clatworthy produced so much work that he began making autochrome lecture tours all over the country and is responsible for truly introducing autochromes to the American people. Their early publication in *Camera Work* hardly counted. For years Clatworthy, whose work was known through the *National Geographic, Field and*

Stream, and his work for the railroads, was an immensely popular public speaker. He gave lectures in all the principal cities of the country to audiences that averaged over a thousand people and gave one lecture in 1922 to over three thousand. He projected his five- by seven-inch autochromes with a special magic lantern which he had constructed that weighed nearly a hundred pounds. He was invited to present his autochrome lectures at the National Geographic Society and the American Museum of Natural History in New York. He also sold black and white copies of his prints that he hand-colored after the autochromes. By this time Clatworthy had moved to Colorado, where he lived until his death in 1953.

Clatworthy's work was well known and highly respected during his lifetime, but it has slipped through the cracks of photohistorical studies because he was a commercial photographer and because he chose to work primarily in autochrome, an image that did not allow for easy exhibition. Van Deren Coke wrote of him and his friendship with painter R. H. Tallant, who used Clatworthy's autochromes "as sources for some of his Rocky Mountain views," but Coke constantly refers to him as "Fred Chatworthy."[13] Clatworthy had a long association with the National Geographic Society which began in 1916 with a letter from Gilbert Grosvenor purchasing seven of Clatworthy's photographs for a total of $16.75 and with the postscript: "Allow me to say that we will always be glad to consider any photographs you may care to submit." Before long Clatworthy was making $10.00 apiece on the autochromes the *National Geographic* used and as much as $250.00 for his Geographic Society lectures. His correspondence with the National Geographic Society reveals clearly how deeply he treasured his work; when he shipped his plates to Washington or when they were shipped back to him, he always insisted that each autochrome be insured for $50.00. Of course, part of his livelihood was based on his lectures for which he needed his plates, but his passion for color—"black and white is only half a picture," he said—and his love of the places he photographed are what most comes through in his words.

It is this same spirit that comes through in his work. There are certain characteristics one expects to find in the work of any experienced photographer—excellent composition, a skillful manipulation of light, and so forth. Then for the photographer who takes on the natural world as his or her subject—a Renger-Patzsch, an Ansel Adams, or an Eliot Porter, for example—one expects principally to see two things: beauty and drama. Clatworthy's work is marked by both, as well as by all else that would be expected in the work of any master photographer. But there is another thing present as well, a quality that is extremely rare in the work of most autochromists and quite uncommon until contemporary color photography—and that is a fully developed color aesthetic. In the work of many autochromists, including a number who were famous for their other work—Stieglitz, Coburn, Haviland, White, even Kühn occasionally—color is badly handled. They only took the image's general composition into considera-

tion when planning it — not the composition of the colors. It only makes sense that this would be the case. If after a lifetime of painting exclusively in black and white a painter decided to begin using the complete palette, one could hardly expect the same competence — at least not without practice. However, there is more here at work than practice. Charles Zoller made thousands of autochromes, some of which are lovely, but many of which are unsuccessful as photographs in color. A photographer who chooses to work in color must have as refined a sense of color — and what the colors will look like on paper reduced to two dimensions — as he or she would of composition, lighting, or any other of photography's most basic elements.

Fred Payne Clatworthy was a master of color and had an understanding of color composition that has still not been surpassed by any photographer who has come after him. Of the several hundred Clatworthys I have seen, there is not one that is not beautiful. But in art we are mistrustful of beauty for its own sake, especially if it is a beautiful image of something that is already beautiful, such as a picturesque landscape or a lovely face. In fact we usually avoid the word "beautiful" to describe such an image, but will defer to the word "pretty." However, curiously enough, this is not the case with a thing, an object. A beautifully made photograph of a beautiful object, such as an African mask by Charles Sheeler or an architectural detail by Durandelle or even a tool simply placed on a blanket by A. J. Russell, is not only called *beautiful* but also *work of art*. Though we might expect a work of art to be beautiful, we also expect the beauty to be in the service of a higher good, some sort of truth beneath the beauty. Or so we have been schooled to believe — especially since the Romantic Revolution. There is, however, great art of earlier periods with no substance but beauty alone. Are the paintings of Watteau and Fragonard, the music of Rameau, the poems of Herrick, or buildings like Burlington's Chiswick House about anything, any truth but the sheer joy and delight of beauty for its own sake? It is a clear sign that a culture has come to take itself too seriously, become self-important, and turned its back on the joie de vivre when it decides that beauty needs any justification but itself.

In our self-important time, however, work like Clatworthy's often gets dismissed without serious attention because it is beautiful and it is of beautiful places. A superficial glance at his work might suggest stock photographs, the kind one sees in advertisements, pretty pictures of pretty spots. But nothing could be more incorrect. Clatworthy had a powerful and profound artistic vision, a vision that we have difficulty perceiving today. The current omnipresence of photography has caused us to lose our aesthetic appreciation of beauty in service of the beautiful, at least in modern photography. The nineteenth century did not have this problem, nor do we, in viewing nineteenth-century photography. Only a madman would claim that Baron Gros's rapturous daguerreotypes of Greece or Muybridge's or Watkins's beautiful mammoth views of California scenes were not

beautiful or art, but let a contemporary photographer — other than Ansel Adams in the case of the California scenes — make a similar view, or, even worse, make it in color, and few will call it art. We have come to mistrust color today because too many photographers, instead of mastering the difficulties of the color aesthetic, have either avoided it or only played with it slightly; their avoidance and play have, of course, suggested disdain and that they did not quite feel a photograph in color was a work of art, at least not to the extent that the same photograph in black and white could be. It is a crippling and insidious notion, but it exists and it has affected taste. In order to appreciate Clatworthy's vision and his craft, one must view his work outside of any of these prejudices about natural beauty or color.

There are two fundamentals at the heart of Clatworthy's photographic aesthetic: the world is beautiful and it is in color. All of his work portrays this quite clearly; however, his dramatic sunrise studies (plates 21 and 22) made from the roof of his cabin in Palm Springs are classic examples of Clatworthy's art. Barbara Clatworthy Gish recalled that she could remember him "getting up at the crack of dawn and standing there" on top of the roof to get these and the other images in this series. There is nothing else in autochrome like this and little since the autochrome that can equal the drama.[14] They are both like scenes J. M. W. Turner might have painted. Equally dramatic is *The Wind River Trail* (plate 23) of 1920, which actually appears three-dimensional, and *Toward Fall River Road* (plate 24) of 1917, which suggests that same Symbolist solitary road imagery I discuss in "American Symbolism: Visions of Spirituality and Desire." Both of these images, which were made in Rocky Mountain National Park in Colorado, as well as the next two, appeared along with twelve others in a photo essay by Clatworthy entitled "Western Views in the Land of the Best" in the April 1923 issue of the *National Geographic. Harvest Time* (plate 25) was also taken in 1917. It is a quintessential American photograph; a more American image would be difficult to imagine. The little boy with his head sticking out of the pile of stalks is the photographer's son, Fred Clatworthy, Jr. *Bear Lake* (plate 26), also from Rocky Mountain National Park, is one of Clatworthy's earliest autochromes and dates from sometime between 1910 and 1915.

Though Clatworthy often did include people such as his son or his daughter (plate 27) in his autochromes, these portraits are usually more revealing of the place than the individual. They may be brilliantly beautiful, as in the case of his portraits from Hawaii and New Mexico (plates 28 and 29), but Clatworthy's eye for color and his compositional skill are what we primarily notice and admire. Clatworthy has created a composition that resembles a Japanese woodblock print. The dramatic use of the tree cutting the corner of the image is like nothing we are accustomed to seeing in photography; however, we have often seen it in Japanese art. It is an effect Hiroshige uses in work after work as if it is a near-signature mark. Clatworthy picks up the fluting effect of the bark in the edges of

the open umbrella, which along with the lady's face is balanced between the dramatic tree in the foreground and another in the background. The *Taos Pueblo* view is equally dramatic in its composition, but it best serves to demonstrate Clatworthy's actual color aesthetic.

In looking at a group of autochromes one tends to think there is a profusion of color because the color is so dazzling, but the art of the autochrome or of color photography in general is not about using a great many colors. Like all art, it is about understatement, about less being more. What one begins to appreciate in looking at Clatworthy's work is his restraint. He clearly limits his use of color to the most dramatic combinations. The blue of the dress is as intense and powerful as it is because there is nothing in the image of a similar intensity to distract the viewer's eye. The same is the case in his 1921 view *Mesa Verde* (plate 30), the Estes Park, Colorado, views taken near his home (plates 31 and 32), even the very dramatic and colorful, yet highly restrained, view along 17 Mile Drive near Carmel (plate 33). But probably no image better suggests Clatworthy's color aesthetic, the power of his eye, his compositional skills, or his ability to play with light and shadow than the one he called *Lemon and Nut* (plate 34). Its power is its beauty, and its beauty alone is its truth.

Though Clatworthy's work does exhibit a conscious color aesthetic, I do not think it or the work of any other American autochromist, for that matter, reveals any distinctly American aesthetic, except for those echoes of the Boston school in the portraits of B. J. Whitcomb.[15] On the other hand, in certain Europeans' work a clearly European aesthetic can be perceived. The work of Antonin Personnaz, one of France's masters of the autochrome, clearly reflects an anachronistic look back to the paintings of the previous generation, and his work apes that style and aesthetic. Heinrich Kühn, one of the great artists of the century and a photographer whose work derives from that same sacred spring out of which flowed the work of Klimt and the Viennese Secession, produced autochromes aesthetically consistent both in terms of form and of emotional content with the rest of his work. Wladimir Schohin, Finland's master autochromist, created a highly modernistic body of work in autochrome that reflects the spirit of Scandinavian Modernism. But the color work of these autochromists' American contemporaries — Stieglitz, Eugene, Seeley, White, and Coburn — bears little similarity to their black and white imagery.[16]

American autochromes seem less imbued with an aesthetic than with an attitude. Even George Seeley, America's arch Symbolist, produced autochromes that can best be described only as beautiful color pictures. A few of Stieglitz's autochromes truly look like Stieglitz photographs, but a number also look like anyone else's nice color pictures. What is present in the majority of American autochromes was, as Franklin Price Knott put it and as naive as it might sound, the desire "to portray dream places."[17]

It is that same voyaging spirit that defined much of the work of Carleton

Watkins, Eadweard Muybridge, and other American photographers of the nineteenth century. But just as it was in the nineteenth century, the voyages were technological as well as geographical. American daguerreian photography is marked not only by the physical expanse of the voyage – from New England to California – but by the technological expanse of the voyage – from the trachea of a silkworm to the craters of the moon. American photographers simply found ways of making pictures of things others had only dreamed of; through technology they found their way to the dream places. It all sounds quite heroic and positive, and it was, but we know what happened. When technology ceases to be the way or the map to the dream and becomes the dream itself, the dream places turn into nightmares, to Hiroshimas, Chernobyls, and Love Canals.

As the American daguerreotypists had done a few generations earlier and as Daguerre himself had done, the American autochromists bent technology to aesthetics and made it an aspect of their artistic craft. A perusal of the literature of the daguerreian period, particularly patents for improvements in the process, will suggest the importance of technology to art. And one can find a similar literature of the American autochrome.[10] A typical but striking example is an essay entitled "The First Autochromes from the Ocean Bottom" by the well-known autochromist Charles Martin and Dr. W. H. Longly, a noted ichthyologist.[19] The resultant autochromes, and two in particular, one of a Hogfish and one of French grunts, are among the most beautiful autochromes published in the *National Geographic*. The fish look like Symbolist jewels, clasps from the veils of Salome, swimming in the musical *Aquarium* of Saint-Saëns.

Steichen may have sought a Symbolist beauty and charm in his autochromes, but in Longly's and Martin's case that charm is both an accident and outgrowth of technology. An autochrome plate could not register fish moving in water; therefore, they had to hypersensitize the plates so that exposures could be reduced to a twentieth of a second. The sensitizing had to be done at five o'clock each morning, the coolest time of the day in the Florida Keys, to prevent the emulsion on the plates from melting. But below fifteen feet the reduced sunlight spoiled the images, so Martin invented a flash-light-powder mechanism that could be discharged by the underwater photographer when the fish swam into view. The discharge had to be synchronized with the shutter so that it would be wide open when the flash reached the peak of illumination. This required a pound of magnesium powder. Longly was seriously burned and nearly killed by a premature explosion of the powder. It took months of experimentation to produce the final autochromes, and the thought of art probably entered no one's head, even though more artistic autochromes would be difficult to find. The dream places and the technology to get to them were what was uppermost in Martin's and Longly's minds and in the minds of Fred Payne Clatworthy, Franklin Price Knott, and their fellow *Geographic* autochromists. That attitude defined the American autochrome and shaped its artistry.

The Art of the Cyanotype and the Vandalous Dreams of John Metoyer

a blue, true dream of sky,
of everything which is yes
— e. e. cummings

I think it is appropriate, even though it might be a bit curious, to begin a discussion of the art of the cyanotype with a quotation from the great American poet of celebration and joy e. e. cummings, for certainly no other photographic process seems a more apt vehicle for carrying the same celebratory, affirmative message that runs through so much of his work than the strange, absurd, beguiling cyanotype. Apart from the bizarre and often oddly attractive imagery of certain late pictoralists such as Mortensen and Thorek or Witkin and Faucon, there is nothing within the photographic arts any stranger or more absurd than the cyanotype process, the result of which is a kind of deranged metamorphosis of all the colors of the world into shades of blue. And the strangeness is inherent in the process itself regardless of the imagery, just as the cyanotype's charm is also inherent in the process and does not depend upon the imagery.

The cyanotype was invented by Sir John Herschel and first described in his 1842 paper "On the action of the rays of the solar spectrum on vegetable colours, and on some new photographic processes."[1] The blue color is the result of iron rather than silver salts in conjunction with cyanogen. The process owes much of its beauty not only to its visual minimalism but its technical minimalism as well. "It is," as Larry Schaaf points out, "an exceedingly simple and elegant process, involving only two chemical compounds: ferric ammonium citrate and potassium ferricyanide. These can be applied to ordinary writing paper with a brush or sponge. The paper is dried in the dark and is then ready to be placed under a negative (to make a print) or a flat object (to make a photogram) and exposed to the rays of the sun. The only other chemical compound involved is one that is

often taken for granted: water. Simply washing the exposed cyanotype brings out its rich blue color and makes the print permanent."[2]

Henri Le Secq, Carleton Watkins, and other master photographers of the nineteenth century made cyanotypes, as well as a number of the pictorialist photographers of the early twentieth century such as Holland Day, A. L. Coburn, Gertrude Käsebier, Paul Haviland, and Joseph Keiley. Edward Curtis and Charles Lummis both used the process as well, and some of their most affecting Indian portraits are in cyanotype. Contemporary photographers such as Bobbi Carrey, Darryl Curran, John Dugdale, Robert Fichter, Betty Hahn, Catherine Jansen, David McDermott and Peter McGough, and John Metoyer have also found the strange blue process a powerful medium for artistic expression.

However, Peter Henry Emerson, one of the first theorists of artistic photography and one of the nineteenth century's photographic masters, took a different view of the cyanotype. In his *Naturalistic Photography* he complained, "No one but a vandal would print a landscape . . . in cyanotype."[3] John Metoyer frequently does, and though works such as his *Illuminated Path* (plate 35) might have shaken Emerson's fine but authoritarian eye with the absolute depravity to which vision could fall, to my eye it is one of the most beautiful studies of trees and of light that I have seen. In fact, little about the cyanotype seems particularly vandalous to our modern eyes — or did to many nineteenth-century eyes either, especially those of the amateur photographers. It was surely the oddness of the image that provoked Emerson's outrage because cyanotypes are provoking images; however, most people are aroused to delight instead of anger.

Henry Snelling's popular 1854 *Dictionary of the Photographic Art* came closer to describing the general attitude toward the process than Emerson did and also probably accounted for much of its popularity with the amateur photographers. In a discussion not quite three pages long the following expressions are used: "very beautiful negative," "pictures of great depth and sharpness," "very beautiful," "preeminent beauty," "a high degree of sharpness and singular beauty," and "pictures of great beauty and richness."[4] Of course, there is something haunting and surprising about all cyanotypes regardless of the artist's imagery. They possess a peculiar magic derived from the peculiarity of their craft; they simply look less like what we have come to expect photographs to resemble than any other kind of photographic image, even the daguerreotype. The effects of the iron salts are so unusual in photographs that the resultant images woo our eyes with the eccentricity of their beauty.

It is immediately obvious that the cyanotype produces a very strange rendering of reality — a blue dream, if you will — but that is also the case with every photographic process because every photograph, like every painting, is a distortion of reality — or at least reality as it is perceived by our fellow human beings. We do not look so closely or so long at anything. Photographs are fragments of stopped

worlds and do not record the things we see as we actually see them. Even though photography often claims to be the most realistic and truthful of the arts, it rejects reality on another level as well. When the photographer sets out to be deliberately *realistic*, the results are not true realism but usually some kind of bizarre hyperrealism equally foreign to what we actually see. Those stark close-ups of pores and stubble are finally not realistic at all simply because the eye itself does not see faces with such clarity, probing, and acuity; only the camera has so fine an eye. What we consider realism in photography is probably even less realistic than the misty, rainy soft-focus of the Pictorialists. Our pleasure in photography is much the same as our pleasure in the other arts, especially painting — a pleasure in the slight distortions of reality because those distortions often reveal, or so our psychology suggests to us, deeper realities. All those unrealistic, unflattering, but brilliant close-up portraits of Helmar Lerski or Richard Avedon are often deeply moving because they seem to offer a deeper, more realistic vision of their sitters. And they probably do offer greater depth, just as the soft, shimmering images of George Seeley seem to hint at deeper symbolic truths than they, on the surface, reveal.

But is there any truth beneath the cyanotype's eccentric blue charm? Is the blue dream of cummings "true" in any way with regard to the cyanotype? I think the answer is yes, that its truth resides in the blues themselves, in the psychology of the blues. In the same way that detailed close-ups of faces or shimmering landscapes can seem to suggest certain truths below the surface of their imagery, color too can possess an emotional vocabulary. Adepts and sensitives — from religious mystics who claim to be able to see an individual's aura to poets, musicians, and painters such as Rimbaud, Scriabin, and Rothko — have all acknowledged this. I argued in *The Art of the Autochrome* that the primary reason people are so drawn to the autochrome's color is its "idyllic light, a lying light [which] gives the world a softness, a near shimmering, it has never known," and that we respond to autochromes because they "are the color of dreams, . . . [and are unlike] the real world [which] was always harsher than they would suggest it was."[5] In other words, sometimes we seem to do more than merely view a color; we experience it as a psychological effect. There does seem to be something positive about blue and our associations with it. It is celebratory and joyous; it is even the color of our favorite clichés: of sky and birds' eggs and babies' rooms. Too often, in fact, its joyousness seems to verge on the cloying, but still the color blue *is* positive, rich, and happy. A blue photograph, then, might have a built-in psychological advantage if the photographer is trying to suggest the joyous.

Some of what we now see as the earliest artistic work in the cyanotype process was created by Anna Atkins, whose interest in botany led her to print and publish the first photographically illustrated book, *British Algae: Cyanotype Impressions*, the first volume of which appeared in October 1843 and thereby even predated William Henry Fox Talbot's *Pencil of Nature*. Atkins commented in her

introduction to the book that she had been "induced . . . to avail [herself] of Sir John Herschel's beautiful process of Cyanotype" because of "the difficulty of making accurate drawings of objects as minute as many of the Algae."[6] The resultant images, though utilitarian in their intention, were exceedingly beautiful and to our modern eyes are clearly works of art, as are her leaf and feather studies, the latter of which are certainly among some of the most exquisite of nineteenth-century photographs on paper.[7] The art of the past is a function of the eye of the present, an eye dependent upon the caprices of time. What was often merely utilitarian — Shaker furniture, for example — another time sees as art. And this is certainly the case with Atkins' cyanotypes.

Henri Le Secq's work is a different matter, however. Le Secq was a painter, a student of Paul Delaroche, like fellow photographer and painter Charles Nègre, and an enthusiastic preservationist, something of a Eugène Atget before Atget, who wanted to record the Paris he loved before it was all razed. Eventually he came to be considered one of France's finest architectural photographers. But Le Secq's genius was more than as photographer of buildings and architectural details. His views of ships at Dieppe are among the most striking of French maritime and nautical views.[8] His still lifes, often in cyanotype, are among the most poetic of that genre in photography. And Eugenia Parry Janis's poetic yet precise picture of them is one of the finest descriptive passages in the literature of photography. "Winter apples on a table dissolve into shadows, their withered skins seeming a thousand years old. The leaves of an artichoke in another arrangement, having shrunk slightly during the long exposure time, leave pentimentos of their former contours in the image. Smoked herring suspended against a wall have iridescent scales that seem hammered out by a master in precious metals. . . . Unique in nineteenth-century photography, these still lifes show objects of daily existence suspended in a dream of time's slow passage."[9] And finally his landscape and scenic views, such as this *Rustic Scene* (plate 36), are masterpieces of photographic seeing. This particular image, a cave with a farmhouse built partially into it,[10] creates a dramatic interplay of light and dark that seems quite modern. Less than half of the image is anything the viewer can see, and we study it as if we expect something to materialize from the darkness.

Carleton Watkins, Edward Curtis, and to some lesser extent Charles Lummis are among the best known of photographers of the American West. Watkins' mammoth landscape views of Yosemite Valley and Mariposa Grove are some of the greatest of all photographic landscapes, and Curtis's vast artistic documentation of the North American Indian is another of the great monuments of photography. Lummis also left a fine documentation of Indian life including many lean, severe still lifes of Indian pottery that are as powerful and minimal as the objects themselves. And all three, particularly Lummis, worked in the cyanotype process. Watkins's cyanotypes are rarely seen and none have previously been published. His strange and atypical *Yolo Buggy* (plate 37) is from an 1880 topo-

graphical survey of the Yolo County California Base Line. The strange, towerlike structure is the Yolo Buggy, a moving platform used in making the measurements. Curtis's cyanotypes are also quite rare and extremely powerful and disturbing when used to record the more bizarre or haunting images, such as the well-known *Waiting in the Forest—Cheyenne*[11] or the *Kominaka Dancer, Kwakiutl* (plate 38), on the reverse of which Curtis wrote, "After the taming by fire the dancer performs in this costume." The touching portrait of Lummis and his son (plate 39), somewhat reminiscent of Heinrich Kühn's studies of his children, is radically unlike most of his other work and seems informed more by the Pictoralist aesthetic than the documentary one that is usually seen.

Frances Benjamin Johnston was one of the most well-known of late nineteenth- and early twentieth-century photographers. She received great recognition in her lifetime, including a gold medal at the Paris Exposition of 1900, the Grand Prix at the Third International Photographic Congress, and over $26,000 in grants from the Carnegie Corporation between 1933 and 1936. She was also the unofficial White House photographer for Cleveland, Benjamin Harrison, McKinley, Theodore Roosevelt, and Taft and was known as the first woman press photographer. Her work ranged from the journalistic and documentary, for which she received many commissions, to the more pictorial and artistic. Her artistic work impressed George Davison enough to include it in the 1897 London Eastman Photographic Exhibition and even publish an example along with only seven other photographers in a small deluxe volume of gravures made by J. Craig Annan of images from the exhibition.[12] The following year Stieglitz included her work in *Camera Notes*, and though he never published her in *Camera Work*, he did admit her into the Photo-Secession.

Eugenia Parry Janis, writing of Johnston's well-known Hampton Institute series of young black men and women, noted that "she turned the view camera's potential for expressive alignment to a moral purpose. She had her sitters, exemplars of 'the right path' prescribed for black America, adjust their bodies to repeat invisible parallel lines receding from the ground-glass back of the camera. How strangely self-conscious, and yet how eloquent, are these idealistic tableaux. . . . What a peculiar rhetoric of betterment Miss Johnston's aligning art stands for here. In her maneuvered theater of self-improvement, she is content to dwell upon externals."[13]

All the same things could be said of *Measuring* (plate 40), a rich and detailed cyanotype of schoolchildren learning about measurement. We look at this and immediately know that such diligent little measurers will grow up to be serious adults, adults who know exactly how many bricks it will take to build a building and how much each brick will cost. But what a beautiful picture it is! In reality the children are probably thinking of popguns or dolls, and the teacher there in the center of the composition probably wishes Miss Johnston would finish the picture so she can get back to her classroom, but Johnston's "maneuvered the-

ater of self-improvement" is finally so convincing that even we, knowing better, believe the camera's lying eye, believe we are looking at future engineers and architects, future adults for whom measurement alone will be truth.

Until very recently Bertha Evelyn Jaques's work (plate 41) was completely unknown. Again and again great photographers, individuals with remarkable vision and often dazzling craft, men and women who deserve a place in the history of nineteenth- or twentieth-century art, have been forgotten or lost because photography has not, in the popular mind, had the status of art. If photographs looked more like paintings or stock certificates, we'd know a great deal more about the history of photography today than we do. Bertha Jaques, who was born in 1863 and died in 1941, studied at the Art Institute of Chicago and was primarily known as an etcher. She organized the Chicago Society of Etchers and exhibited there, as well as the Paris Salon, the 1915 Panama-Pacific International Exhibition, where she took a bronze medal, and elsewhere.

As a photographer Jaques, a dedicated member of the Wildflower Preservation Society, was something of a cross between Anna Atkins and Henri Le Secq. Because of her interest both in botany and preservation — of endangered species of plants as opposed to old Paris — she made over a thousand cyanotypes of plants between 1906 and 1908. These are works of great beauty and importance not merely to the history of the cyanotype but to the history of photography in general. Keith Davis's insightful comments about Edwin Hale Lincoln's series of New England wildflowers could equally apply to Berthe Jaques: "These flawless images, which combine a botanist's descriptive precision with an artist's feeling for composition, suggest an aesthetic midway between the Victorian naturalism of John Ruskin and the modernist purism of Edward Weston." [14]

As I said earlier, several of the Pictorialist photographers also used the cyanotype; however, this work is quite rare, seldom seen, and rarely published. Five of Holland Day's appear in James Crump's lavish and brilliant study of Day's work, *F. Holland Day: Suffering the Ideal*,[15] and four of Paul Haviland's are included in the Musée Rodin's exhibition catalogue *Le Salon de Photographie*,[16] but apart from these, the cyanotypes of the turn-of-the-century art photographers are unpublished. Haviland was an associate editor of *Camera Work* and one of Alfred Stieglitz's closest associates. He exhibited in the important International Exhibition of Pictorial Photography at the Albright Art Gallery in Buffalo in 1910. Though Haviland was relatively new to photography and this was his first major exhibition, Joseph Keiley described his work as having "the simple bigness of the Dutch school" and called one print "one of the finest things" in its section. Coburn also reviewed the show and wrote that he was "particularly impressed with the prints of Paul Haviland." [17] *Blue Girl* (plate 42), like all of Haviland's cyanotypes, was made between 1910 and 1915, and is not only a fine cyanotype but an excellent example of Haviland's own art and particular vision.

Ema Spencer, another member of the Photo-Secession, was also included in

the Albright Gallery exhibition, won awards for her photographs at exhibitions in Italy in 1902 and in Germany in 1903 and 1922, and had one of her photographs appear in *Camera Work*. Her work was influenced by Clarence White, about whom she even wrote a highly laudatory essay for *Camera Craft* in 1901.[18] *On the Longed-for Hobby Horse* (plate 43) is a charming and sensitive photograph that obviously suggests White's compelling pictures of his children.

Though many famous photographers have worked in the cyanotype process, much of the most exciting surviving work is anonymous or might as well be so since we know nothing about the photographer. *Butcher* (plate 44) is a good example. It is a great photograph and would be a great photograph regardless of the process. But who was W. V. Walter of Bath, Pennsylvania? His stamp on the back of the image identifies him as "Artist," gives his address, and states that he made "Architectural Views. Landscapes Groups & Portraits." But at present he is lost to the history of photography, and what a tragedy because any photographer accomplished enough to make so dramatic a picture must surely have made other photographs equally as good. There is a grisly nonchalance about it, something akin to Andres Serano's well-known *Cabeza de Vaca*, an elegant portrait of a slaughtered cow's head atop a pedestal, its eye cast in what appears to be a reflective gaze, and all as classical looking as the great horse's head from the east pediment of the Parthenon. But Walter's picture is not elegant, and it is not about the surface elegance of artifice. The nonchalance here is no affected nonchalance, no aspect of artifice, and no comment on how the truly beautiful can be truly ugly and vice versa. Walter's picture is about something else.

What is the other man doing in the picture, the onlooker? He obviously completes the composition, fills the necessary space, and adds an element of mystery, but as is always the case in representational art, we expect to be able to understand the imagery. We want to know what his function was, why he is in the picture, and why he is holding a rope. He is not dressed like the butcher, and so we would assume that he is not the butcher's assistant. Is it his beef that is being butchered? Is he someone who simply enjoys watching a good slaughter? Or is he merely part of the composition?

The image is fairly large, 8¼ by 6¼ inches, and the fact that Walter inscribed it "Butcher Dec. 14 1893" does not seem to suggest that it was destined for the sitter. But were this Walter's own personal print, one would not expect it to be so formally mounted, as if it were something he offered for sale. And was it actually offered for sale as an art print? Since the photographer did consider himself an "Artist," could he have known Rembrandt's *Slaughtered Ox*, and could this be something of an homage to that painting? These are some of the questions that so many early photographs often pose. And some of them are the same questions that a great many paintings also pose, works like Giorgione's *La Tempesta* with its nursing nude, soldier, and lightning bolt. In paintings, however, we know we are often dealing with an allegory that we simply cannot read, but we do not ex-

pect photographs, apart from some Pictorialist work and the work of a few contemporary photographers, to be allegorical. The literal reality of a photograph, especially an early photograph, makes us want to understand it realistically; however, that is not always possible, and we should no more expect it of a photograph than we would of a painting. Meaning always lies below the surface of visual reality.

We know that what we see in Johnston's *Measuring* is "maneuvered theater" and does not represent the *reality* of that instant, just as we know, even without Ema Spencer's title, that the meaning of her image is not merely what we see, not merely a child posed on a rocking horse. Its meaning or its *actual* reality is deeper than what we see on the surface and has to do with the excitement of play, the thrill of toys and gifts. We may even read Christmas, with all its assorted associations, into the image, and all of those things we read into the image are the image's meaning, its actual reality. We know what that picture means instantaneously; we don't even have to think about it. And that is the case with most photographs, paintings, etchings, and so forth. It is when we cannot *immediately* read an image that we are perplexed about its meaning, and at that point, we should move into the world of allegory, of myth, of the archetypes. We do it all the time and in all the visual arts except for photography, because we are prejudiced by the reality of that fraction of a second it took for the camera to record the image, a far shorter time than it would take for a model to sit for any painting.

Photographs like the *Butcher*, which are not immediately readable, which drive us to deeper considerations of their meaning, are, like similar works of art, often among the most rewarding because they drive us to deeper considerations of ourselves and what it is that our interior, our most personal and secret, eye sees. The surreal portrait of the woman by the big metal tube (plate 45) is another case in point. What a wonderful and crazy picture. What on earth could possibly be going on, and why is the woman's back to the camera? Whatever it was about or whatever it meant at one time, today in a world after Sigmund Freud it means something entirely different.

Though a surprisingly late cyanotype, Gordon Coster's *Lingerie* (plate 46) from the early 1930s, may have been made to proof an advertisement, it is difficult to imagine the advertisement being any more effective than its cyanotype version; however, it is also difficult to imagine that it would have had any effect as an ad at the time had the lady been blue. Coster was a *Time-Life* photographer, taught at the Chicago Institute of Design under Moholy-Nagy, and is well known for many of his modernist images — montages, powerful industrial photographs, portraits half in negative and half in positive. *Lingerie* is an absolutely perfect cyanotype and a charming photograph, but we would hardly call it modernist. In fact, it is one of those rare pictures we would call cute without meaning it in a pejorative sense. It may have even been slightly titillating at one time, but what is it today and what does it say to our eyes?[19]

Of course, meaning is not the central issue in most anonymous cyanotypes; it's the anonymity and the frustration of the anonymity. The view of *The Pensacola Stranded at Villefranche* (plate 47) is as lyrical as a Gustave LeGray and is clearly the product of an artistic eye, but whose? It is from a series of U.S. vessels at Villefranche, and the photographer has inscribed in French on the verso, "The American frigate Pensacola stranded at Villefranche by a strong 'mistral.'" The curious view of *Sand Dunes* (plate 48) and the two men, one watching the other pull grass, was made by the painter C. H. Turner, who was president of the Boston Art Club, but nothing is known of his photographic work. The image of the moored, rotting *Palmetto* (plate 49) from an album of New England nautical views was possibly mere documentation, but it strikes us today as a haunting yet beautiful photograph — a picture that is about reflected light and decay, the decay not only of the *Palmetto* but a New England industry and way of life as well. The wonderful portrait printed on cloth of the child with the basket of flowers (plate 50) could easily be mistaken for the work of a dozen of the great art photographers of the turn of the century, but there is hardly a chance that it was by any of them.

Anonymity is simply a fact of life in the study of nineteenth-century photography. There are more cyanotypes, autochromes, and daguerreotypes by unknown artists than there are by the artists whose names we have. But this is not a bad situation for it forces the student of nineteenth-century photography to levels of connoisseurship unknown in most other areas of the arts. There is nothing to rely upon but one's own eye. If all art were studied, collected, and sold without any knowledge of the artists' names, more than a few museums and private collections might, with time, truly become museum quality.

Of the contemporary artists working in cyanotype I find none more affecting than John Metoyer. Metoyer has invented a vocabulary for the cyanotype that has never been seen before and crafted a unique style that is the signature of his work, a style that combines the joyous with the ominous. His cyanotypes look like no cyanotype anyone has ever seen. The major problem with much contemporary work in cyanotype is a lack of originality; the images usually have as their sources one of two traditions: contemporary printmaking and contemporary art or the nineteenth-century cyanotype. The first uses the cyanotype more as a curiosity than a medium and the results are usually as boring as the art it apes, and the second, with few exceptions, merely looks imitative of better work done in the past.

The recent lavishly produced volume of John Dugdale's cyanotypes, *Lengthening Shadows before Nightfall*, is a case in point. The two best images, one of a glass of hyacinths and one of a sheep, could have been produced by a talented nineteenth-century amateur, but the others are all imitations, either of Holland Day or mediocre late nineteenth- and early twentieth-century male nude studies, or what is worse, the work of two other contemporary cyanotypists, David

McDermott and Peter McGough, whose very imagery is repeated in Dugdale's work. McDermott and McGough have produced some lovely pictures but pictures that have a distinctly antique feel about them and look as if they might have been taken from some forgotten amateur's elegant turn-of-the-century album. No one would deny the charm of such work; anachronisms are always appealing because they speak to our love of nostalgia and the sentimental in us; witness the great sales of photo books and photo essays about Tasha Tudor walking in her garden or gathering herbs or dressing young girls in lovely white antique dresses. I think it is legitimate in criticism simply to call certain things *silly*. Such a term is, of course, foreign to fashionable thought today with its totems, icons, subtexts, metonyms, been-ness, othering, indexicality, Barthes, Foucault, Derrida, ontology, and, of course, hermeneutics, even though so simple a term would not have been unclear to so clearheaded a thinker, critic, and prose stylist as Samuel Johnson.

Silly or not, I would not deny the possible *art* of such anachronistic photography — or any other photographic fantasy, for that matter, including even David Hamilton's, which in some camps raises political issues! I would, however, question all of these makers' aesthetic integrity. As Philip Larkin wrote in "Poetry of Departures," "I'd go today, / Yes, swagger the nut-strewn roads, / Crouch in the fo'c'sle / Stubbly with goodness, if / It weren't so artificial, / Such a deliberate step backwards / To create an object: / Books; china; a life / Reprehensibly perfect."[20]

In John Metoyer's hands the cyanotype is clearly a viable aesthetic medium and a vehicle for his own unique contemporary voice. Metoyer's work might at times allude to the past but could never be mistaken for it. Both Anna Atkins and Man Ray are acknowledged in his *The Egg: Homage to A. and M.* (plate 51), where we find a photogram or rayogram, the edges of which are redolent with the lush feather imagery of Anna Atkins and the brushed effects often seen in nineteenth-century work. However, it isn't just an antique lyricism Metoyer captures. We notice a chicken-headed woman gaily dancing off from an exceedingly curious and disturbingly sexual egg, an egg which seems to have an umbilical cord attached! The surreal chicken-lady, who has possibly just given birth or perhaps just been born — it is difficult to tell — may be drawn from the world of Man Ray but she also suggests some of the stranger shapes that appear rather hauntingly in Atkins' work too,[21] and somewhat redefines Atkins' elegant feather imagery. Something is going on here that never went on in nineteenth-century photography.

As richly celebratory as much of Metoyer's work is, often, as is the case with *The Egg*, there is also something clearly unsettling and disturbing present, something Metoyer alone among cyanotypists has recognized is also potentially inherent within the blues. It is curious that with all our positive associations with blue we should also use the word to mean sad or depressed, as in "I feel blue." The *Oxford English Dictionary* illustrates that this negative association has been pres-

ent in English since at least 1550, along with several other similarly negative ones. Even as late as Lord Byron the expression "to burn blue" with regard to a candle was taken as an omen of death or the presence of the Devil, ghosts, or evil spirits. It was also often used to describe the color of plagues or to mean indecent or obscene, as in our modern term "blue movie." And so even though we might initially think of the positive associations of blue, as e. e. cummings certainly does with his blue dreams of *yes*, the word does have a darker side to it as well, which Metoyer as both a poet and a photographer is keenly aware of.

No one so utilizes the two contrary natures of the cyanotype as does Metoyer. He seems to have captured that other but equally important side of the cyanotype's potential, a side modern cyanotypists have eschewed in favor of the lyrical and celebratory but which is often seen in nineteenth-century work, in Edward Curtis's *Kominaka Dancer, Kwakiutl*, W. V. Walter's *Butcher, Dec. 14, 1893*, and the bizarre view of the woman beside the strange object and with her back to us. John Metoyer's rapturous blue meditations on the process utilize both the cyanotype's inherent potential to charm and its inherent potential to disturb. And when the imagery is somewhat out of the ordinary, as is often the case in Metoyer's work, the tensions between beauty and oddness, charm and curiosity can at times be dramatic, as in *Innocence: Jaws and Legs* (plate 52). As visually compelling an abstract composition as *Innocence* is, it is difficult to confront it purely from a formal standpoint. We find ourselves wondering, especially with the presence of that word "innocence" in the title, what those jaws might do to those baby legs.

Birds and angels and images of birth and death run through Metoyer's work and are at the center of many of his most disturbing cyanotypes. There is clearly something haunting and terrifying in the imagery of *The Angel of Melrose* (plate 53), *Self Portrait as Azrael* (plate 54), and *The Altar Boy with Death and Tree* (plate 55). *The Angel*'s off-center printing, the deliberate granulation of the print with salt, and the depth of the blue — its *blue burn* — all work to create as unsettling a portrait as I have seen and one that quickly brings to mind Rilke's famous line from the *Duino Elegies*: "Every angel is terrifying." Metoyer's freakish *Self Portrait* as the Angel of Death is equally suggestive of angelic terror, but pain as well, in its similarity to the Elephant Man's face. Why *are* Metoyer's angels so terrifying?

The Angel and *The Altar Boy* are images from the Creole community around Louisiana's famed Melrose plantation. Clarence John Laughlin also photographed there, but for John Metoyer, even though he was born and grew up in Chicago and did not come to Louisiana, except for summer visits, until his mid-twenties, Melrose is not merely a picturesque or haunting location but the ancestral home of his family. Of all the plantation homes in Louisiana, it is perhaps the most interesting because it was not the product of white slave-owning society but the creation of the free black matriarch of the family, Marie Thérèse Coincoin, a brilliant and enterprising woman who had been brought from Africa in

slavery, fell in love with Claude Thomas Pierre Metoyer, a French trader who freed her, had ten children by him, and built Melrose. *The Altar Boy* stands on the grounds of the eighteenth-century church built by John Metoyer's several greats-grandfather, Augustin Metoyer, the oldest son of Marie Thérèse. Ironically, the Metoyer family, like so many of Louisiana's "free men of color," lost everything — including Melrose — with the collapse of the Confederacy. The photographs seem to suggest there is little left here but graves, death, and either the sardonic smile or the pitiful visage of the angel of history, who presides over the same kingdom Azrael does.

A similarly terrifying angel with its skeletal portent of death is seen in *Push* (plate 56). The title initially seems somewhat funny, or zany perhaps, but what is this about and what is happening here? Upon inspection it is clear that this is not funny at all; a skull-headed woman with baby-head breasts has given birth to something part bird and part man, part flesh and part bone, an angel perhaps. Yet for all of the unsettling aspects of the scene, it is still an elegant and graceful image that the eye returns to again and again for its color, its composition, its dramatic use of white space, but finally returns to, as in all of John Metoyer's images, because his work seems to be speaking something we know is true, something unsettling yet compelling, something we hear but cannot quite understand.

None of Metoyer's poems deal directly with his photographs; however, as one might expect, certain major themes are present in both. A poem about himself is entitled "Blue Me"; there is occasional photographic imagery; and there are many stark, frank poems in the voices of embalmers, cremators, coroners, nurses from the cancer ward, and others who live with death. *Confessions from the Funeral Trade* is a chilling collection of poems, and it is not without its angels, too; however, their voices are silent. In the title poem Metoyer writes:

> What they want is a final miracle.
> I've never witnessed the transformation.
> Never heard the voice of angels.
> There is only the wrench
> of the closing door, the click
> of ignition, and the rush of heat.

As dark as some of the poems and photographs both are, Metoyer can also write of "what we're meant to be: / intricate manufacturers / of cartilage and bone — / makers of dust and gods." And he can see how his grandmother's "grace captured sunshine / and was frozen with the shutter / of the cameraman's shot." And he can even see "the permanent reflection of" himself as the "sky shimmies clouds / in a wondrous glow / of azure gilded rapture."

It is a similar lyric and positive imagery such as this that seems to shape another body of his work, the majority of which is in calotype, but some of which, like *The Illuminated Path* (plate 35) or work from the *Fiddlehead* series (plate 57),

also exists as cyanotypes. These are images of pure lyrical joy, photographs of things whose grace has also captured sunshine. Metoyer's very painterly *Fiddle-heads* immediately attract the eye and they have won numerous awards. He has also produced beautiful abstract images of water in which he achieves spangling effects that I have only seen in some of Heinrich Kühn's gum prints. But perhaps his most inspired images are those that seem to participate jointly in both the joyous and the dark, in the negative and in the positive, works like *The Angel Heron* (plate 58), which come full circle in his imagery and ideas. There, posed on dark waters, stands a luminous angel, a pure form from nature graced by light, an angel without terror—other than perhaps for the brilliance of its aura and its indifference to the world of men. It is an exquisite, vandalous image, as exquisite and vandalous as Metoyer's art, his vision, and the cyanotype itself.

American Symbolism

Visions of Spirituality and Desire

Is it out of a sense of mere nostalgia that at another century's turn we find ourselves drawn to the strange, beautiful, but often perplexing artistic imagery of the last century's turn? Or is it something more significant? Is there something in our moment — a similar malaise, a similar fear, a similar spiritual yearning — that harkens back to a century ago and a world that was on the verge of destroying itself, a world that knew it was at the brink of the heart of darkness and turned, therefore, *à rebours*? Or are we perhaps only having a birthday party, celebrating a particular artistic centennial? I doubt if it is merely the latter, certainly not exclusively so, but whatever it is, Symbolism is in the air again as this century comes to its close.

For example, in 1995 the Montreal Museum of Fine Arts presented *Lost Paradise: Symbolist Europe*, the most comprehensive Symbolist exhibition ever staged, an exhibition that surveyed the entire movement from photography, painting, and sculpture to the decorative arts.[1] The photographs of Steichen, Seeley, Käsebier, Day, Eugene, Brigman, von Gloeden, and others were presented right alongside the paintings of Klimt, Delville, Burne-Jones, Gauguin, Von Stuck, Khnopff, Redon, Ranson, the jewels of Lalique, the glass of Gallé, and the furniture of Mackintosh and Majorelle. An oversized 550-page catalogue containing essays by several distinguished scholars was published to accompany the exhibition and included one essay specifically about photography.

In late 1995 and early 1996 the Fotomuseum im Münchner Stadtmuseum presented *Frank Eugene: The Dream of Beauty*, the first comprehensive exhibition of Eugene's work, and also published an oversized, nearly 400-page catalogue to accompany it.[2] In 1995 the Santa Barbara Museum of Art organized an exhibition scheduled to travel until 1998 and published a catalogue along with it

entitled *A Poetic Vision: The Photographs of Anne Brigman.*[3] The year was also marked by publication of the most lavish book ever produced on a Symbolist photographer, James Crump's brilliant *F. Holland Day: Suffering the Ideal.*[4] In 1994 the J. Paul Getty Museum and the Huntington Library presented *Pictorialism in California,* which included Symbolist work by Brigman, Adelaide Hanscom, and others.[5]

The year before, I addressed Symbolism and its relationship to color photography in *The Art of the Autochrome.*[6] In the book I made the point that Symbolism is difficult to define because there was no single style; however, it did produce a body of work with certain attitudes in common. In some ways those attitudes are best expressed by the Italian Symbolist painter Giuseppe Pellizza da Volpedo, who wrote, "The reality that we see before our eyes is in constant conflict with the truth in our minds — which is the one we choose to represent. In my paintings I should not be aiming to represent *real* truth but ideal truth. . . . If the artist sticks too closely to reality in his search for the truth, he cannot achieve his full potential. The ideal truth can only be reached by sacrificing the real world."[7]

The sacrifice of the *real* world for a greater truth, a greater reality, is the major visual characteristic of Symbolist art. That is also what religions enjoin their followers to do. Of course, religion itself might be defined as a kind of symbolist art form. It too is enshrouded in mystery; it attempts to visualize the unseeable, know the unknowable, and utter the ineffable, and, therefore, its most powerful and poignant communication is through its symbols, a few of which might be understandable only to the initiated but most of which partake of archetypes and are universal.

The fact that the world seen in Symbolist paintings and photographs does not always look exactly like the *real* world should be no more bothersome than religion is bothersome. Most people, even those raised outside of traditional religions, are usually brought up from birth believing in a greater reality than the *real.* The linguistic oddity of such a phrase, a phrase like a greater perfection than the perfect or a greater infinity than the infinite, seems to perturb no one, and no one has difficulty in understanding exactly what is meant — even though what is meant is clearly beyond language. The same is the case with Symbolist art. We can understand and make sense of it, even when it is apparently vague, if we do not insist upon a literal reading. The symbol is the vehicle by which myth is communicated. And it is myth that finally is at the heart of Symbolist art.

Desire, both sexual and spiritual, and the variations upon passions, as well as their entwining, seem to shape the content of most Symbolist photographs. But desire is as difficult to discuss in art as it is in life. It is simply one of the inexplicables of the human condition, a part of eroticism and of need, both of which are often aspects of the spiritual, which is equally difficult to define. Devotees of the spiritual life seldom see, or seldom seem to see, the links between eroticism

and spirituality, but they are quite apparent to psychiatrists, historians, artists, and even some religious mystics. Again and again we find them linked in art — most often in depictions of Teresa's orgasmic ecstasy and Sebastian's equally orgasmic martyrdom.

At a pure and emotional level desire, of course, is lust, an expression of the sexual appetite, but at another pure, emotional, yet nonsensory level, desire often manifests itself in spiritual terms. Lust and God are equally nonintellectual; it is not through intellect but passion that we know them. Art, being an emotional expression, is therefore an ideal vehicle for their depiction. Photography, however, is better at dealing with lust than with God because it is the most sexual of the arts. Its raw material, the photographic image, is a greater erotic stimulant than paint, words, bronze, or music. For some people music is more titillating than any photograph; for others, words are the great stimulant. But clearly for the majority of people photographic images have the greatest pornographic potential; witness the multimillion-dollar X-rated film and magazine industry. There is no comparable X-rated painting or music or book industry. Why photographs, or erotic graffiti, considering that they are two-dimensional and miniaturized, can carry an erotic charge is an interesting question. Few people would probably be excited at the sight of living, breathing eight-inch tall, two-dimensional, naked people cavorting around, but whatever stimulates human sexual response did not consider that fact.

Other than purely pornographic images, the most erotic of photographs are those that usually fall under the classification *pictorial*, a term, however, that is difficult to define because it can legitimately be used to describe radically dissimilar work. The Symbolist photograph falls historically within the early years of Pictorialism, but it is usually less overtly sexual; however, it finally can be deeply erotic, just as it also can be deeply spiritual. Symbolist photographs pullulate with desire because of something we can read within the image but which is not stated on its surface. They arrest us through the power of reference, reference to the myths they suggest and the archetypes they stir in our barely conscious thoughts. In fact, when they are too clear or too obvious, when their desire, be it sexual or spiritual, is too blatantly expressed, we are quick to deride the work as kitsch.

The reason that many, though certainly not all, of the nudes of Robert Demachy and Constant Puyo, the heterosexual equivalents of Holland Day and Wilhelm von Gloeden, strike most viewers as bad art is that their Symbolist aesthetic, that distinctive Symbolist look, is being imposed on highly realistic, non-symbolic work. Demachy is famous for a series of arousing views of a young girl exposing her breasts little by little. They are delightful, just as von Gloeden's Sicilian boys and Irina Ionesco's similarly arousing portraits of her daughter or Bruce Weber's *Bear Pond* boys are delightful. They are not Symbolic; they are sexual. Steichen's great Symbolist nudes might also stir desire, as any good nude

study should do, according to Kenneth Clark, but they are finally not about desire. They are about something else, something mythic and even more erotic, *la belle dame sans merci*, the femme fatale, the blessed damozel. The reason Holland Day's depictions of Jesus's death strike most viewers as bad art is not, as their apologists try to suggest, that the sexual element, Christ's orgasmic languor, is being missed or misunderstood. How could it be? The problem is that the Symbolist aesthetic, that Symbolist look, once again is being imposed on highly realistic, nonsymbolic work.

Day's studies of St. Sebastian, however, are completely successful because they *are* clearly symbolic. They are less obvious as to what they are — a tied and bound boy, a single arrow, or in one case an intensely beautiful face, the torso cropped right below the nipple, and a single wound. No Sebastian from painting ever looked like this! Also Day's Sebastian studies immediately pose two narratives: the obvious spiritual narrative of a saint's life and the equally obvious erotic narrative of the beautiful boy, bound and submissive, penetrated and in ecstasy. But finally they are neither essentially spiritual nor erotic; they are about what we all recognize as one of the greatest of tragedies — youth struck down, the fallen god. It's every such tragedy from Christ or Icarus to Billy Budd and Housman's athlete or the brilliant high school senior with bone cancer.

One could say that is the same narrative of Day's Christ studies, but their blatant realism stops us before we get to the level of the myth. Myth cannot be penetrated by reality, but only through symbol. Again and again reality or a reliance upon reality stops the seeker in his quest. It is only when reality is sacrificed that the myth can be approached, understood, or incorporated into one's life. "The ideal truth can only be reached by sacrificing the real world," as Pellizza said. And though what I have described might be the nature of the classic spiritual quest, it can also be used to consider and critique an art built from the same spiritual materials.

What one sees again and again in Symbolist photographs are strange, often miraculous, often disturbing, landscapes and desirable men and women. And, of course, they are often merged in one photograph. Whether one is considering the American or the European Symbolist image, much of the same imagery is encountered. The European Symbolist landscape tends, however, to be less forbidding than its American counterpart. For example, Edouard Hannon's landscapes (see "Masters of European Pictorialism," plates 75–77) are all deeply spiritual images. They are destinations, places one would want to find, the ends of quests. We look at them and know the Grail lies waiting within because this is the place at which we have always wanted to arrive. The seemingly unintelligible narratives of most Symbolist photographs are Grail quests, even those of *les femmes et les hommes fatals* because they are presentations of the Grail itself, the Grail made flesh. But the American landscape in photograph after beautiful photograph seems to present the journey, the quest itself, and they all read like

descriptions of states of desire and loneliness. Symbolist photography is always about the ideal, even when it is the negative ideal or the ideal is not yet fulfilled.

Harry Rubincam's *The Horseman* (plate 59) is an excellent example of the Quest image. It obviously brings to mind Theodor and Oscar Hofmeister's well-known *Solitary Rider* or *Solitary Horseman*,[8] but the Hofmeisters' is not so ominous a picture. The large size of the Hofmeisters' photograph and the small scale of the rider in relation to the beautiful trees in the landscape might suggest exhaustion and the idea one still has a long way to go, but the Quest that the image seems to suggest is home, the known, and the familiar. The trip looks as if it might be long, but it does not appear to be dangerous. Rubincam's, on the other hand, is clearly a dangerous journey, as all true Grail quests are. The tree that dominates the image is a classic black nightmare tree with fingers outstretched to grab the rider. It even looks like the landscape Sir Gawain must traverse on his way to the Green Chapel and his fate at the hands of the terrifying Green Knight in *Sir Gawain and the Green Knight*, one of the great quest poems of the Middle Ages.

One might wonder if Rubincam drew his photograph out of his own consciousness or whether he had seen the Hofmeisters'. Stieglitz had published it in *Camera Work* in 1904, and so it is possible that Rubincam was influenced by their imagery, but one cannot be sure because the majority of Rubincam's work was informed by the same Pictorialist / Symbolist aesthetic as that of the other members of the Photo-Secession, which he joined in 1903. It is an interesting aside to note that the horseman in Rubincam's photograph may very well be Edward Steichen, perhaps the greatest of all the American Symbolists. In 1906 Steichen and his wife visited with Rubincam in Colorado and Rubincam made several photographs of Steichen, including one of him on horseback beside some ominous trees.[9] Today Rubincam, however, is primarily remembered as a Modernist because of his famous *Circus Rider* that appeared in *Camera Work* in 1907, a photograph the Gernsheims called "a landmark in modern photography" and compared to Coburn's *Octopus* and Stieglitz's *Steerage*.[10] Of course, it is finally unimportant whether Rubincam ever saw the Hofmeisters' photograph or not; what *is* important is the mythic aspect of his own work.

We can see the same mythic quality in the work of John F. Collins, another photographer who, like Rubincam, is thought of more for his modernity than his symbolism.[11] Collins's *Morning Fog* (plate 60) pictures the scene Rubincam's Horseman could be witnessing, a road certain even through fog but one with an uncertain destination. It is an early work of Collins and in a style completely unassociated with the major body of his work; however, he obviously was proud enough of the picture to continue submitting it to exhibitions, fifteen in all, into the mid-1930s. Collins's first work from 1904 and through the teens is in the pictorial tradition. He even made autochromes, but by the 1920s he was producing geometric modernist works that bear a striking resemblance to the images

Pierre Dubreuil was making at exactly the same time.[12] Most of Collins's work during the twenties was produced for major commercial accounts, such as Kodak, Corona Typewriters, Oneida Silverware, Bausch and Lomb, and so forth, but the work was of such high quality that Collins was the first commercial photographer to become a Fellow of the Royal Photographic Society, which even staged an exhibition of his commercial work. From the 1930s on he worked for Kodak and continued photographing into his late nineties.

Collins's *Morning Fog* is a classic Symbolist image. The road with the uncertain destination is an obvious metaphor for life itself, and the visually beautiful image in this context immediately rises to another level, the symbolic level wherein the composition, the imagery, every aspect of the craft, and finally even the sense of beauty we might perceive exist in service to something higher than beauty, higher even that art. Art has become a vehicle for meaning, for truth, as the Symbolist perceives it. Symbolist art does not present that Keatsian equivalency of beauty and truth but something entirely different. Beauty is integral to truth for it is through beauty and art that truth is revealed, but truth finally has to be superior to beauty, for it is truth that is the primary goal of the seeker. It was not art for its own sake or beauty for its own sake that drove Giuseppe Pellizza's art, as he made quite clear. His art, like that of all the Symbolists, was first a search for truths. However, the meaning or the message that is intended to transcend the ephemeral and surface beauties of the work need not be blatant or obviously stated; in fact, when it is, the results look like William Mortensen's skillfully crafted propaganda and desire. Though Mortensen may well have been successful in his search for truth, we are disturbed by the crudity of its presentation, as we are in the work of painters like Elisar von Kupffer, where too much art has been sacrificed for the sake of a message.

It is a difficult balance that we seem historically to demand of the artist. We expect art to be understated, and when it isn't, except in the case of baroque architecture, we nearly always damn it as propaganda of some sort — social in Mortensen's case, sexual in von Gloeden's, or political in Heinrich Hoffmann's. Occasionally we even agree with the truth of the propaganda, the truth of the work's content, but not the truth of its art, the truth of its form. This makes the production of Symbolist art exceedingly difficult because if the actual goal of the truth is arrived at in too obvious or crude a manner, the work may very well be unsuccessful as art. But this is more than a clever balancing act, the mere manipulation of charming artifice. If the truth can be reduced to too simple a formula, then, regardless of whether it is true or not, it will not have the sense of revelation about it, the sense of something having been discovered. Truth is, the Symbolist would argue, as much about how one arrives at it as what finally is arrived at. No myth is read for its conclusion; conclusions are obvious and the results of journeys. We read the great myths to partake of the journeys of discovery their seekers also took. The Grail itself is unimportant, as unimportant as

Mortensen's blatant photograph of *Human Relations 1932* depicting two fingers plunged into a man's eyes. The knight is tested in the search for the Grail or the brotherhood of man or whatever, and the truth is revealed in the act of being tested.

The contemporary individual hates being lectured to, told what to think or to do worse than any individual from the past; it is an outgrowth of the great and beneficent Romantic fictions we all live by today and have come to accept as holy writ — notions of fundamental rights, personal liberty, equality, progress, and the other premises of Romantic democracy, notions nearly as dangerous for us to call into question as the structure of the heavens was for Giordano Bruno to question. A university professor today could certainly be denied tenure for questioning some of these. Even the existence of God could be debated in a medieval university, but the tenets of Romanticism, our current religion, are sacrosanct — especially those involving our modern notions of equality. We are so protective of our new faith that even the raising of certain questions is met with immediate denunciation and attack. Both modern society and the modern academy are filled with zealots as pure in heart as those who once were so quick to cry "Witch, witch."

Our present-day notions of freedom in the arts and distaste for didacticism — and even to some extent for form itself — are an outgrowth not of the aesthetics of Romanticism but of its politics. But had Romantic politics never been grafted onto Romantic aesthetics there is little chance that Kandinsky or Mondrian or many other artists would have been adequately freed from their earlier and more traditional styles to craft a new vision. Artistic events even of the most radical nature do not develop in an artistic vacuum freed from all the other events of the world — political, social, economic, and so forth. Everything is hostage to everything else. We tend not to associate notions of art for art's sake with Modernism but with the fin de siècle; however, little art until modern art was truly about nothing but art and did not have as its purpose that dual task of delighting and instructing. As much as the aesthetes might have talked of art for its own sake, who in the 1890s was actually committed to such a proposition? Not Oscar Wilde. *Picture of Dorian Gray* is as didactic a work if there ever was one, despite Wilde's preface.

But from the teens until the thirties when depression, dustbowls, fascism, and the age of dictators began to craft a more social — even storytelling — art, the object itself was both the mind's and the eye's sole delight. It is easy to understand why so many photographers turned against all aspects of Pictorialism and began to extol the straight photograph — the white fence, the abstract clouds, the bell pepper. The new aesthetic and its adoration of the art for its own sake is the very thing that made the Royal Photographic Society invite a commercial photographer to exhibit his ads, ads that to the modern eye were of such beauty and purity that they were seen as art. And they still look like art to us today, just as

many of Edward Steichen's, Paul Outerbridge's, Charles Sheeler's, Hans Finsler's, Piet Zwart's, and Jaroslav Rössler's advertisements and commercial work do as well. They appear to our eyes as perfect examples of Modernist art because Modernism redefines artistic truth. The truth of an object or a thing is in the thing itself, not some mythic drama suggested by what a picture might conjure up. A photograph of eyeglasses is not about Vision, improved or diminished, but about eyeglasses. An empty road is about an empty road. The reality itself is the purest truth that art can approach. This view and the Symbolist view are not so much matters of conflicting aesthetics but conflicting epistemologies. Modernism suggests that there is little that we can truly know, even ourselves, which Freud showed us to be fragmented. The past was more hopeful and felt there was a great deal we might be able to know. Out of these two conflicting epistemologies come conflicting aesthetics. Art born from one view will be as radically different as art born from the other.

Many photographers, including two of the arch Symbolists, Alvin Langdon Coburn and Edward Steichen, were caught in the aesthetic transition. They began as Symbolists but turned into Modernists. Along with Albert Schaaf, perhaps the least known of the great American photographers of this period, they offered Symbolist views of the culmination of the Quest. Schaaf was a member of the Boston Camera Club in the 1890s, was one of the first to join the Council of Forty along with Dwight Davis, and had a work featured on the cover of the *Photographic Journal of America* in 1915. He was a car racer, bicycle enthusiast, sailing enthusiast, automobile manufacturer, and a director of Fiat.[13] Photography occupied a major part of his life, but there were other concerns as well. Being not so caught up in the politics of photography, he slipped through the cracks of its history until the entire body of his work was rediscovered some years ago by the indefatigable George Rinhart, whose scholarship and research has added so much to redefining our view of this century's photographic history. Schaaf's work is now entering major museums such as the National Gallery of Canada and the Amon Carter Museum and is beginning to receive the recognition long overdue.

Schaaf's *South Bay* (plate 61) of 1898 is remarkable both for its Symbolism and for its Modernism. It is a work that is at least a decade ahead of its time in terms of its imagery. There is nothing else like this in photography at so early a date — or in painting either. Curiously enough, however, Schaaf does not appear to have exhibited the print until 1929 at the Albright Gallery in Buffalo, over thirty years after he made it. It is the dark, bleak yet geometrically exciting modern landscape that Schaaf captures in *South Bay*, a work that bears a striking resemblance to those views of the Pittsburgh industrial landscape that A. H. Gorson began painting in 1908 and continued to paint for more than two decades. Such imagery is not generally seen in photography until Coburn's 1910 studies of New York and Pittsburgh.[14] In fact, Coburn's well-known *Pillars of Smoke, Pittsburgh*

is the same scene in several of Gorson's paintings. Schaaf's Modernism is muted by a deliberate lack of clarity that is the result of the pigment process he chose to use, a process a number of Symbolists and Pictorialists favored. This looks nothing like Sheeler's bright, clear, and positive industrial views or even Margaret Bourke-White's or Edward Weston's.

What Schaaf sees is a vision right out of the last pages of *À rebours* where Huysmans, writing in 1889, describes "the vast, foul bagnio of America, . . . the limitless, unfathomable, incommensurable firmament of blackguardism of the financier and the self-made man, beaming down, like a despicable sun, on the idolatrous city that grovelled on its belly, hymning vile songs of praise before the impious tabernacle of Commerce." "Could it be," Huysmans' Des Esseintes asks, "that to prove once for all that He existed, the terrible God of Genesis and the pale Crucified of Golgotha were not going to renew the cataclysms of an earlier day, to rekindle the rain of fire that consumed the ancient homes of sin, the cities of the Plains? Could it be that this foul flood was to go on spreading?" [15]

In general the Symbolist vision tended not to be so bleak. Alfred Kubin and Odilon Redon presented terrifying visions, but they were of the mind's fantastic monsters, those products of the sleep of reason Goya also knew. They might haunt a few people, but what Schaaf saw as early as 1898 was the next century's destiny, and it would come to haunt us all.

The more typical kind of dark landscape seen in Symbolist photography, especially American Symbolist work, is found in Steichen's *Late Afternoon—Venice* (plate 62). This is not the joyous Venice of Canaletto or even the Venice of the photographs of Carlo Naya. This is Aschenbach's Venice, the Venice of plague, driven desire, and dark water. In fact, the image is composed nearly exclusively of dark water. Coburn's *Lombardy Poplars*[16] (plate 63) is a similar dark image of the end of the quest, the negative goal, the anti-Grail, which after Huysmans was very much part of the Symbolist tradition. By presenting the negative, we can often find our way to the positive. This is not an exclusively Symbolist attitude. In the eighteenth century the same effect was achieved through satire and in the nineteenth century through rage, as William Blake railed against the "dark Satanic Mills" and Blake called for his "bow of burning gold," his "Arrows of desire," and his "Chariot of fire," and swore, as did Karl Marx, that his sword would not "sleep in [his] hand / Till we have built Jerusalem / In England's green and pleasant land." Schaaf, Steichen, Coburn, and other Symbolists simply presented the negative Quest without satire, without rage, but with the implication that we turn away. Such images, though it might be less obvious, are also finally spiritual, just as is Des Esseintes' final rage before accepting the world and returning to it.

When the world is accepted, humanity is encountered and it, too, must be accepted. We usually think of crowd scenes and street photography as reportage, documentation, or simply an aspect of Pictorialism, as in the case of Maurice

Bucquet's beautiful Parisian scenes (see "Masters of European Pictorialism," plates 87 – 89). However, in certain hands such renderings seem more than that, seem Symbolic in their suggestiveness. Robert Demachy's famous 1910 image *La foule*, shot from above and looking down upon the crowd, is a case in point. It is difficult to look at any oil-pigment print and read it only as reportage or documentation, but especially one like *The Crowd*. It looks as if it must be saying something more significant than, Here are a lot of people. It is so alive and so packed with humanity that it speaks to us in the same way *The Steerage* does. And though less packed than either *The Crowd* or *The Steerage*, Albert Schaaf's 1905 oil-pigment *Market – Strasbourg* (plate 64) carries some of the same symbolic message.

In most Symbolist scenes involving individuals as well as landscape, it is as if something Edenic is being suggested, as in Schaaf's 1894 *Idyllic Scene* (plate 65), depicting his wife and two of her friends, or Coburn's *Lillian and Laura Seeley* (plate 66), a highly Symbolic study of fellow Symbolist George Seeley's two sisters. These might also be seen as end of the Quest images, especially Coburn's because his is suggestive of far more than the *luxe, calme, et volupté* of Schaaf's photograph. Behind the sisters, who are wearing the same robes in which they posed for their brother's well-known *The Burning of Rome*, looms one of those great Symbolist spheres, globes, or balls that haunt photograph after photograph from this period. One can find them also in White, Stieglitz (in some of the joint works with White), Käsebier, Brigman, Steichen, Seeley, Boughton, and de Meyer. Francis Bruguière even made a portrait of Brigman looking into one of those "wondrous globes," as Brigman herself referred to them. They are noticeably absent, however, in European Symbolist work.

In some ways they seem merely a decorative device in American Symbolist photography from this period, yet any sphere does seem to suggest something about unity and completeness. It is interesting to note that they are used nearly exclusively with female sitters. White posed a young boy beside one in *Rain Drops* and Brigman a young faun looking into one in *The Wondrous Globe*, but the globe is clearly something primarily feminine. Perhaps it does suggest some kind of notion of female completeness or perfection. Adelaide Hanscom's illustration for *The Rubáiyát*[17] (plate 67), in which a woman is completely circumscribed by a circle, or possibly enclosed in a "wondrous globe," implies a kind of spiritual completeness, a self-sustaining independence that is potentially frightening to the male, because it suggests he is less complete, less self-contained, and possibly even unnecessary or irrelevant. Hanscom powerfully emphasized male irrelevance in another image (plate 68) which suggests that even were there room within the circle's compass, there would be no room for him. A beautiful young woman has taken his place and holds the hand of the central figure.

The female in her various guises, especially in the guises of spirituality and desire, seems to be at the heart of Symbolist art. As I wrote in *The Art of the*

Autochrome, "The Symbolist depiction of the female ran from the strangely disquieting to the *femme fatale,* the outright vampire, while its later . . . depiction moved between inviting eroticism and glorified motherhood. It is this later image of the female that one primarily sees in turn-of-the-century art photography. However, both visions shared a common ground, a similar surface of easy attractiveness, a look based on male stereotypes of male fear and male desire" (p. 7).

Arthur Becher, whose work appeared in both *Camera Notes* and *Camera Work,* was an artist, a student of Howard Pyle's, and a friend of Steichen's from Milwaukee. His untitled study (plate 69) is a powerful depiction of female indifference. The lady looks as languid and lovely yet unapproachable and uninterested as many of Julia Margaret Cameron's women, while Coburn's *Classical Study* (plate 70), a luminous, gold toned platinum print, with its radical cropping typical of several of his portraits from this period, may be suggestive of classical sculpture, but the lovely arm is clearly flesh. It seems to shimmer suggestively, yet the lady is as unapproachable as if she were a statue. For the most part cropped out of the image, she suggests not even a complete statue but a classical fragment.

Adelaide Hanscom was a successful but tragic San Francisco photographer who opened her studio in 1902. Four years of great success, which included the publication of her *Rubáiyát* and a partnership with photographer Blanche Cumming, ended with the 1906 earthquake. Her prints, except for a few at her home, as well as her negatives were all destroyed, and she was nearly killed in an attempt to save them. She then moved to Seattle, opened another studio, and had two prosperous years before making an unhappy marriage to a man who walked out on her following an argument, enlisted in World War I, and was killed in his first battle. She was left with two small children. Mental illness soon followed, and eventually death from a hit-and-run accident. From her surviving work and the *Rubáiyát* illustrations it is clear that she was a major Symbolist photographer.

Most of the photographs in *The Rubáiyát* have little to do with actually illustrating the poem and are only vaguely suggested by it. Omar writes of a potter, and a barely dressed young man is seen posed beside some pots. It was as if Omar's poetry and "Persian Symbolism," which Hanscom made reference to in her acknowledgments, merely provided a context, the costume, the garb, so to speak, for her own art. The highly decorative acknowledgments page included a design, also reproduced on the leather cover, that she said, "SIGNIFIES STRUGGLE BETWEEN THE PHYSICAL, MENTAL AND SPIRITUAL." She also indicated the colors of the physical, mental, and spiritual and reproduced two other designs that appear in the photographs. One she called "THE SIGN OF SATURN OR THE SEVENTH HEAVEN," and following the other she wrote, "A BIRD CAN FLY WITHOUT WINGS." This is clearly the thinking and approach of the artist who finds truth outside the limits of the real world.

Hanscom's *Rubáiyát* illustration (plate 71), rather like her globe-enclosed

figure, is another image of female superiority and desirability. She proffers a cup, but with so regal and imposing an air would a man dare take a sip? Jonathan Green, taking the term from Dante Rossetti's poem, calls this figure "the Blessed Damozel." She is, he says, the "synthesis of the inaccessible woman of secular romance and the major female figures of the sacred world — the Virgin Mother and the temptress Eve — her languid, sensual beauty continually reappears in all nineteenth-century art forms. Her inaccessibility suggests modern man's inability to escape from the materialistic present, and her latent sensuality may be seen as a libidinous manifestation of the yearning for the supposed sexual and psychic energy of the medieval and mystical past."[18]

The figure of the temptress is one of the most common in Symbolist art, and she takes various forms. In her most dangerous manifestations she might seem like von Stuck's *Sin*, all snake entwined and man eating, but probably looks more like Lolita or the youthful Jean Simpson (plate 72), Edward Steichen's Lolita.

Sexual temptation doesn't always take the form of the female, however. Tadzio can be as distracting as Lolita. The paintings of Simeon Solomon, Magnus Enckell, and Jean Delville illustrate this quite well. Freud believed the attraction to the beautiful boy was an attraction to his femininity. "Among the Greeks," he wrote, "where the most manly men were found among inverts, it is quite obvious that it was not the masculine character of the boy which kindled the love of man; it was his physical resemblance to woman as well as his feminine psychic qualities, such as shyness, demureness, and the need of instruction and help."[19] Of course, the "feminine psychic qualities" Freud named are not innate but societal. And are men really attracted to shyness, demureness, and helplessness? Perhaps some are, but a simpler explanation of the beautiful boy's attraction might be that beauty distracts.

What is it about the look of Antinous or Lord Byron or Elvis or *Bay Watch*'s David Charvet? Might there not be in certain faces inherently pleasing structures, structures neither societal nor aesthetic but of nature itself? Might certain faces not contain structures such as the Fibonacci sequence, a mathematical sequence which appears to be some curious human discovery but is omnipresent in nature — in the way rabbits breed, in the generation of bees, in the spirals of the sunflower, and the leaves and petals of many plants? As the sequence increases, the ratio between the numbers stabilizes at .618 to 1, the most famous of all ratios, the Golden Section of the Greeks — and of artists, architects, and designers because those proportions are the most aesthetically pleasing of relationships, which also happens to be the same ratio in the human body between the length from the top of the head to the navel and the length from the navel to the toes. Might there not be golden sections of desire built into certain faces and might desire not be a matter of instinctual aesthetics and as physiological and natural as lust?

These are potentially disturbing questions because in our society open discussions of homosexuality are less embarrassing than these of desire's ambivalencies; too often men are frightened that the admission of an attraction to a Tadzio undermines their masculinity. One might as well be embarrassed by an attraction to a Lolita. Though Symbolist photographers with the exception of Holland Day, Wilhelm von Gloeden, and Wilhelm von Plüschow preferred *la femme fatale* to *l'homme fatal*, he can also be seen in Adelaide Hanscom (plate 73).

Green argues that it was George Seeley who pushed that "single most pervasive motif . . . the Blessed Damozel . . . to its limit" (p. 19). Seeley's women seldom seem temptresses, however, nor do they seem like mothers either; most are just beautifully unapproachable. Even when Seeley actually does depict motherhood, as in *Golden Dawn* (plate 74), a photograph of Seeley's niece, Marion Byron, as a baby in his sister's arms, his depiction is unusual and nothing like those classic versions of motherhood seen in the photographs of Heinrich Kühn. One could look at *Golden Dawn* and not even recognize it as a mother-and-child image. An imposing woman stands beside a tree that could have come straight out of Kōrin or Hiroshige, and she could be holding any number of objects. We only know it to be a baby because we know this was one of the very last of the original group of Seeley's works to have been sold by Marion Byron, who inherited the Seeley archive and was reluctant to part with a photograph of herself in her mother's arms.

But soon all this imagery would pass away. Greater truths than reality had little meaning to a world that had for the first time encountered modern warfare. As I wrote in *The Art of the Autochrome*, "To a post-1918 world the metaphors and images of Symbolism seemed irrelevant. 'The age demanded an image / Of its accelerated grimace,' as Ezra Pound put it. Symbolist introspection looked and sounded like so much mumbo jumbo after the realism of the Somme. And the dreamlike Secessionist seductions of *Wien, Stadt meiner Träume* simply vanished with empire or grotesqued themselves into nightmares — or operettas. . . . To a man in constant fear for his life, a man who had for months been trapped in the mud and excrement of the trenches, who had watched the blasted, unretrievable bodies of his comrades rot a few feet in front of his eyes, images of Eve or Circe, Venus or the Madonna were all irrelevancies, all part of a blasted world. The very frame of reference in which such a woman might be depicted was now illusory — or just so much rubble. The Great War demythified woman and caused her to shed both her horror and her beatitude" (p. 7).

The shedding of woman's horror and beatitude was also the shedding of Symbolism's visions of desire and spirituality. Such elegant truths became too expensive for daily maintenance. They seemed, whether they were or not, luxuries even the leisure class could not afford, affectations the artists could no longer believe in.

Masters
of European
Pictorialism
and the
Problem of
Alfred Stieglitz

Pictorialism is not easy to define. We only need look at an issue of *Photograms of the Year: The Annual Review of the World's Pictorial Photography* from the 1920s to get some sense of the complexity of the term. There we can find cute pictures of kittens snuggled up with mean old mutts, obvious exemplifications of the taming power of innocence coupled with ignorance; photographs of pigeons with enigmatic titles like "In the Danger Zone," pigeons presumably able to fly but posed beside big automobile tires; and lots of naked women that do not justify the more artistic term "nudes." All this beside photographs by Rudolf Eickemeyer, Charles Job, and Leonard Misonne that look like the same pictorial work they became known for doing twenty-five years earlier; Modernist masterpieces by Dubreuil and Drtikol; and an occasional wonderful surprise like Laura Gilpin's classic *The Prairie* or a Coburn, a Malcolm Arbuthnot, a Rudolf Koppitz.

Probably little if any of this work — even the good — would fit the term "pictorial" as Stieglitz used it to describe the work he included in the 1910 International Exhibition of Pictorial Photography at the Albright Gallery in Buffalo. Because the term so expanded over the years to include so much, without extensive clarification it cannot be used today with much precision. Like pornography, it is something we all recognize when we see; however, we often can't agree that we are looking at the same thing.

I won't try to define the term but will use it in the context of this essay to apply to turn-of-the-century European artistic photographers whose work was never included in *Camera Work*. European photographers who got the Stieglitz stamp-of-approval by being published in *Camera Work*—photographers like

Heinrich Kühn, Theodor and Oscar Hofmeister, Robert Demachy, and Craig Annan — have ended up in the history books and deservingly so. However, others who only appeared in the equally lavish German equivalent of *Camera Work* — *Kunst in der Photographie* — or the less lavish but still elegant *Photographische Rundschau*, or in the Photo-Club de Paris's four sumptuous *Exposition d'Art Photographique* catalogues of 1894 – 1897 or its 1903 – 1908 *Revue de Photographie*, or in any number of other similar publications have too often been forgotten. A great many of these artists deserve our attention and a place in photography's history.

We cannot begin to understand the history of photography by looking at or reading histories of photography. Most surveys repeat the ideas, prejudices, and even the images of other books. Scholarship that primarily relies on the ideas of other scholars will always be secondhand and can never be any better than the borrowed material. At the opposite pole is that work which relies on nothing but its author's fertile imagination. The most fascinating conjecture is worthless if it is not founded upon fact. It is only from a study of primary source materials that we can begin to see what the history of photography actually looked like, and there is no way to do that other than by studying the various European and American reviews, journals, annuals, exhibition lists, and photographic publications during a certain period. Such study will begin to reveal something of the look of the photographic art of that time. Insight in the visual arts must always first be the result of ordinary sight.

When we begin to look into the non-Stieglitz publications of the pictorial period, we find many of the same photographers in both: Stieglitz, Steichen, Kühn, White, Käsebier, the Hofmeisters, Demachy, etc. What is striking, however, is all the less familiar names we see year after year and in publications from a number of different countries — names like Edouard Hannon, Maurice Bucquet, Otto Scharf, Eduard Arning, Paul Bergon, and Rudolph Dührkoop. Hannon was one of the greatest masters of light that photography has known. No one ever made street scenes greater than Bucquet's. Scharf's and Arning's work was always brilliant and expressed amazing versatility. Bergon is uneven — his nudes can be as saccharine as Demachy's and Puyo's at their worst — but at times he is absolutely brilliant. And Dührkoop was simply one of the finest portraitists that photography has produced.

The work of this period is so rich that there is no way I can do it justice in a single essay, especially considering the photographers I had to omit — most notably Georg Einbeck, Pierre Dubreuil, Heinrich Wilhelm Müller, Hugo Erfurth, Charles Job, James Page Croft, and A. Böhmer. Dubreuil and Erfurth have had books devoted to them, and Einbeck's great *Das Schweigen* has been reproduced many times. But what a shame there are no monographs on Einbeck, Müller, Job, Croft, Böhmer, Hannon,[1] Bucquet, Scharf, Arning, Bergon, Dührkoop, or even

those *Camera Work*-ers Hugo Henneberg, the Hofmeister brothers, and George Davison, about whom one would certainly expect them. There is no field in photohistory so ripe for research and so rich with potential reward as this period.

Many of the artists were clearly influenced by Symbolism, especially Hannon and Einbeck, though probably not to the degree that Americans such as Steichen, Seeley, Coburn, Day, Hanscom, Käsebier, and White were. Symbolist photography seems to have been more of an American art form than a European one, while Symbolist painting was more European than American. Much of the European work of this period does clearly appear to be "pictorial" by any definition of the word. And some of it, even as late as 1900, simply looks lovely but old-fashioned, like portraiture and scenic photography of the 1880s. The sixteen artists that I have chosen to look at, with the exception of Mazourine, some of whose work looks like sentimental Russian genre scenes, were all completely caught up in the artistic style that dominated turn-of-the-century photography, the style from which we derived the idea of "artistic photography," as misleading as the term might be considering that photography was artistic from its earliest beginnings.

In "American Symbolism: Visions of Spirituality and Desire" I wrote that "Edouard Hannon's landscapes (plates 75 – 77) are all deeply spiritual images. They are destinations, places one would want to find, the ends of quests. We look at them and know the Grail lies waiting within because this is the place at which we have always wanted to arrive." Hannon's work and the work of a number of the European masters seem to present such magic landscapes. They are not places we have ever seen before, but they seem familiar. It is the same in Alexandre's (plate 78), Pompejani's (plate 79), Arning's (plate 80), and Warren's (plate 81) work. In some cases they seem familiar because, as in Arning's trees or Warren's *Estuary*, they are abstracted images, things we have seen but in their larger, less magical context. Arning and Warren lifted these scenes from their surroundings—just as photographers are always doing—thereby giving them more meaning and making us see something as magical that we normally would pass over. Of course, Hannon's *After the Storm* is pure magic. It is one of the most remarkable photographic images I have ever seen. It seems both negative and positive, a solarized effect Hannon created by radical manipulation of the tonal properties. This is great work, and there was no greater photographic master of light and its manipulation during this period than Hannon.

Edouard Hannon (1853 – 1931) became one of the founding members of the Association Belge de Photographie in 1874. He went on to take a diploma in engineering in 1876, traveled worldwide in his work, lived in Brussels in a house designed by Brunfaut and decorated by the great Symbolists Emile Gallé and Louis Majorelle, and collected modern Belgian paintings, which of course were among the finest products of Symbolist art. He was clearly a man in tune with the *zeitgeist*, and his own work illustrates that fact.

Alexandre (1855–1925), whose complete name was Alexandre Edouard Drains, was also a member of the Association Belge and lived most of his life in Brussels. He too had ties to the Belgian Symbolist movement and for over ten years worked with Fernand Khnopff photographing his paintings. He was elected to the Linked Ring, the English artistic photography association, in 1893.

About Aldo Pompejani and W. J. Warren virtually nothing is known. Pompejani was active between the 1890s and the 1930s and worked in a variety of processes. His work changes from Symbolist-pictorial to Modernist-pictorial. He was still exhibiting in Rome as late as 1933. Horsley Hinton, one of the greatest of the English artistic photographers, makes but a passing reference to Warren as "a writer on artistic subjects" in his essay "English Landscape Photography" in the English landscape issue of *Die Kunst in der Photographie* that Warren's photograph appears in. In 1898 Warren published *A Handbook to the Gum-Bichromate Process* and the following year *A Handbook of the Platinotype Process*.

Eduard Arning (1855–1936) was a Hamburg physician whose work regularly appeared in the leading German photographic publications. His powerful gum print factory scene *Hüttenwerk* was impressive enough for Ernst Juhl to reproduce it in the catalogue accompanying the Tenth International Exhibition of Art Photography in Hamburg, an exhibition that included all the major European and American photographers.[2]

Ernst Juhl was this period's great theorist of artistic photography, art editor of the *Photographische Rundschau*, founder of the Society for the Advancement of Amateur Photography in Hamburg, organizer of the international photographic exhibitions at the Hamburg Kunsthalle from 1893 to 1903, and Steichen's first real champion, though photographic history would suggest that it was Stieglitz. Stieglitz met Steichen in 1900, purchased three prints for five dollars each, and published a single image in *Camera Notes* in 1901. Steichen's first exhibition opened in Paris the following year amid great controversy over his manipulated Symbolist prints. Juhl, however, was excited by the work, gave the entire July 1902 issue of the *Rundschau* over to Steichen, published ten photographs from the Paris exhibition,[3] some of which have still never been reproduced elsewhere, and wrote an article on him in which he called Steichen "a pathfinder." That celebrated issue was so controversial and there were so many threats of cancellations if the magazine continued on such an artistic course that the September issue opened with a letter "To Our Readers" announcing Juhl's resignation over the "storm" the Steichen pictures had caused. However, Juhl was unstoppable; the following year he published a book on the camera art of modern times with a frontispiece by Steichen, an essay by Steichen, and four other Steichen images.[4] In April of 1903 Stieglitz published ten of Steichen's images in the second issue of *Camera Work*.

Juhl, like Stieglitz, was also important as a collector. The 6,000-image collection, now divided between Hamburg and Berlin, is the largest and finest Euro-

pean collection of Secession photography. Juhl's collection, as Janet Buerger put it, "restores the balance to Stieglitz's bias." As she wrote, "Juhl amassed not only the work of the major European and American protagonists of art photography but those of Americans . . . whom Stieglitz did not foster. Juhl also collected the classicizing, the religious, the expressionist and the European Symbolist pieces omitted by Stieglitz from the American Photo Secession."[5]

Among the most common imagery in European Pictorialism is the magic landscape, which always seems positive and a place one might want to be. It tends at times to merge into a more mysterious kind of landscape, not, however, the brooding ones I described as common to the American Symbolist photograph. Warren's *Estuary* leads the way into the misty, not exactly uncomfortable, but strange and tentative realm of Ralph Robinson's *Mist on the Thames* (plate 82), Andrew Pringle's *Night on a Norwegian Fjord* (plate 83), Paul Bergon's *The King's Daughter* (plate 84), Alexandre's *Fisherman* (plate 85), and Gatti Casazza's *Evening, Lake Como* (plate 86).

The work of Ralph Robinson (1862 – 1942), son of Henry Peach Robinson and one of the founders of the Linked Ring, has been greatly overshadowed by that of his more famous father. Much of his work is as trite as his father's. Stieglitz even published one of these horrors, *Old Cronies*, a photograph of two old women talking to each other, in *Camera Notes* in 1900, yet by this time Ralph Robinson had produced work far in advance of its time. His *Mist on the Thames* was exhibited in 1894 at the first of the four great exhibitions staged by the Photo-Club de Paris. It's an amazing work; it looks like Coburn fifteen years later. It could easily be from Coburn's 1909 book *London*. Its radical cropping of details in the foreground, its large open areas, its misty, soft quality make it a unique vision and a unique work for its day. It was by far the finest work in the 1894 exhibition, an exhibition in which the great Modernist Alfred Stieglitz was represented by *The Card Players*, a photograph as trite and sentimental as H. P. Robinson's work, a retrograde image that looks back to the worst of genre scene photography.

I am unaware of any published images by Andrew Pringle other than the one here reproduced, or of anything that has been written about him. He wrote two books on the magic lantern and lantern slides, a book on photomicrography, the text for the H. P. Robinson issue of *Sun Artists*, and a book with W. K. Burton on *The Process of Pure Photography*. None of these enterprises could give any hint of the capacity to produce a photograph as startling as *Night on a Norwegian Fjord*. It looks like a Japanese print; in fact, it must be the earliest example of *japonisme* in photography. Here again is another characteristic Coburn quality but ten years before Coburn.

Paul Bergon (1863 – 1912), René Le Bègue's uncle, was one of the major French photographers of his time. He was a member of the Société Française de Photographie and the Photo-Club de Paris, and was both a musician and a biologist. The strange and beautiful image *The King's Daughter* was only published in

Germany and under the title *Die Königstochter*. It appears to be a mysteriously Symbolic work, and its narrative, if there is one, is possibly drawn from some myth; however, without the original French title one wonders, especially considering the presence of the reeds, if it is not supposed to be Pharaoh's daughter and *Königstochter* was simply a bad translation. But whatever the case, it is like Alexandre's and Gatti Casazza's photographs — magical, haunting, and mysterious but by no means intimidating.

It was not just the landscape, however, that the European Pictorialists celebrated in their work but also the beauty of modern city life. A number of photographers were producing such imagery in the nineties, but Stieglitz was probably the first and did so as early as 1893. By the second half of the decade we can see that kind of image in George Davison, Étienne Wallon, Maurice Bucquet (plates 87–89), Otto Scharf (plate 90), and others. It is a very different kind of vision from earlier cityscapes and represents a deliberate attempt to define modern city life as something beautiful, even seemingly unattractive aspects such as rain, snow, steam, fires, and crowding. It took late-nineteenth-century artistic photography to see such things as that, but it was a vision that did not last long.

It had clearly changed by 1910 and the publication of Coburn's *New York*. Here too was beauty, but it was the beauty of abstract geometric design. What Coburn captured and was perhaps the first photographer to record were those shapes Whitman called out to arise, those shapes of the modern world. What Stieglitz, Bucquet, Scharf, and Davison recorded, though in a sense a paean to the modern world, seems to our eyes a bit too nostalgically beautiful, a bit sentimental, even a bit patrician. They make us think of the beautiful paintings by Gustave Caillebotte or Childe Hassam. But, of course, nothing is wrong with that. Beauty can be its own justification, as I argue in "The American Autochrome."

Maurice Bucquet (1860–1921) was the founding president of the Photo-Club de Paris, a member of the Société Française de Photographie, the Linked Ring, an editor of *La Revue de Photographie*, and a corresponding member of Gesellschaft zur Förderung der Amateurphotographie Hamburg; in other words, he was as involved with the European photographic community as intensely as anyone of his time. He made many photographs of street life, all beautiful but none perhaps more wonderfully photographic than *The Effect of Rain* (plate 88), depicting an empty Parisian café in the rain. It is difficult to imagine this work being visually conceived in any way other than through a wedding of the camera's eye and the artist's eye. Bucquet's *Rainy Day in Paris* (plate 89) is also beautiful, but it does look like Caillebotte. *The Effect of Rain* looks like no painting, print, or drawing I am aware of. Its dazzling display of light is a purely photographic moment, the kind of scene that might never have been seen without a camera.

The work of Otto Scharf (1858–1947) is seen again and again in the publications of this period. In Juhl's first Hamburg exhibition in 1893 Scharf was represented by fifty-three works and fourteen in 1903, the last of Juhl's exhibitions,

an exhibition in which only Dührkoop, the Hofmeister brothers, and Müller had more and in which Steichen had twelve.

These celebratory views of city life can be seen carrying over, or perhaps it's the other way around, into celebrations of the individual, individual beauty and individual moments. Mazourine's (plate 91), von Gloeden's (plates 92 and 96), Rudolph and Minya Dührkoop's (plate 93), Brémard's (plate 94), Diesler's (plate 95), and Bergon's (plate 97) work all seem joyous evocations of ideal moments or of individual beauty.

Alexis Mazourine (1846–1911) was one of the few Russian photographers whose work was as internationally known as the leading German, French, English, or American photographers of this period. His work was particularly well known in Germany, and he also was a member of the Hamburg Gesellschaft zur Förderung der Amateurphotographie and published in the German journals of the time. His *In Summer* is an excellent expression of the aesthetic of the time; it looks like work by Albert Schaaf, Rudolf Eickemeyer, and many other artistic photographers, but none produced a lovelier variation on this theme than Mazourine did.

Wilhelm von Gloeden (1856–1931) was not collected by Juhl but was published three times by Stieglitz in *Camera Notes* and in quite a few other respected journals and magazines, including even the *National Geographic*, for which Mrs. Alexander Graham Bell supplied her own von Gloeden prints! What is one to make of von Gloeden? A great deal is certainly made of him today, more than ever before. In fact, more books have been produced on von Gloeden than even on Stieglitz. If current recognition and publication were taken as the test of importance, von Gloeden would have to be seen as the most important photographer of the period. Most of his current popularity has to do with the gay imagery of his work not its artistic quality, which is not to say that it is not also artistic. The untitled portrait study (plate 92) is as beautiful and artistic as any European portrait from this period; it might not have the powerful Symbolist qualities of Steichen's, Coburn's, or Seeley's portraits, but it is a seductive and celebratory vision, as is plate 96. Of course, what's being celebrated might be troublesome to some—and I'm not referring to homosexual passion but about sex in general. It is a theme we have not taken well to in photography, witness the debates of the past decade. If a photograph is obviously erotic, it is suspect as art. This is not the case nor has it historically been the case with literature, painting, sculpture, and even dance, so long as it's the product of a "primitive" culture.

But sex can never be divorced from art, for art has only three subjects: sex, death, and God, or since the late eighteenth century Nature, which usurped God's position. Everything else is merely a variation on or an entwining of those themes. So why should eroticism in photography be more troublesome than it is in the rest of art or in life itself? Why is that fraction of a second reality that once

existed and was recorded on film more troublesome that a nude model suggestively posed for hours? Why can we accept paintings of a swan having sexual intercourse with a woman but not photographs of a man and woman doing the same thing, or two men, or two women?

We are as troubled by sex as we are by death and by God—their power is too mysterious and so we've made them the subjects of our art but also made them—or aspects of them—into our taboos. What we cannot deal with we both glorify and demonize. Still, why is what might be tolerable in painting intolerable in photography? It obviously has to do with the way photography is perceived as a true and accurate recorder of reality, which of course it isn't. The current debate over Jock Sturgis's and Sally Mann's use of children in their sometimes sexually charged images is not a debate we should be involved in anymore than we should be involved in a debate with an artist about his or her use of a model. It is not *our* business. It is a matter between artist and sitter, and if the sitter is truly a child—I am not speaking of an eighteen- or even sixteen-year-old adult—then it is a matter for artist and parents to deal with, just as Lewis Carroll and his sitters' parents dealt with it. We are living in the world's most protective and parental society: it guards us against injury by ordering adult bikers to wear helmets and adult passengers to buckle up; it tries to protect adults from smoking, eating, and drinking what they might choose to; it legislates what adults may or may not do in their own bedrooms or grow in their own gardens; and it constantly pushes up the age of adulthood. In the Middle Ages the Church recognized that a girl of twelve was at the age of consent; today we would define the culture that built Chartres and Canterbury and produced the *Summa Theologica* as pedophile.

Rudolph Dührkoop (1848–1918) and his daughter Minya Duhrkoop (1873–1929) were the greatest German masters of portraiture during this period. They produced work both separately and together. Their *Portrait* (plate 93) is a highly manipulated gum print on which brush marks are clearly visible. In fact, it looks far more like a charcoal drawing than a photograph and is suggestive of much of the manipulated work of this period. Rudolph Dührkoop was a member of the Linked Ring and won the 1899 gold medal at Hamburg, as well as many other awards and distinctions, including a one-man show at the Royal Photographic Society in England in 1909. Rudolph and Minya Dührkoop's work was widely written about—even by Sadakichi Hartmann—and published worldwide, especially in the United States in *The American Annual of Photography*.

About Maurice Brémard (active 1892–1907) and Betty Diesler, little is known. Brémard was a lawyer, painter, and photographer, and a member of the Photo-Club de Paris and the Linked Ring. Diesler's *Study* is apparently her only published work.

In looking at such remarkable images one wonders repeatedly how such art and ability got lost in the history of photography. There are, of course, several

reasons — the influence of Stieglitz, the historical accident that Germany lost World War I, the loss of a generation of Europeans, the modernistic direction photography took both in Europe and in the United States. The loss of young artists for so stupid and senseless a war may not actually have been a major reason, but it certainly is the most poignant. In issues of the *Photographische Rundschau* from directly before and during the war one sees names never heard of again. There was also extensive writing about the autochrome between 1907 and 1914 in all the European photographic journals. It fell off dramatically during the war and then began again in 1920 with some of the same authors writing; however, there were individuals who had for years annually published on the autochrome whose names are never seen again. And it is not difficult to imagine what happened to them.

But the most profound reasons for the loss of much of photography's history have to do with the taste of Alfred Stieglitz, a blind, ignorant inheritance of that taste, and its subsequent propagation in the work of Beaumont Newhall and later American photographic historians. No one can deny Stieglitz's true greatness or importance, but it has become a critical cliché to offer unreserved praise for all of his work, especially his highly *self*-touted cloud studies, many of which we should be honest enough to say are not masterpieces of abstraction but are rather pedestrian, occasionally muddy cloud pictures. Stieglitz *was* a master photographer, but he was not always brilliant nor was he Moses pointing the way to the Promised Land. A lot of photographers knew exactly where the Promised Land of Photography lay and didn't need Stieglitz to show them. However, that is not what one might think from the picture that photographic history seems to present of him.

It is clear from his writing and transcribed conversations that Alfred Stieglitz was by no means a likable human being,[6] but no one's artistic reputation should suffer because of his unpleasantness, his ego, or his politics. It is the height of provincialism to demand that our artists ascribe to our ethics. Of course, when those ethics are based on certain relatively recent Romantic assumptions about the rights and nature of man and, more recently, of woman — assumptions we hold as creed — even the most logical of us are occasionally blinded by the gentle but fierce shades of Locke, Rousseau, Jefferson, Wilberforce, Marx, Shaftesbury, Anthony, Pankhurst, Goldman, and all those other men and women of good heart we have so rightly come to revere.

But Alfred Stieglitz was no man of good heart. In an essay entitled "How I Came to Photograph Clouds" he wrote, "I knew what I was after. I had told Miss O'Keeffe I wanted a series of photographs which when seen by Ernest Bloch (the great composer) he would exclaim: Music! music! Man, why that is music! How did you ever do that? . . . And when finally I had my series of ten photographs printed, and Bloch saw them — what I said I wanted to happen happened *verbatim*."[7] Such cant, such transparent lies, like so many of his other equally

pompous public statements, would have been set by a Molière, as they so often were, not in the mouth of an artist but in the mouth of a fool, the kind of fool an audience would have laughed at mercilessly. But the audiences of Molière had not yet been tutored by the Romantic spirit. Romanticism made antisocial behavior acceptable if it was perpetrated by an artist, and over time Romanticism's adoration of creativity made us become as tolerant of an artist's vision, even if it was empty and shallow, as we were of his or her behavior. The twentieth century did not give us any true Byronic figures, and now after the Somme, after the sadistic lunacy of Nazism and the broken promise of the Soviet state, in these final days of the century and probably of Romanticism as well, we find ourselves left with the best our time could manage — artists, heroes manqué, the Stieglitzes, the Ezra Pounds, the Igor Stravinskys — geniuses, but intolerable, strutting geniuses.

Maybe they should have been laughed at when they sounded like fools, but they weren't, and because they weren't, they probably helped precipitate the mindless acceptance of any individual as an *artist* merely because the person has so styled himself or herself. They also helped precipitate an accompanying, though minor, social problem: the toleration of intolerable behavior from someone just because he or she claims to be an artist.

There is no avant-garde today, and there hasn't been for over eighty years. There is no artistic or intellectual time lag between the artist and the public at the end of the twentieth century. But because there was at the beginning of the century, because Stieglitz and Pound and Stravinsky had to instruct our ears and eyes and help them catch up with what was happening, we are now intimidated by *con artists* who would have us believe we simply cannot understand their productions because they are so brilliant and we are so dull. The poetry-reading or gallery going or concert-listening crowd concludes, "It's probably better than I could do, so I shouldn't criticize it." To a similar observation Dr. Johnson, one of the most levelheaded critics in any time, replied that such an idea was rubbish. He said that he, not being a carpenter, might not be able to make a table, but that did not keep him from telling a poorly made one from a well-made one.

But of course Stieglitz, Pound, or Stravinsky will not be the ones to blame when at some point in the future everyone looks back at all the naked, strutting emperors and empresses and snickers at all the *art* that wasn't there: the mountains of volumes of poetry no one but the author, the author's mother, and the author's lover ever read more than once; all the paintings that never forced an eye to return to them; and the heaps of scores of solid dissonance that those who love music closed their well-tuned and modern ears to. The propaganda machines our heroes created are, unfortunately, still churning out bad art, but it is important to remember that neither Stieglitz nor the others ever praised effect over substance; it took a later generation to discover that effect alone was far easier to create. Fortunately, Stieglitz's real legacy will be what he loved — the art

he made and helped others to make. And for all his vanity, there was none in having done that. As Pound said in his great Canto LXXXI:

> *What thou lovest well remains,*
> > *the rest is dross*
> *What thou lov'st well shall not be reft from thee*
> *What thou lov'st well is thy true heritage. . . .*
> > *Pull down thy vanity, I say pull down.*
> *Learn of the green world what can be thy place*
> *In scaled invention or true artistry,*
> *But to have done instead of not doing*
> > *that is not vanity . . .*
> > *To have gathered from the air a live tradition*
> *or from a fine old eye the unconquered flame*
> *This is not vanity.*
> > *Here error is all in the not done. . . .*

Past, Passing, or to Come

The Conceptual Songs of Jerry Spagnoli

ὁ ἀνεξέταστος βίος οὐ
βιωτὸς ἀνθρώπῳ

There is something about the actual, physical quality of certain daguerreotypes that can be nearly overwhelming, and it's a quality, a beauty, having nothing to do with the looks of the sitter or the subject. They stop you; they hold you; they make you come back to them. That, of course, is what art does to us; it's the way art affects us: it stuns us and never lets us forget it; it demands that we return to gaze again and again. But that is also what the Medusa demands, because these are the same attributes of the awe-full. Beauty and horror have the same pull. The Beautiful and the Awful are the twin faces of the Janus of our desire.

One reason that daguerreotypes inspire awe is that they are more than works of art and our response to them is not completely an aesthetic one. They are reliquaries of light, strange cultural artifacts that occupy a unique place between the worlds of truth and beauty, a place that combines factuality and aesthetics. They resemble art, and we treat them as we treat art; however, their true place is between the fact and the crafted object, a place not unfamiliar in literature but rare in the visual arts, a place that combines reportage with art and melds the world of the document to the world of the painting. No contemporary daguerreotypist knows this better than San Francisco conceptual artist Jerry Spagnoli, a painter, sculptor, draftsman, constructor, photographer, and daguerreotypist.

Art distances itself from us and allows us to distance ourselves from it. But that is not possible with the daguerreotype. In most works of art there are imaginative spaces between the object and the viewer, spaces created in that very act of their making. But with the daguerreotype there is no such distance and nothing between the object and the viewer but time. And this is not a characteristic peculiar to all photographs. Most have at least something of the distance of

paintings because of the intermediacy of the negative and the mechanics of the darkroom — steps, spaces, distances, between the actual reality and the object representing it. However, with the daguerreotype what we are seeing in a portrait is that actual reality, not a *creative* transformation, not a *creative* act but a dual act of craft — Daguerre's crafted production of an optical and chemical reaction, and the individual daguerreotypist's craft of lighting, posing, and developing. But it is a combined act of extraordinary craft, and the results are so moving, so palpable, and so like art in every other way that we are struck with awe! And we are touched as we are by the touch of art!

But this very daguerreotype that so moves us is actually more artifact than art, an object more akin to a reliquary than a painting. All photographs to some extent are stolen moments, postmortems, *memento mori*, holding, like reliquaries, little bits of what we were. We can glimpse the skeleton leering out from every portrait, and we know that every snapshot in our scrapbook or album is the reminder and proof that we, too, are aging. We also know that everyone in every daguerreotype is now dust, but because of the daguerreotype's ability to record the lips, the hair, the eyes with such intense sensuousness, the knowledge that all this is now decay, dust, nothing at all is both poignant and chilling. And so the daguerreotype not only inspires awe but literally partakes of the Awful — as well as the Beautiful. Few objects in the history of mankind's making of things are so universal. The daguerreotype is as Janus-faced as our desire, and it is our own enigmatic desire, the thrill of our fears as well as our lust, that we see when we look into its glaring silver.

Among contemporary daguerreotypists there are many fine artists and several true masters of the process, individuals like Irving Pobboravsky, Patrick Bailly-Mâitre-Grand, Kenneth Nelson, Gerard Meegan, and Robert Shlaer.[1] Jerry Spagnoli, who has been making daguerreotypes only since 1991, is, however, clearly another of the modern masters. Spagnoli, like Bailly-Mâitre-Grand, comes to the process and to photography from the world of the artist. Photography and daguerreotypy are simply two of a variety of forms of expression his art takes. Spagnoli's work can be as traditional, beautiful, and impressive as that of any of the other modern daguerreian masters. His *Panorama* (plate 98), seven half plate daguerreotypes measuring forty-two by six and a half inches, and his *Seascape* (plate 99) are not only dynamic and powerful images but tours de force of the daguerreian art simply because of their grand formats. Few contemporary daguerreotypists have chosen to work on such a scale, and none more successfully. But what Spagnoli brings to the process that no one else does is the inventive, playful eye of a Joseph Cornell, a Marcel Duchamp, or a Man Ray, an eye that can see the daguerreotype as one element of a larger artistic complex.

Daguerreotypes, as I said, are more than works of art and our response to them is more than aesthetic. Spagnoli knows this and manipulates both the daguerreotype and the viewer to emphasize this fact. He won't let us forget it and

in so doing intensifies our aesthetic response and creates a sense of absolute wonder. He, better than any other artist working with daguerreotypes, knows they *are* reliquaries of light, that they *are* strange artifacts floating somewhere between the worlds of truth and beauty, factuality and aesthetics. And he manipulates their oddity like no one else ever has.

He magnifies their reliquary-like quality by pushing them into the world of sculpture and construction. Perhaps his most amazing work is his series of *Reliquaries* (plate 100). These are large, beautiful, handmade planchonia wood boxes nine by nine by ten inches with an opaque glass sheet of glass set into the top of each. From the front all one sees is a brass drawer pull and a peep hole. If the drawer is open, one finds a half plate daguerreotype of a flower, which in every case is a fresh, vibrant, and beautiful image. Looking into the peep hole, one sees the actual mounted flower Spagnoli daguerreotyped but now dead and, though completely sealed, drying out. We know that in a century or so it will be dust, just as are all the individuals in old daguerreotypes, and that though the flower's physical body or form is preserved in the reliquary, its *real* form is preserved on the daguerreotype plate in a reliquary of light.

Spagnoli has created other daguerreian sculptural constructions, including a box containing both a daguerreotype of a seascape and a square foot of ground from the site where the camera was placed and *A Machine for Destroying Daguerreotypes*. The *Machine* was exhibited at the Oakland Museum in 1995, then removed from exhibition when a member of the museum staff became convinced that it was creating a "deadly poison," and then later reinstated. The construction contained a daguerreotype of a flower suspended under a bell jar. Also under the glass but on the wooden base was a mulch made of the plant the flower came from and a small cup of sulphur. Next to the base was a dropper bottle containing water. The mulch decays and produces gases that eventually tarnish the plate. Fitted to the top of the wooden base was a pipe through which a few drops of water could be added to maintain the process, and the sulphur was added to help nature along. The title actually refers not to the apparatus but to time itself.

As inventive, humorous, and finally as poignant as Spagnoli's *Machine* is, his most brilliant construction is *Explosion* (plate 101), which he says is another kind of reliquary and is for him the very metaphor for the creative act, as well as a statement on mortality. It is an extremely elaborate artifact created by the briefest event in time. The quarter plate daguerreotype contained in the drawer in the face of the box records a small explosion that took place on top under the aluminum. The top of the box preserves the actual form of the explosion in the anodized aluminum sheet, and secreted under the drawer is the spent shell. The box is of birch and measures ten by ten by eleven inches.

Spagnoli is presently working on a series of sixteen of these which will be presented together entitled *A Pack of Firecrackers*. About this work he has written:

"First the form of the box is intended to resemble a pedestal upon which one would normally expect to find a statue or bust of some notable individual; what you find instead is the spent form of a burst of energy. Inside the pedestal you find a further artifact of the event whose form was captured on top. The light is the deeper secret of the burst, and it is captured on the most notorious medium for communicating proximity to an event, the daguerreotype. . . . What you have is an elaborate object generated by an event, a freestanding aesthetic format, the shadow of an event long gone and privately experienced." Spagnoli argues that this is his way of presenting mortality and creativity, both of which he says are "intense private experiences which can only be shared with formal devices" because "the event itself cannot be held."[2]

Though Spagnoli is very much the conceptual artist, every detail and formal aspect of his work is both beautiful and perfectly crafted. In fact, it is for beauty's sake he turned to the daguerreotype, for "the easy seductiveness of the plate itself," as he puts it. He wants his work to be visually entrancing, wants it to captivate the viewer's eye so that the second, the third, and subsequent viewings of the work might begin to reveal the conceptual underpinnings, which to him are essential and are the actual *raison d'être* of his art. Spagnoli uses beauty to undermine truth. He feels we as a whole are still in the grip of nineteenth-century notions of truth's objectivity and that though no serious thinker might still think, as does Mr. Gradgrind in Dickens' *Hard Times*, that the accumulation of facts leads to truth, the predictability of behavior, or the betterment of humanity, it is a notion that still haunts society. In Spagnoli's hands, then, the camera, the fact-catcher, a machine which might for some seem the epitome of objectivity, becomes an agent for suggesting truth's subjectivity.

Habitat: Icon / Text (plate 102) is an excellent example of Spagnoli's subjectifying of the seemingly objective and creating a beautiful object at the same time. It is from a series of half plate daguerreotypes of wooded areas, each from a different habitat: a redwood forest, an English lake, a fern forest, a marsh, a eucalyptus grove, and so forth. All, however, were made in Golden Gate Park, a park laid out by John McLaren in the 1870s. At that time the land it presently occupies was sand dune and chaparral. McLaren created a park that had embedded in it a series of idealized landscapes which would provide the casual stroller an aesthetic encounter with nature but not real nature. This is nature made, shaped, and determined by man, nature as we would have it. Spagnoli set out to find those perfect idealized bits set into the landscapes, extract them onto the daguerreotype plate, thereby concealing their origins, and present them as "natural" nature. The daguerreotype, that very medium Robert Vance, the first great California daguerreotypist, claimed gave "no exaggerated and high-colored sketches, got up to produce effect, but . . . the stereotyped impression of the real thing itself,"[3] has been subverted by Spagnoli. What he has captured is not "the real thing itself" for there is no *real thing* — only a nineteenth-century simulacrum.

William Butler Yeats, this century's greatest poet and possibly our greatest prophet as well—we shall soon find out—wrote in "Sailing to Byzantium" of the form and power of artifice, of "such a form as Grecian goldsmiths make / Of hammered gold and gold enamelling," a form with the power "to sing / Of what is past, or passing, or to come." This is the song of Spagnoli's work, and its possibly prophetic final verse is not reassuring. The image from *The Vanished World* (plate 103) is part of an ongoing series designed to be shown at the turn not of this century but of the next. The outlandishness of the idea after a moment or two fades as we begin to contemplate the idea, to contemplate the world then, the audience, and even whether there will be an audience.

We may no longer be worried about bombs, but the newest research in both France and England indicates a radical decline among males in sperm count since 1970. It is taking place at such a rate and with such dramatic annual decline that serious infertility problems are predicted for the next century. It is thought that the culprit may be food preservatives, in which case Spagnoli's image may be prophetic in more ways than one. The European-American-Japanese industrial world may preserve itself into extinction, but the Third World seems to be flourishing. The world that is vanishing in Spagnoli's *The Vanished World* may very well be what we so symbolically see in the image itself—our Eurocentric industrial world but at its core, at its very heart and center, the principles of Greek humanism. The image may literally be The California Bank, and even with its name backwards because of the nature of the daguerreotype process, but its truth is something else; its truth is the classical tradition, and though it may be symbolized by a Corinthian column, it is not about architecture. It is about ideas—the idea that the unexamined life is not worth living; that it is our duty to know and to question ourselves; and that we finally are the measure of all things—three ideas that find themselves in radical conflict with more than one Third World philosophy, three ideas that by the time of Spagnoli's 2099 exhibition may also be part of *The Vanished World*.

Notes

AMERICAN DESTINY OR
MANIFEST MYTHOLOGY

1. Quoted in Alonzo Delano, *Life on the Plains and at the Diggings*, chapters 20 and 21, in *Pictures of Gold Rush California*, ed. Milo Milton Quaife (Chicago: R. R. Donnelley & Sons Co., 1949), p. 287.

2. Henry A. Boller, *Among the Indians: Eight Years in the Far West, 1858–1866*, ed. Milo Milton Quaife (Chicago: R. R. Donnelley & Sons Co., 1959), p. 426. Subsequent references will appear in the text.

3. *Journals of Forty-Niners: Salt Lake to Los Angeles with Diaries and Contemporary Records of Sheldon Young, James S. Brown, Jacob Y. Stover, Charles C. Rich, Addison Pratt, Howard Egan, Henry W. Bigler, and others*, ed. LeRoy R. Hafen and Ann W. Hafen (Glendale, Calif.: Arthur H. Clark Company, 1954), pp. 20–21.

4. *The Footprints of Time: And a Complete Analysis of Our American System of Government* (Burlington, Iowa: R. T. Root, Publisher, 1874), pp. 8–9.

5. Bancroft, pp. 260–61.

6. Alvin M. Josephy, Jr., ed., *The American Heritage Book of Indians* (New York: American Heritage Publishing Co., 1961), p. 247.

7. Josephy, pp. 187 and 247.

8. Joseph Glover Baldwin, *The Flush Times of California*, ed. Richard E. Amacher and George W. Polhemus (Athens, Ga.: University of Georgia Press, 1966), p. 43. Subsequent references will appear in the text.

9. Josephy, p. 246.

10. *Turtle Island Alphabet: A Lexicon of Native American Symbols and Culture* (New York: St. Martin's Press, 1992), p. 24.

11. *Jefferson's Instructions to Lewis* in *Original Journals of the Lewis and Clark Expedition, 1804–1806*, ed. Reuben Gold Thwaites (New York: Arno Press, 1969), VII, 250.

12. According to a note in the case, plate 1 is a portrait of George C. Baumford "as he appeared on the Ranch in his Buck-Skin Suit." It was taken "in 1853 – time we established our cattle ranch at 'Wyeletpou' Walla Walla Valley." Wieletpu was an earlier name for the city of Walla Walla, Washington. An additional note records that Baumford was "Driven from the County by Indians in 1855" and that he died in Florence, Italy. Plate 2 is a portrait of a Dragoon scout from the early 1850s. According to John N. McWilliams, an expert on the Western image and the owner of this image, "The blue Dragoon Army cape, from the Dragoon Great Coat of the period and the Gauntlet gloves plus the buckskin coat all suggest that this man had both a military and a frontier affiliation ... all [of which] points to this person being a Dragoon Scout." During the 1850s the Topographical Engineers were mapping the frontier and looking for a suitable route for a transcontinental railroad. The Engineers were led by a company of Dragoons, who in turn were led by a scout. Because there were very few such guides during this period, McWilliams' research has led him to conclude that this is possibly a guide by the name of William Potter who worked for Engineer Captain John Williamson Gunnison. Gunnison had the task of finding a railroad route through Utah, but his expedition was wiped out by Indians in October 1853. On his shoulder one can see the pony beads and tassel, and the pouch at the lower left of the image was probably for tobacco. Plate 3 is identified as a portrait of Lyman Alvinson Rundell, whose fancy miner's shirt shows both a crossed pitchfork and shovel and a miner, though upside down, leaning on a shovel. For other similar portraits of miners and life in the West, see Drew Heath Johnson, "Silver & Gold: A Preview of Cased Im-

ages from Northern California Collections," in *The Daguerreian Annual* 6 (1995), 75–113.

13. Luzena Stanley Wilson, *Luzena Stanley Wilson '49er: Memories Recalled* (Mills College, Calif.: Eucalyptus Press, 1937), p. 2. Subsequent references will appear in the text.

14. Vincent Geiger and Wakeman Bryarly, *Trail to California: The Overland Journal of Vincent Geiger and Wakeman Bryarly*, ed. David Morris Potter (New Haven: Yale University Press, 1945), p. x.

15. Étienne Derbec, *A French Journalist in the California Gold Rush*, ed. A. P. Nasatir (Georgetown, Calif.: Talisman Press, 1964), p. 153. Subsequent references will appear in the text.

16. Delano, p. 275.

17. Alfred Doten, *The Journals of Alfred Doten, 1849–1903*, ed. Walter Van Tilburg Clark (Reno: University of Nevada Press, 1973), I, 207. Subsequent references will appear in the text.

18. George D. Dornin, *Thirty Years Ago: Gold Rush Memories of a Daguerreotype Artist*, ed. Peter Palmquist (Nevada City: Carl Mautz Publishing, 1995), p. 2. Subsequent references will appear in the text.

19. George W. B. Evans, *Mexican Gold Trail: The Journal of a Forty-Niner*, ed. Glenn S. Dumke (San Marino, Calif.: Huntington Library, 1945), p. 240. Subsequent references will appear in the text.

20. *Gray's Poems, Letters, and Essays* (London: Dent, 1966), p. 106.

21. Reuben Cole Shaw, *Across the Plains in Forty-nine*, ed. Milo Milton Quaife (Chicago: R. R. Donnelley & Sons Co., 1948), pp. 118–19.

22. Geiger and Bryarly, pp. 94–96.

23. Her strength and independence extended even further than never mentioning her husband's name. When worried about Indians at one point, she wants

to join with the camp of the "Independence Co." with its "five mule-teams, good wagons, banners flying, and a brass band playing. They sent back word that they 'didn't want to be troubled with women and children; they were going to California.' My anger at their insulting answer roused my courage, and my last fear of Indians died a sudden death. 'I am only a woman,' I said, 'but I am going to California, too, without the help of the Independence Co.!'" (p. 3).

24. T. A. Barry and B. A. Patten, *Men and Memories of San Francisco in the Spring of '50* (San Francisco: A. L. Bancroft & Co., 1873), pp. 143 – 44. The portrait is of William McKnight and is accompanied by a series of painful and poignant letters. McKnight wrote to his mother from Los Angeles on July 11, 1852, saying "I have always waited to get better but have grown worse every day. . . . It oppresses me to think of what will become of my poor mother, wife & children." On July 18 he wrote, "I am this day thirty-five years old. I am now five hundred miles away from my wife and not a person about me who would do any thing without pay – The mail is about to close and I must bid Farewell perhaps forever. I can't say anymore Farewell – God bless you is the prayer of your dying Son." The letter was never sent by McKnight, but written on the same piece of paper is a letter from Margaret McKnight to her mother-in-law dated August 13. It began: "Alas he is gone. Died last night about ten oclock."

25. Elisha Oscar Crosby, *Memoirs: Reminiscences of California and Guatemala from 1849 to 1864*, ed. Charles Albro Barker (San Marino, Calif.: Huntington Library, 1945), p. 107. Subsequent references will appear in the text.

26. Though Crosby notes that "Gold dust was rated at $12 an ounce at that time, about the middle of March '49'" (p. 24), Thomas Larkin, the U.S. consul, records in February of 1849 in Monterey "all being valued in this town at sixteen (16) dollars pr troy ounce," and in March

in Sacramento Larkin received a promissory note agreeing to pay "five thousand dollars in gold dust at the rate of sixteen dollars per ounce troy weight"; and also in June of 1849 a note from a San Francisco shipper stated "taking dust here at 16$ pr oz." See Thomas Oliver Larkin, *The Larkin Papers*, ed. George P. Hammond (Berkeley and Los Angeles: University of California Press, 1962), VIII, 138, 184, 245. Luzena Wilson also records that "all debts were paid in gold dust at sixteen dollars per ounce" (p. 12), and that later "One day that summer an enterprising pioneer of agricultural tastes brought in a wagon load of watermelons and sold them all for an ounce (sixteen dollars each). I bought one for the children and thought no more of the price than one does now of buying a dish of ice-cream" (p. 28). The entire matter of prices at this time is most interesting and few journals do not discuss them. Even doctors' prices get recorded. A few months before George Evans' death, he wrote in his *Mexican Gold Trail*, "To be sick in California is one of the hard things of this world, for want of proper attention and nursing, and on account of the ten-dollar visits of the worldly and gold-seeking physician" (p. 320). For an excellent "description of a single day" in San Francisco "in the beginning of September 1849" including a variety of prices, see chapter 12, "San Francisco by Day and Night" in Bayard Taylor, *Eldorado or Adventures in the Path of Empire* (New York: Alfred A. Knopf, 1949), pp. 86 – 92.

27. J. D. Borthwick, *Three Years in California*, chapter 17, in *Pictures of Gold Rush California*, ed. Milo Milton Quaife (Chicago: R. R. Donnelley & Sons Co., 1949), p. 237.

28. McWilliams thinks these are not actually Spanish Californians in spite of their vaquero dress because of the presence of the large five-pound Walker Colt revolver, a rare weapon (only a thousand were made). The pistols were issued during the Mexican War to two regiments

only, the U.S. Mounted Rifles and the Texas Volunteers, the Rangers. It was a common practice along the Texas-Mexico border during the 1840s and 1850s for Rangers to dress like vaqueros because at a distance on horseback they could not be distinguished as Texas Rangers.

29. See Richard S. Field and Robin Jaffee Frank, *American Daguerreotypes from the Matthew R. Isenburg Collection* (New Haven: Yale University Art Gallery, 1989), pp. 50 – 51, for an extensive discussion of this image. There is also an entire chapter on "The California Gold Rush" with excellent notes, as well as essays by Matthew Isenburg and Alan Trachtenberg.

30. *Poems* (New York: Modern Library, 1921), pp. 12 – 23.

THE
AMERICAN
AUTOCHROME

1. John Wood, *The Art of the Autochrome: The Birth of Color Photography* (Iowa City: University of Iowa Press, 1993). For additional American autochromes by Laura Gilpin, Clara Sipprell, Karl Struss, Edward Steichen, and Charles Zoller not included in *The Art of the Autochrome*, see John Wood, *The Art of the Autochrome Address Book* (New York: Galison Books, 1995).

2. Alfred Stieglitz, "The New Color Photography – A Bit of History," *Camera Work* 20 (October 1907), in Jonathan Green, ed., *Camera Work: A Critical Anthology* (Millerton, N.Y.: Aperture, 1973), p. 126; p. 124.

3. Alvin Langdon Coburn to Alfred Stieglitz, October 5, 1907 (Stieglitz Archives, Yale University).

4. [W. Dixon Scott,] "The Painters' New Rival: Color Photography as an Expert Sees It," in the *Liverpool Courier*, October 31, 1907. Reprinted in *American Photography* 2, no. 1 (January 1908): 13 – 19, as "The Painters' New Rival: An Interview with Alvin Langdon Coburn"

by Dixon Scott. There are slight but interesting differences in the two versions.

5. Eduard J. Steichen, "Colour Photography with the Autochrome Plates," *British Journal of Photography* 55 (April 1908): 302.

6. "The Lumière Autochrome Color Process," *Wilson's Photographic Magazine* 44 (October 1907): 433.

7. "The Painters' New Rival: Color Photography as an Expert Sees It."

8. Franklin Price Knott, "Artist Adventures on the Island of Bali," *National Geographic Magazine* 53, no. 3 (March 1928): 326.

9. G. Courtellemont, "Autochromes on Tour," *British Journal of Photography* 55 (June 1908), Colour Photography Supplement: 46.

10. Only now, for example, is the daguerreotype being adequately studied because it for the most part defies all hierarchies since the majority of daguerreotypes are anonymous and must be dealt with work by work. See Merry A. Foresta and John Wood, *Secrets of the Dark Chamber: The Art of the American Daguerreotype* (Washington: Smithsonian Institution Press and National Museum of American Art, 1995).

11. See Wood, pp. 53–54, plates 40–44, and Guy Courtellemont, *Le Pionnier Photographe de Mahomet* (Nimes: Lacour, 1994), a life of Jules Gervais-Courtellemont.

12. The facts concerning Clatworthy's life and activities are taken from Fred Payne Clatworthy, "Sixty Years in Photography," Denver Council of Camera Clubs *Photogram* (November 1948), and Barbara Clatworthy Gish, "Wheeling West," unpublished manuscript, both of which, as well as the Clatworthy–*National Geographic* correspondence, was very kindly shared with me by Mark Jacobs.

13. *The Painter and the Photograph: From Delacroix to Warhol* (Albuquerque: University of New Mexico Press, 1974), p. 199.

14. There is a sunset by Charles Corbet in Sylvain Roumette, *Early Color Pho-*

tography (New York and Paris: Pantheon / Centre National de la Photographie, 1986), plate 56, but it bears no comparison to Clatworthy's. There are quite a few other autochromes included in that book which are also failures as color photographs because of their disregard of the colors in the prephotographic process. There is also a Clatworthy image (plate 40) included but listed as "Anonymous," and another, plate 6, is possibly a variant view of the Lily Lake at Estes Park, Colorado.

15. See *The Art of the Autochrome*, pp. 50–51, for a discussion of this matter.

16. On the basis of the few surviving Steichen autochromes it does appear that Steichen's work in autochrome is fairly consistent with his other work; however, the aesthetic at hand is not American, I would argue, but merely Steichen's, or Symbolism's. For example, his famous and dramatic 1907 autochrome of Rodin with the *Eve* [for color reproduction, see Colin Ford, *Portraits* (London: Thames and Hudson, 1983), p. 77, or Hélène Pinet and Michel Poivert, *Le Salon de Photographie: Les écoles pictorialistes en Europe et aux Etats-Unis vers 1900* (Paris: Musée Rodin, 1993), p. 173] does not at all seem out of place with any of his other equally dramatic Rodin portraits from 1901 on. His autochrome of Jean Simpson (*The Art of the Autochrome*, plate 13; "American Symbolism: Visions of Spirituality and Desire," plate 72) seems no different aesthetically from his well known 1910 portrait of Mrs. Eugene Meyer (see Dennis Longwell, *Steichen, The Master Prints, 1895–1914: The Symbolist Period* [New York: Museum of Modern Art, 1978], plate 57).

17. "Artist Adventures on the Island of Bali," *National Geographic Magazine* 53, no. 3 (March 1928): 326.

18. Note the bibliography at the end of this volume.

19. W. H. Longly, and Charles Martin, "The First Autochromes from the Ocean Bottom." *National Geographic Magazine* 51, no. 1 (January 1927): 56.

1. *Philosophical Transactions* 132, pt. 1 (1842), pp. 181–214.

2. Larry Schaff, *Sun Gardens: Victorian Photograms by Anna Atkins* (New York: Aperture, 1985), pp. 27–28.

3. P. H. Emerson, *Naturalistic Photography for Students of the Art* (New York: E. & F. Spon, 1890), p. 196.

4. H. H. Snelling, *A Dictionary of the Photographic Art* (New York: H. H. Snelling, 1854), pp. 67–70.

5. *The Art of the Autochrome: The Birth of Color Photography* (Iowa City: University of Iowa Press, 1993), p. 1.

6. Quoted in Schaaf, p. 8.

7. See Schaaf's *Sun Gardens: Victorian Photograms by Anna Atkins*, a beautifully illustrated book which, like all of Schaaf's work, is of the highest scholarly quality.

8. See "Henri Le Secq à Dieppe . . ." in Jean-Jacques Henry, *Photographie, les débuts en Normandie* (Le Havre: Maison de la Culture du Havre, 1989), pp. 33–38. Also see Janet E. Buerger, *The Era of French Calotype* (Rochester: IMP/GEH, 1982), p. 21, for two additional Dieppe views, and André Jammes and Robert Sobieszek, *French Primitive Photography* (Millerton, N.Y.: Aperture, 1969), n.p., for a full-page reproduction of one of the two.

9. André Jammes and Eugenia Parry Janis, *The Art of French Calotype* (Princeton: Princeton University Press, 1983), p. 209. Also see Eugenia Parry Janis and Josiane Sartre, *Henri Le Secq Photographe de 1850 à 1860* (Paris: Musée des Arts Décoratifs / Flammarion, 1986), one of the finest and most beautiful of books on nineteenth-century photography.

10. This fact is not obvious from the Eastman House title, *Rustic Scene*, nor is it exactly obvious from the image itself. A salted paper print not so completely cropped at the top and entitled *Ferme troglodyte*, as well as a beautiful print of

the window to the right, exist in the collection of the Musée des Arts Décoratifs in Paris.

11. See Christopher Cardozo, *Native Nations: First Americans as Seen by Edward Curtis* (Boston: Little Brown, 1993), p. 125; and for the image in two cyanotype versions, see *A Book of Photographs from the Collection of Sam Wagstaff* (New York: Gray Press, 1978), p. 51.

12. See *Kodak Portfolio: Souvenir of the Eastman Photographic Exhibition 1897* (London: Eastman Photographic Materials Co., 1897). The other photographers were Davison, H. P. Robinson, Craig Annan, Horsley Hinton, Eustace Calland, Andrew Pringle, and Adolphus Stoiber.

13. "Her Geometry" in Constance Sullivan, ed., *Women Photographers* (New York: Harry N. Abrams), p. 11.

14. Keith F. Davis, *An American Century of Photography* (Kansas City: Hallmark Cards and Harry N. Abrams, 1995), p. 40.

15. (Santa Fe: Twin Palms, 1995), plates 46, 73 – 76, three of which (73 – 75) seem like rather typical cyanotype portraits; however, the other two, a landscape with nude youth and a portrait, are absolutely stunning and have all the subtlety and softness of lighting as well as those typical rich darks found in Day's other work.

16. Hélène Pinet and Michel Poivert, *Le Salon de Photographie: Les écoles pictorialistes en Europe et aux Etats-Unis vers 1900* (Paris: Musée Rodin, 1993). This is one of the best and most beautiful studies of pictorial photography; it includes essays by Pinet, Poivert, Sylvain Morand, Nathalie Boulouch, and Thilo Koenig.

17. Both reviews from *Camera Work* 33 (January 1911): 28 and 65.

18. "The White School" in *Camera Craft* 3, no. 3 (July 1901): 85 – 92, reprinted in Peter Palmquist's excellent *Camera Fiends & Kodak Girls: 50 Selections by and about Women in Photography, 1840 – 1930* (New York: Midmarch Arts Press, 1989), pp. 113 – 20.

19. One does not see many titillating or erotic cyanotypes. The Musée d'Orsay does have an interesting bondage cyanotype depicting a nude and bound female. The recent "Note on Linley Sambourne (1844 – 1910)" by Dr. R. W. Rimmer in *The Photo Historian* 110 (January 1996), 13 – 15, discusses the work of Sambourne, some 30,000 cyanotypes, which include many nudes and "a preoccupation . . . with voyeuristic images, including photographic, through a keyhole, a girl undressing in a Spanish hotel, and a maid in his own house asleep in bed." In the collected papers of Hugh Walpole (MS Walpole c.12) at the Bodleian Library there is an album of some forty photographs, including cyanotypes, by Frederick Rolfe, Baron Carvo, author of *Hadrian VII*, who in addition to taking photographs of boys also claimed to have accidentally discovered color photography.

20. *Collected Poems* (New York: Farrar, Straus, Giroux and Marvell Press, 1989), pp. 85 – 86.

21. See Schaaf, p. 60.

AMERICAN SYMBOLISM

1. Jean Clair et al., *Lost Paradise: Symbolist Europe* (Montreal: Montreal Museum of Fine Arts, 1995). Ulrich Pohlmann's essay "The Dream of Beauty, or Truth is Beauty, Beauty Truth: Photography and Symbolism, 1890 – 1914," pp. 428 – 47, is particularly noteworthy.

2. Ulrich Pohlmann et al., *Frank Eugene: The Dream of Beauty* (Munich: Nazraeli Press and Fotomuseum im Münchner Stadtmuseum, 1995).

3. Susan Ehrens, *A Poetic Vision: The Photographs of Anne Brigman* (Santa Barbara: Santa Barbara Museum of Art, 1995). The Santa Barbara Museum also staged a 1992 exhibition with an accompanying catalogue, *Watkins to Weston: 101 Years of California Photography, 1849 – 1950*, which included Symbolist work and an essay by the always perceptive Therese Heyman entitled "Encouraging the Artistic Impulse: The Second Generation: 1890 – 1925" (pp. 58 – 71).

4. James Crump, *F. Holland Day: Suffering the Ideal* (Santa Fe: Twin Palms, 1995).

5. Michael G. Wilson and Dennis Reed, *Pictorialism in California: Photographs, 1900 – 1940* (Malibu and San Marino: J. Paul Getty Museum and Henry E. Huntington Library and Art Gallery, 1994).

6. John Wood, *The Art of the Autochrome: The Birth of Color Photography* (Iowa City: University of Iowa Press, 1993).

7. Quoted in Pontus Hulten and Germano Celant, *Italian Art: 1900 – 1945* (New York: Rizzoli, 1989), p. 43.

8. This image, the *Einsamer Reiter*, is a large blue pigment gum print. It was made in 1903 and widely exhibited for years — Hamburg, Dresden, Vienna, New York, Buffalo — and widely published as well. The Hofmeisters considered it their masterpiece, and J. Nilson Laurvik, writing of the National Arts Club Exhibition, called it "The most unforgettable photograph in the show" (*Camera Work* 26 [April 1909]: 41). Kandinsky said that he and Franz Marc came up with the name *Blaue Reiter* in 1911 somewhat accidentally because they both liked blue, Marc liked horses, and he liked riders. He implied that the name just happened, and it surely did, but one cannot but wonder if he and Marc had not seen the Hofmeisters' *Einsamer Blaue Reiter* and it wasn't somewhere in their consciousness when they named what was to become one of the most important groups of painters in the twentieth century.

9. See Weston J. Naef, *The Collection of Alfred Stieglitz* (New York: Metropolitan Museum of Art / Viking Press, 1978), p. 424, for illustration.

10. Helmut and Alison Gernsheim, *The History of Photography* (New York: McGraw-Hill Book Company, 1969), p. 469.

11. See Marty Carey and Howard Greenberg, *John F. Collins: Photographs, 1904 – 1946* (New York: Photofind Gallery, 1987).

12. Compare, for example, Collins's

1928 studies of eyeglasses in *John F. Collins: Photographs, 1904–1946*, and Dubreuil's similar 1929 *Spectacles*, figure 23, in Tom Jacobson, *Pierre Dubreuil: Photographs, 1896–1935* (San Diego: Dubroni Press, 1987), as well as their work in general.

13. See Russell Mamone, "Albert E. Schaaf, Pioneer Wheelman," in *The Wheelmen* 19 (November 1981): 8–15, for a biography of Schaaf but primarily from the wheelman's point of view. There is, however, some discussion of his photographic work.

14. In 1900 and 1902 Eduard Arning did produce at least two brooding gum print factory scenes (see Enno Kaufhold et al., *Kunstphotographie um 1900; Die Sammlung Ernst Juhl* (Hamburg: Museum für Kunst und Gewerbe, 1989). Prescott Adamson has a 1904 factory scene entitled *'Midst Steam and Smoke* that appeared in *Camera Work* 5 (January 1904), and there is an Antonin Personnaz autochrome from about 1908 in the collection of the Société Française de Photographie entitled *Vue usinière*. It is a French scene rather like Coburn's of Pittsburgh. A similar 1907 factory scene by Belgian Gustave Marissiaux oddly titled *Soir de Neige* was published in 1908 in his portfolio *Visions d'Artiste*, but apart from Adamson's none of these images would have been known in the way Coburn's work was, especially the New York views, which were published in lavish book form.

15. J. K. Huysmans, *Against the Grain* (New York: Three Sirens Press, 1931), pp. 338–39.

16. This image is probably from Coburn's 1906 trip to Italy. It with the other two Coburns illustrated in this essay was from the collection of George Seeley and probably dates from around the same time. Plate 66, *Lillian and Laura Seeley*, must have been made and given to Seeley sometime in 1906 because Coburn, too, has posed Seeley's sisters in their *Burning of Rome* costumes sewn by Seeley's mother for that 1906 work. Were it not for Coburn's blindstamp monogram, the im-

age might easily be mistaken for a work by Seeley.

17. *The Rubáiyát of Omar Khayyám* (New York: Dodge Publishing Company, 1905) was an expensive, ornamented, leather-bound edition illustrated with twenty-eight photogravures on tissue. Hanscom enlisted as her models a number of Bay Area poets and artists, such as Joaquin Miller. The book was extremely successful and reprinted in less expensive halftone editions as well.

18. *Camera Work: A Critical Anthology* (Millerton, N.Y.: Aperture, Inc., 1973), p. 19.

19. Sigmund Freud, *Three Contributions to the Theory of Sex*, trans. A. A. Brill (New York: Dutton, 1962), p. 10.

MASTERS OF EUROPEAN PICTORIALISM AND THE PROBLEM OF ALFRED STIEGLITZ

1. Two short exhibition pamphlets on Hannon do exist: Cécile Duliere and Françoise Dierkens, *Edouard Hannon, Photos 1900* (Brussels: Musée Horta, 1977); and Pool Andries et al., *Rétrospective Edouard Hannon* (Brussels: Contretype, 1986); and there was another short group exhibition catalogue, *Kunstphotographie in Belgien um 1900: Evenepoel, Hannon, Misonne* (Cologne: n.p., 1976).

2. Ernst Juhl, *28 Heliogravüren nach Gummidrucken von Mitgliedern der Gesellschaft zur Förderung der Amateurphotographie* (Hamburg: Gesellschaft zur Förderung der Amateurphotographie, 1903), a work that is perhaps most interesting for the purpose of studying the published price list of images. Though not all the work in the exhibition was for sale, the prices of many things seem quite staggering for 1903. In the $5 range, or its equivalent in marks, pounds, or francs, was work by John Bullock, René Le Bègue, Ema Spencer, and others; in the $10 to $20 range, Annan, Coburn, Demachy, Eugene (including $15 for a

gravure of Stieglitz), Keiley, William Post, Puyo, and White; in the $25 up to about $50, the Hofmeisters, Käsebier, and Müller; in the $50+ range, Henneberg, Kühn, Perscheid, Watson-Schütze, Steichen ($50 up to $75 for a gum print of *Watts*), and Stieglitz ($25 up to $100 for *Watching for the Return*).

3. Both Helmut Gernsheim (*The History of Photography*, p. 467) and Sarah Greenough (*Alfred Stieglitz: Photographs & Writings*, p. 222) erroneously state the number of Steichen illustrations in the July *Rundschau* as twelve.

4. Ernst Juhl, *Camera-Kunst: Eine Internationale Sammlung von Kunst-Photographien der Neuzeit* (Berlin: Verlag von Gustav Schmidt, 1903).

5. Janet E. Buerger, "Art Photography in Dresden, 1899–1900: An Eye on the German Avant-Garde at the Turn of the Century," *Image* 27, no. 2 (June 1984): 4.

6. See Herbert J. Seligmann, *Alfred Stieglitz Talking: Notes on Some of His Conversations, 1925–1931* (New Haven: Yale University Library, 1966), the most embarrassing book in the literature of photography.

7. Quoted in Sarah Greenough and Juan Hamilton, *Alfred Stieglitz: Photographs and Writings* (Washington and New York: National Gallery of Art and Callaway Editions, 1983), p. 207.

THE PAST, PASSING, OR TO COME

1. See chapter 5, "The Contemporary Daguerreotype," in John Wood, *The Scenic Daguerreotype: Romanticism and Early Photography* (Iowa City: University of Iowa Press, 1995), for a discussion of all five of these artists.

2. Letter to the author, January 1996.

3. R. H. Vance, *Catalogue of Daguerreotype Panoramic Views in California* (New York: Baker, Godwin & Co., 1851), p. 4.

The Plates

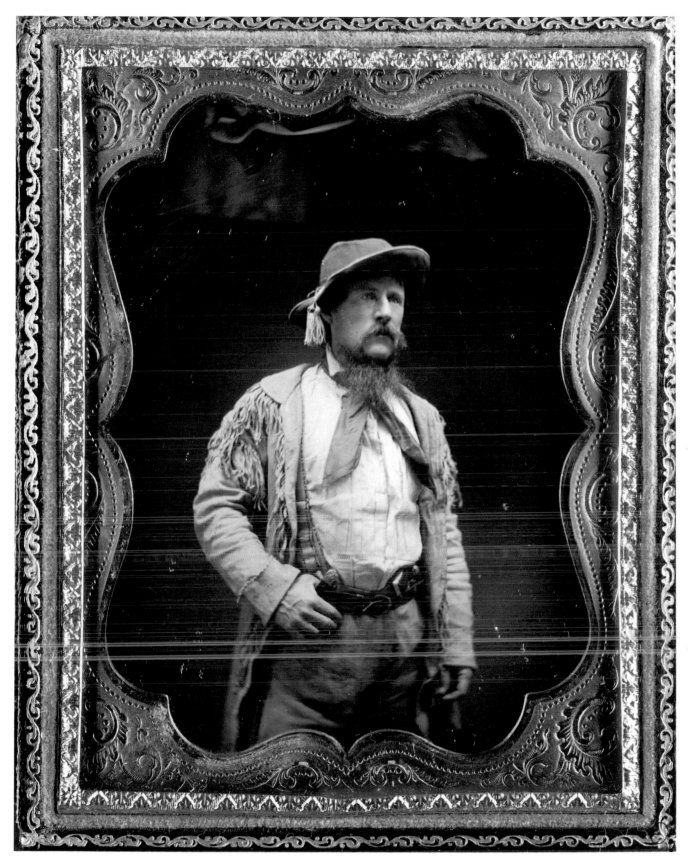

1. Anon. *Portrait of George C. Baumford, 1853*. Quarter plate daguerreotype.
Collection of Matthew R. Isenburg.

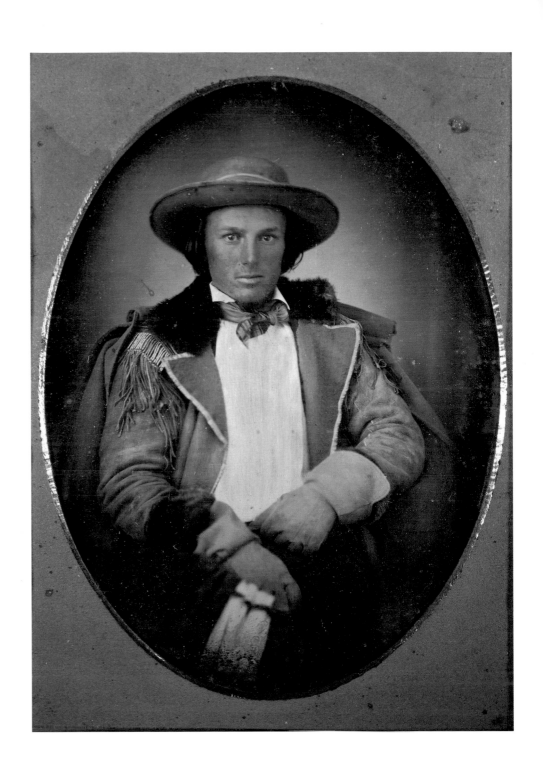

2. Anon. *Portrait of a Dragoon Scout*. Quarter plate daguerreotype.
Collection of John N. McWilliams.

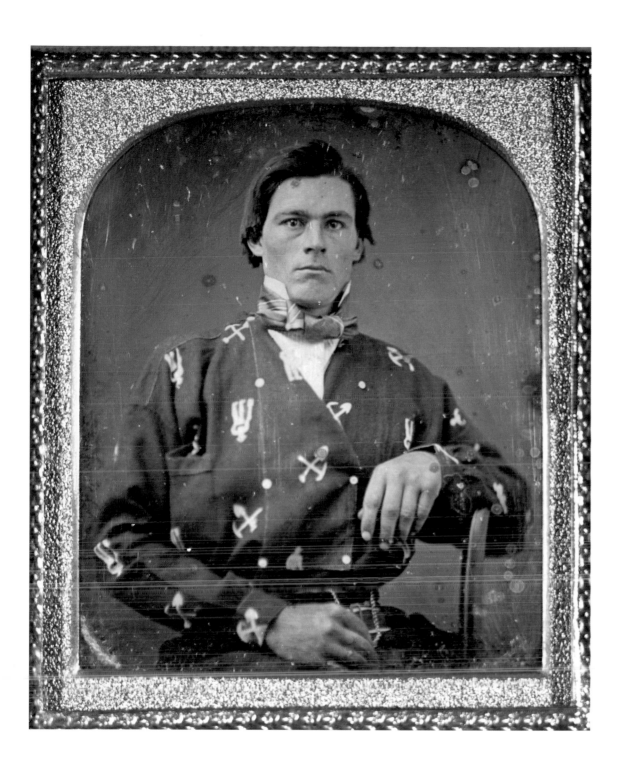

3. Anon. *Portrait of Lyman Alvinson Rundell*. Sixth plate daguerreotype.
Collection of John N. McWilliams.

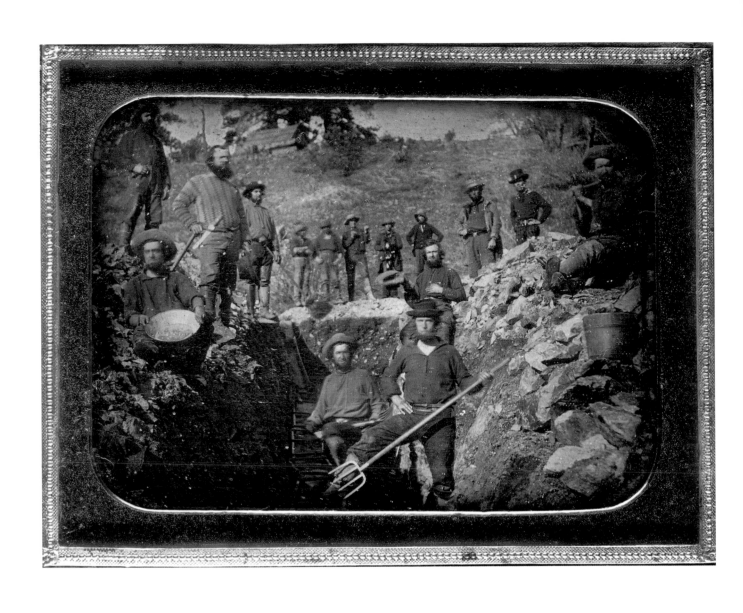

4. Anon. *Mining Scene*. Quarter plate daguerreotype.
Collection of Matthew R. Isenburg.

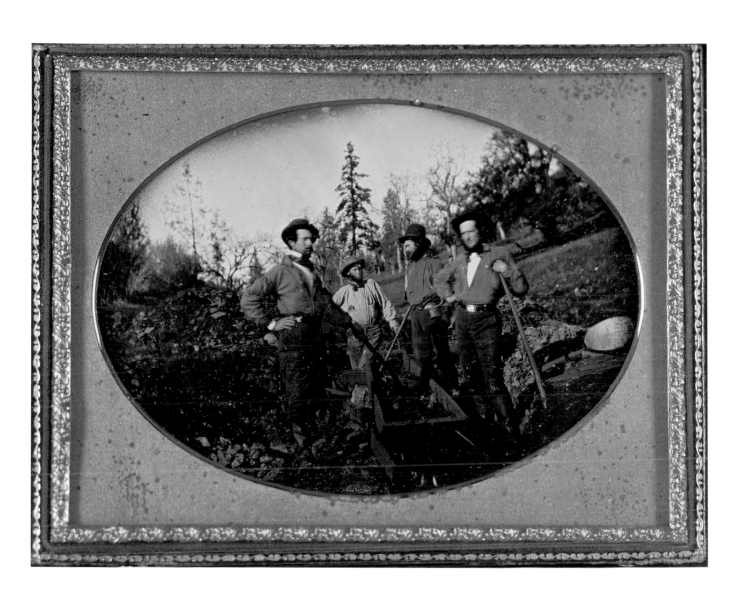

5. Anon. *Four Miners*. Half plate daguerreotype. Collection of Greg French.

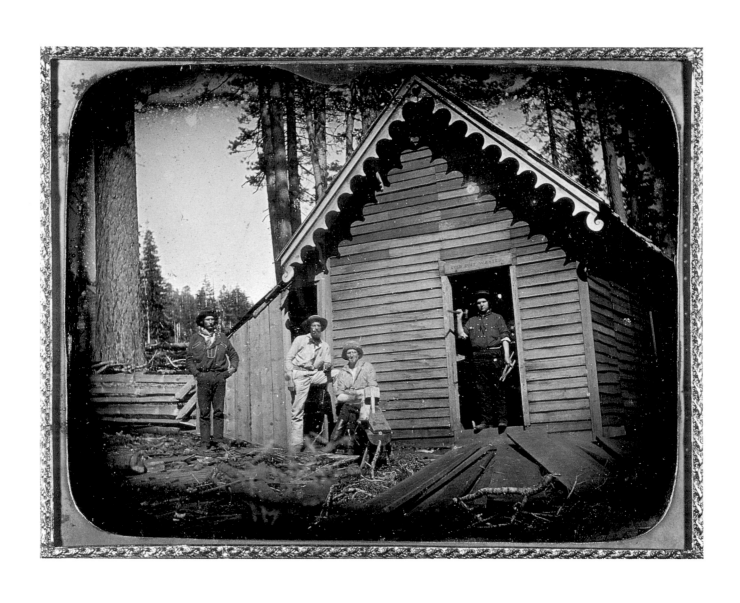

6. Anon. *Gold Dust Wanted*. Half plate daguerreotype.
Collection of Mona and Marc Klarman.

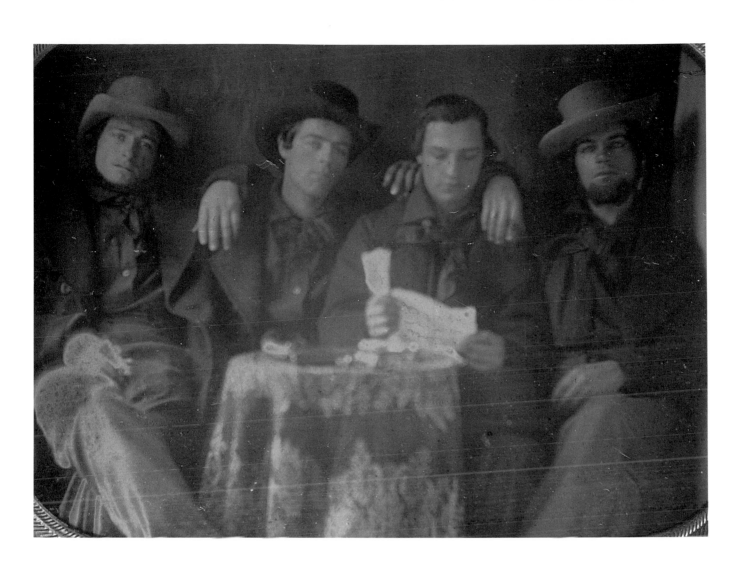

7. Anon. *A Letter from Home*. Quarter plate daguerreotype.
Collection of Matthew R. Isenburg.

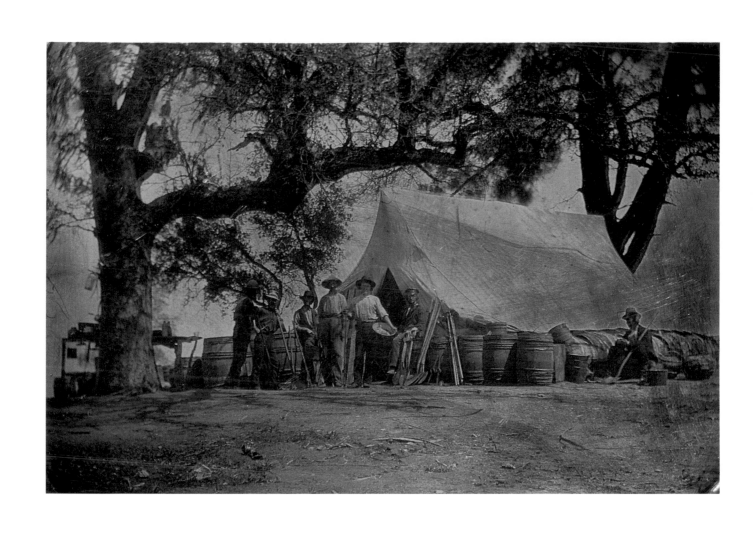

8. Anon. *The Tent Store*. Half plate daguerreotype.
Collection of Matthew R. Isenburg.

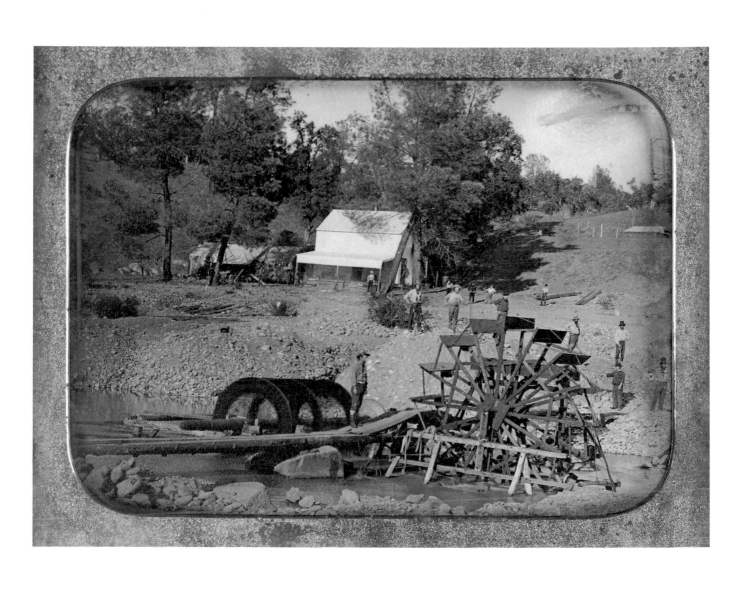

9. Anon. *Gold Mining, North Fork, American River*. Half plate daguerreotype.
Courtesy of Hallmark Photographic Collection; Hallmark Cards, Inc., Kansas City, Missouri.

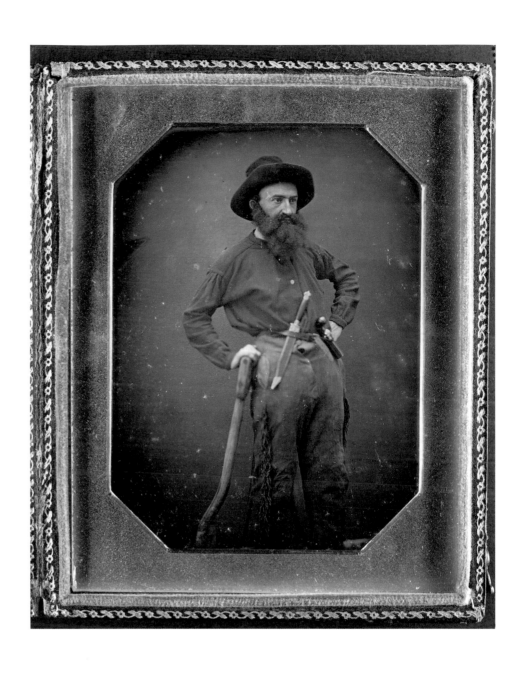

10. Anon. *Portrait of William McKnight*. Quarter plate daguerreotype.
Collection of Matthew R. Isenburg.

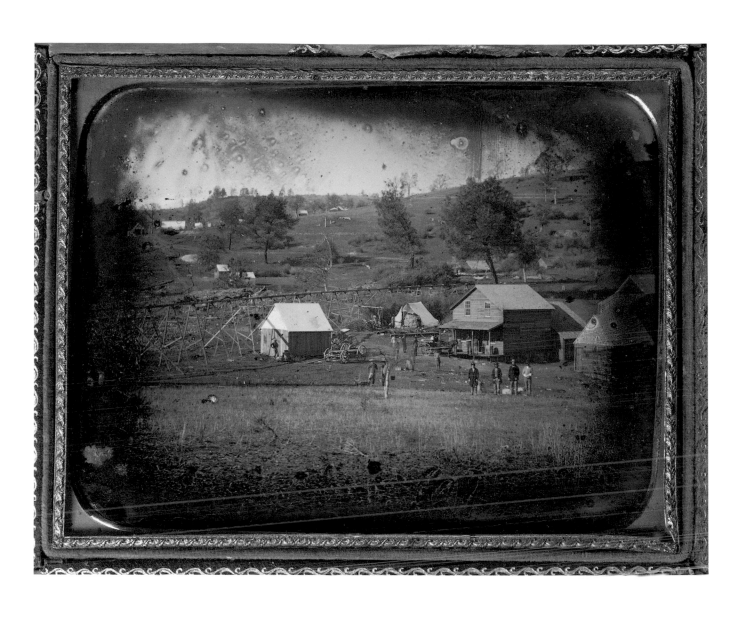

11. Anon. *Mining Scene with Chinese, Flume, and Kiln.* Half plate daguerreotype.
Collection of Matthew R. Isenburg.

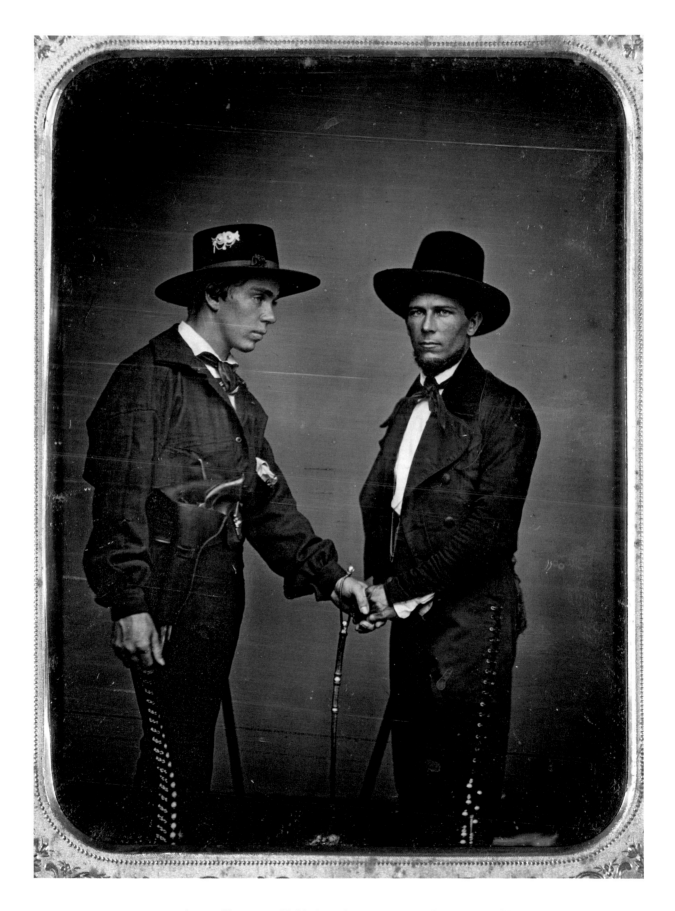

12. Anon. *Vaqueros*. Half plate daguerreotype. Collection of John N. McWilliams.

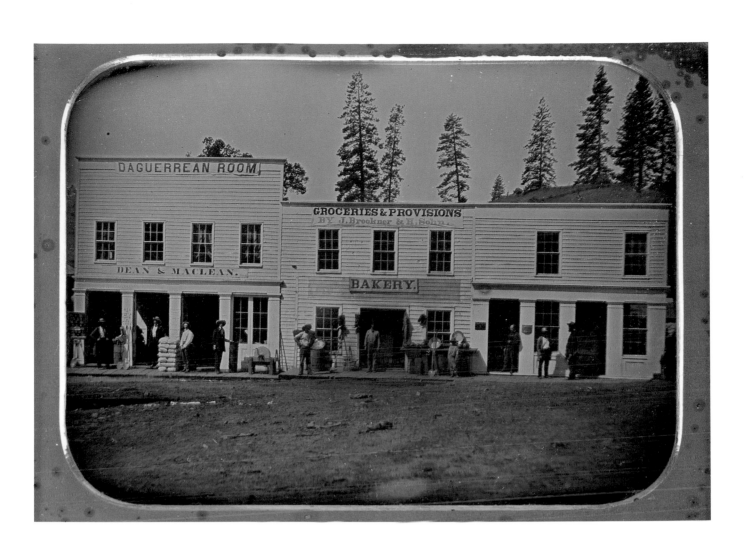

13. Anon. *California Town*. Half plate daguerreotype. Collection of Greg French.

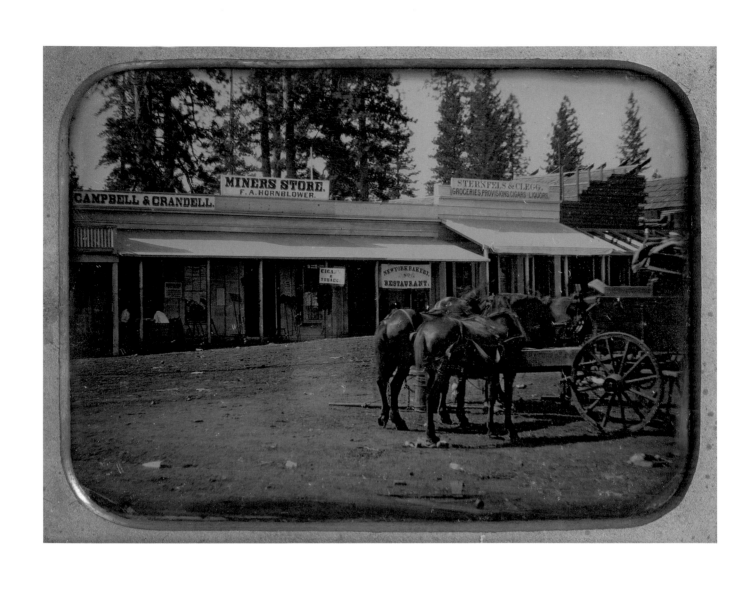

14. Anon. *California Town*. Half plate daguerreotype.
Collection of Matthew R. Isenburg.

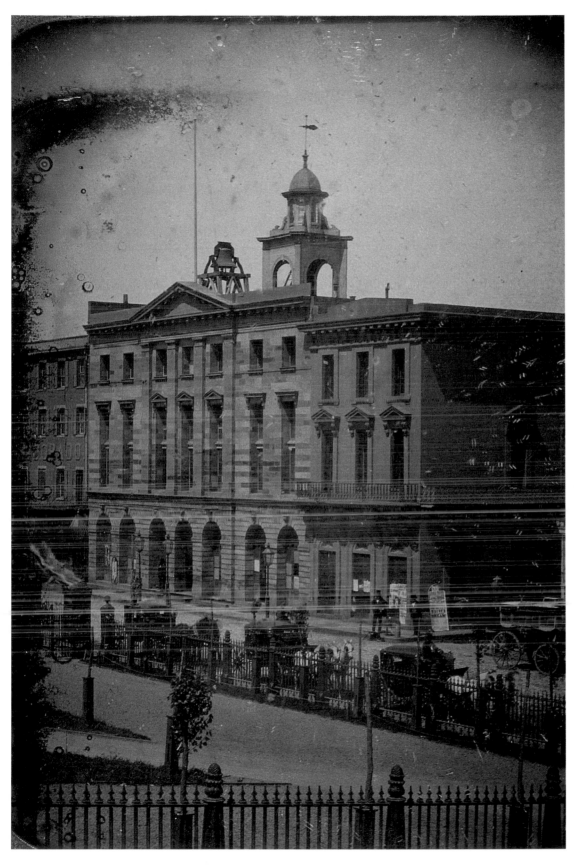

15. Robert H. Vance. *San Francisco City Hall.* Stereo daguerreotype.
Collection of Matthew R. Isenburg.

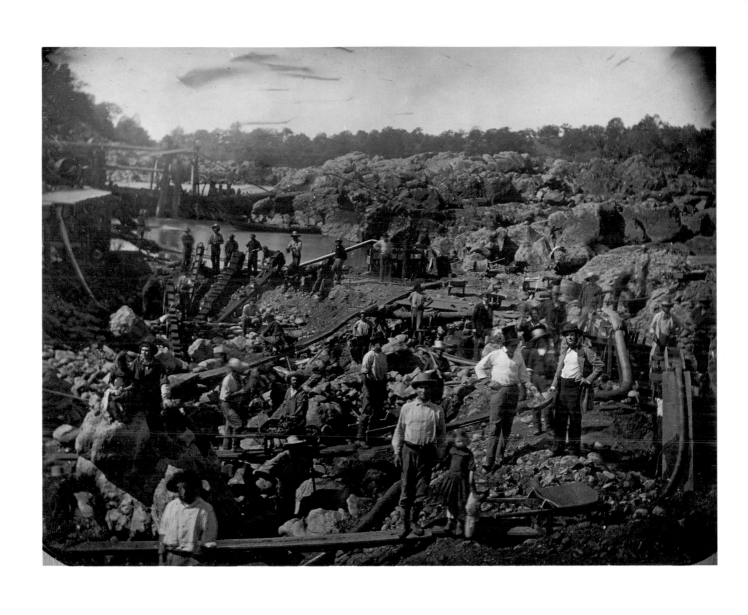

16. George Johnson. *Mining on the American River near Sacramento.*
Whole plate daguerreotype. Collection of Matthew R. Isenburg.

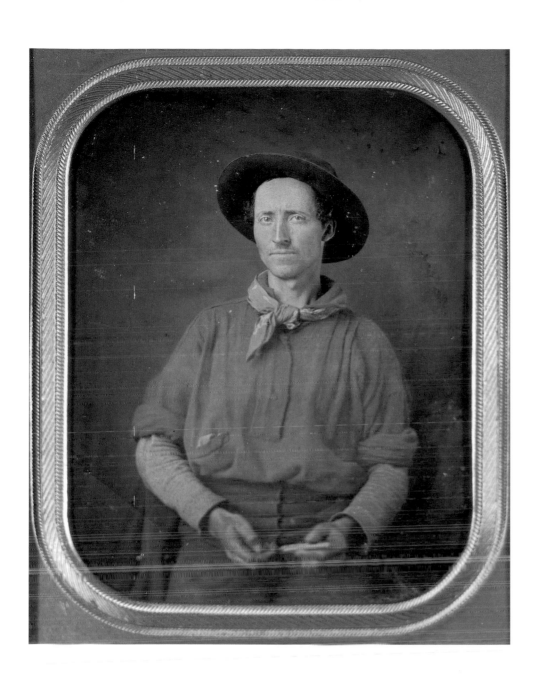

17. George Johnson. *Portrait of a '49er in Red Miner's Shirt.*
Sixth plate daguerreotype. Collection of John N. McWilliams.

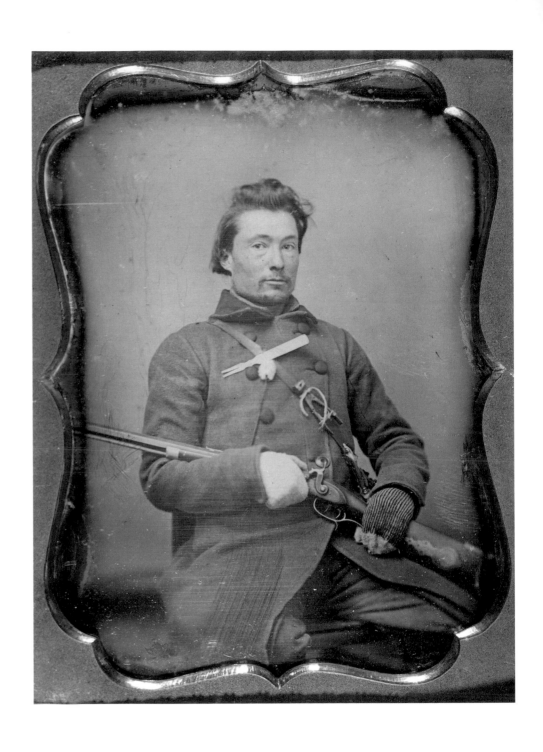

18. Anon. *Frontiersman with Plains Rifle, Fork, Ram Rod, Bullet Mold, and Bowie Knife*. Quarter plate daguerreotype. Collection of John N. McWilliams.

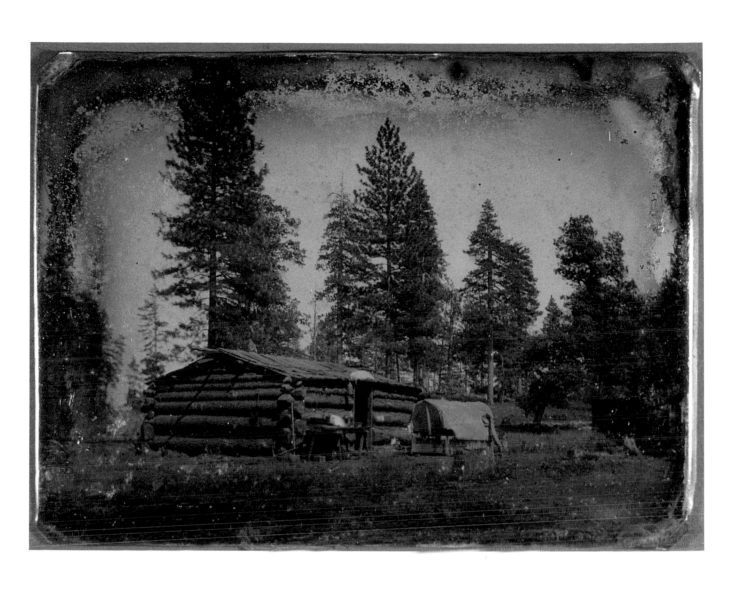

19. Anon. *Moses Warren's Cabin, El Dorado County, 1850.*
Quarter plate daguerreotype. Collection of Matthew R. Isenburg.

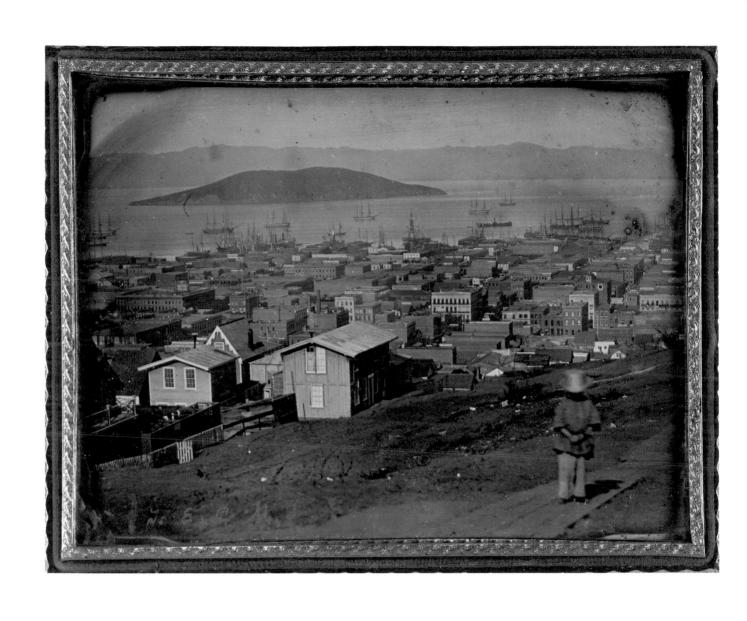

20. Anon. *View of San Francisco*. Half plate daguerreotype.
Collection of Greg French.

21. Fred Payne Clatworthy. *Sunrise*. Autochrome. Collection of Mark Jacobs.

22. Fred Payne Clatworthy. *Sunrise*. Autochrome. Collection of Mark Jacobs.

23. Fred Payne Clatworthy. *The Wind River Trail*. Autochrome.
Collection of Mark Jacobs.

24. Fred Payne Clatworthy. *Toward Fall River Road*. Autochrome.
Collection of Mark Jacobs.

25. Fred Payne Clatworthy. *Harvest Time*. Autochrome. Collection of Mark Jacobs.

26. Fred Payne Clatworthy. *Bear Lake*. Autochrome. Collection of Mark Jacobs.

27. Fred Payne Clatworthy. *Beaver House*. Autochrome. Collection of Mark Jacobs.

28. Fred Payne Clatworthy. *In Hawaii*. Autochrome. Collection of Mark Jacobs.

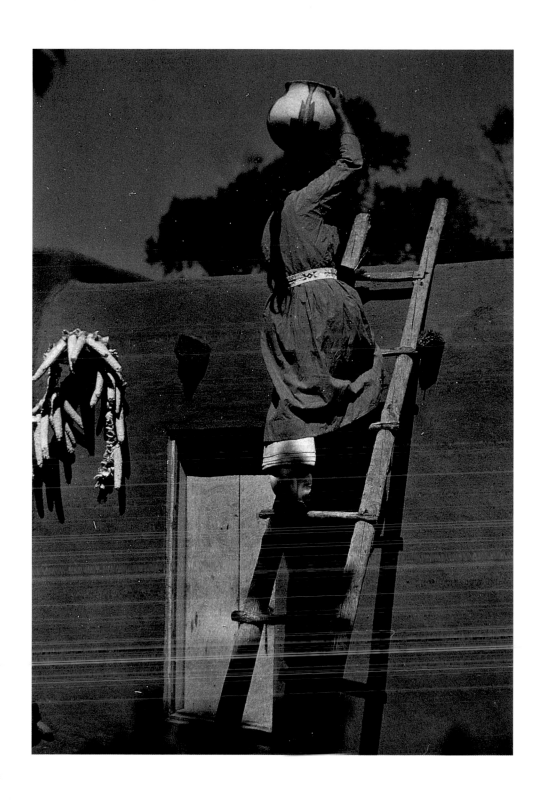

29. Fred Payne Clatworthy. *Taos Pueblo*. Autochrome. Collection of Mark Jacobs.

30. Fred Payne Clatworthy. *Mesa Verde*. Autochrome. Collection of Mark Jacobs.

31. Fred Payne Clatworthy. *The Lily Lake at Estes Park*. Autochrome.
Collection of Mark Jacobs.

32. Fred Payne Clatworthy. *Snow Scene: Estes Park*. Autochrome.
Collection of Mark Jacobs.

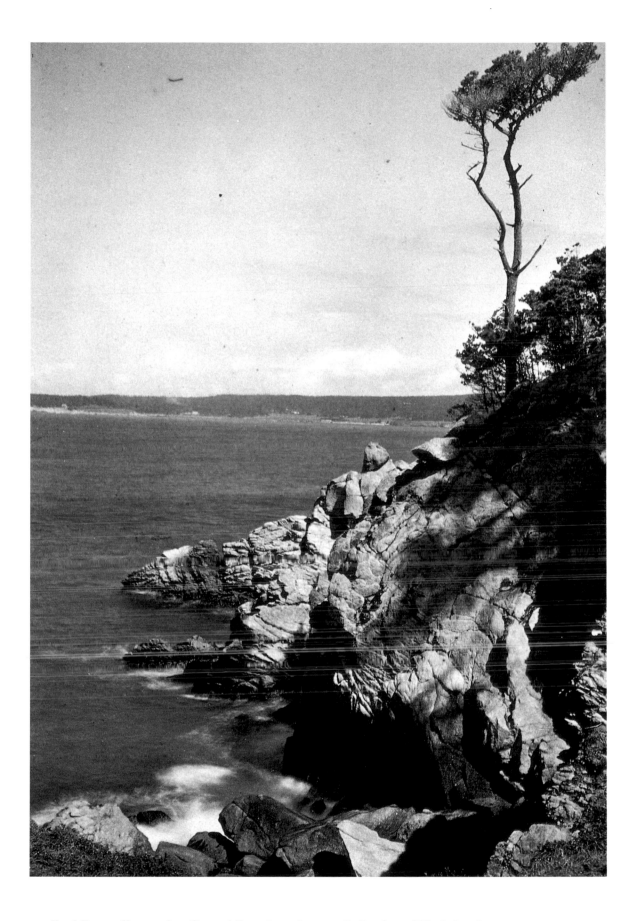

33. Fred Payne Clatworthy. *Carmel Bay*. Autochrome. Collection of Mark Jacobs.

34. Fred Payne Clatworthy. *Lemon and Nut*. Autochrome.
Collection of Mark Jacobs.

35. John Metoyer. *The Illuminated Path*. Cyanotype. Collection of Frank Granger.

36. Henri Le Secq. *Rustic Scene* (*Ferme troglodyte*). Cyanotype.
Courtesy George Eastman House.

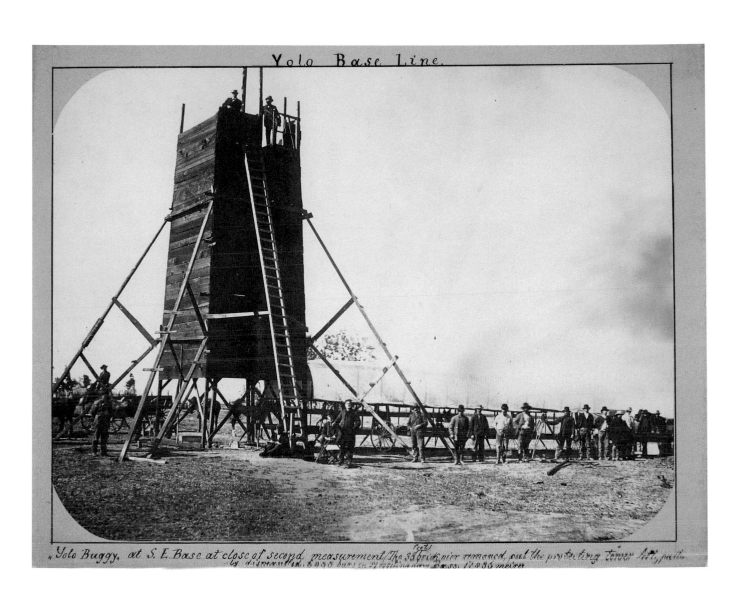

Yolo Base Line.

"Yolo Buggy, at S.E. Base at close of second measurement/The 3 brick pier removed, and the projecting tower left, partly by demolition, 6000 bars in 24 working days / Base, 11.836 metres

37. Carleton Watkins. *The Yolo Buggy*. Cyanotype. Collection of Larry Gottheim.

38. Edward Curtis. *Kominaka Dancer, Kwakiutl.* Cyanotype.
Collection of Larry Gottheim.

JULY 7, 1911

39. Charles Lummis. *Self Portrait with Son*. Cyanotype.
Collection of Larry Gottheim.

40. Frances Benjamin Johnston. *Measuring.* Cyanotype.
Collection of Larry Gottheim.

41. Bertha Evelyn Jaques. *Fleabane with Grass.* Cyanotype.
Collection of Larry Gottheim.

42. Paul B. Haviland. *Blue Girl.* Cyanotype. Collection of Larry Gottheim.

43. Ema Spencer. *On the Longed-for Hobby Horse.* Cyanotype.
Collection of Larry Gottheim.

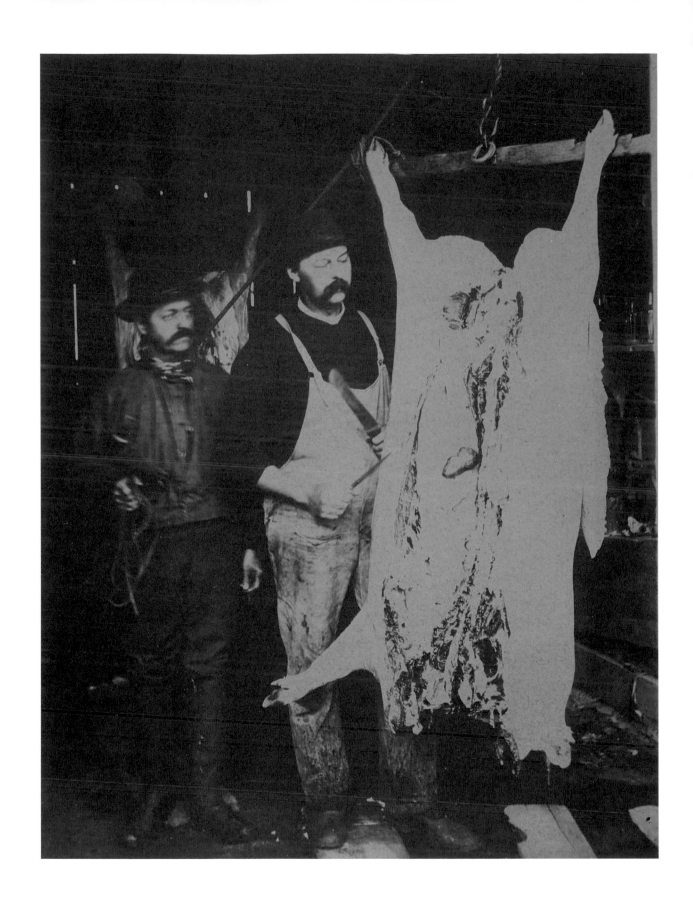

44. W. V. Walter. *Butcher, Dec. 14, 1893*. Cyanotype. Collection of Larry Gottheim.

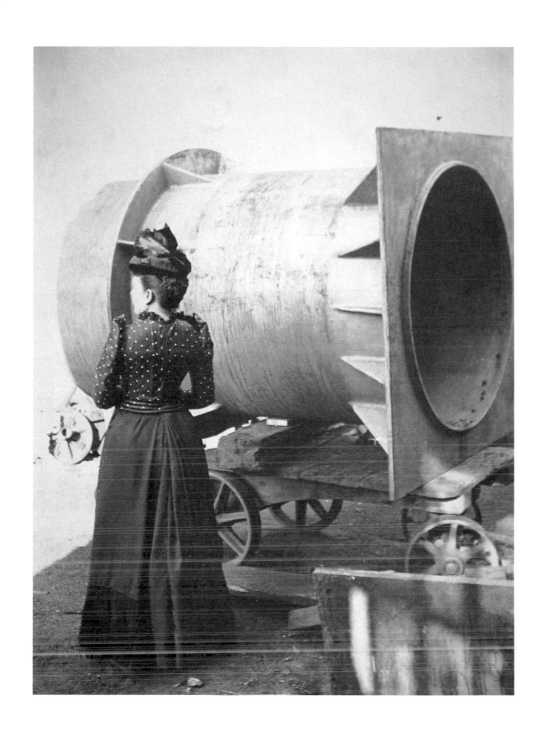

45. Anon. *Portrait of a Lady*. Cyanotype.

46. Gordon H. Coster. *Lingerie*. Cyanotype. Collection of Larry Gottheim.

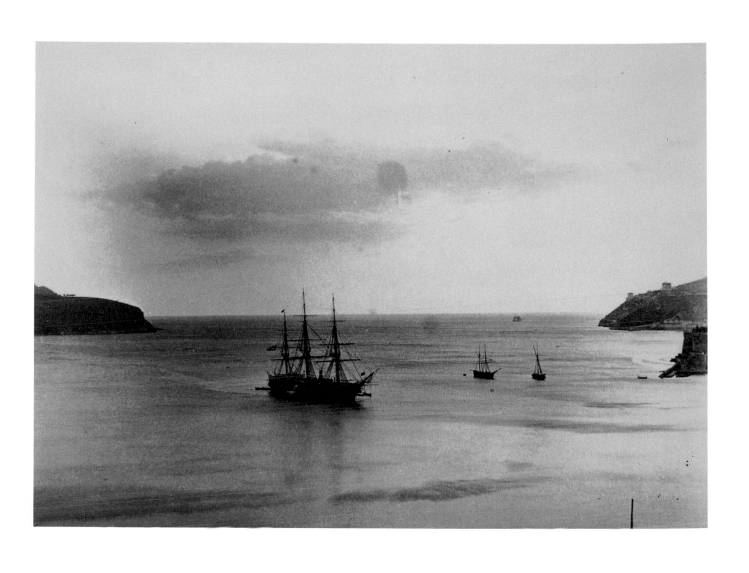

47. Anon. *The Pensacola Stranded at Villefranche.* Cyanotype.
Collection of Larry Gottheim.

48. C. H. Turner. *Sand Dunes*. Cyanotype. Collection of Larry Gottheim.

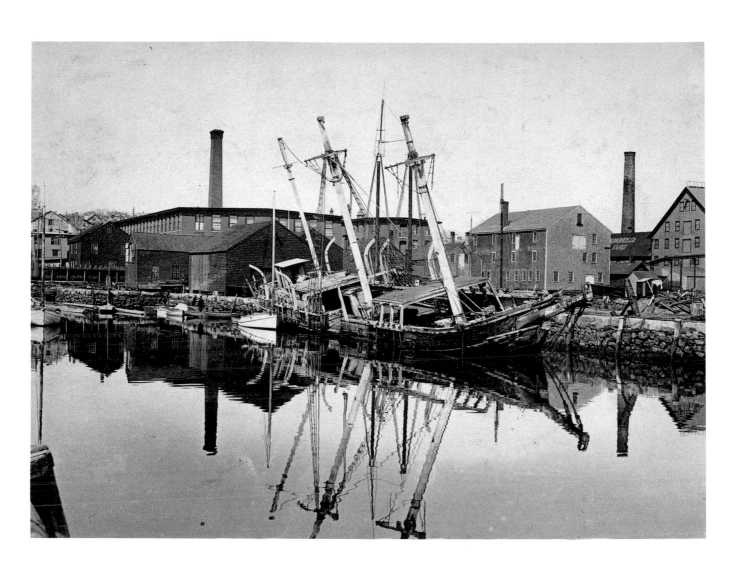

49. Anon. *The Palmetto, 1895*. Cyanotype. Collection of Larry Gottheim.

50. Anon. *Portrait of a Child*. Cyanotype. Collection of Larry Gottheim.

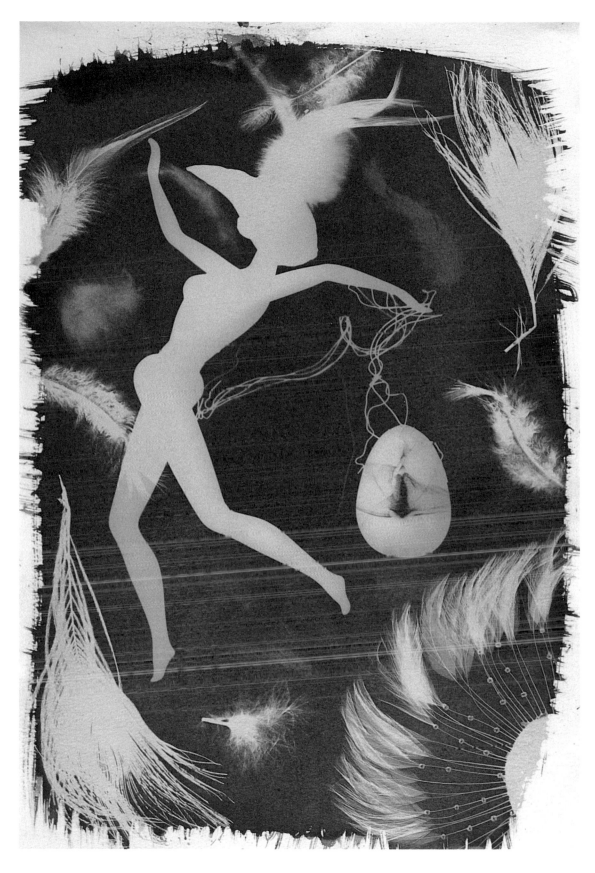

51. John Metoyer. *The Egg: Homage to A. and M.* Cyanotype.
Collection of the artist.

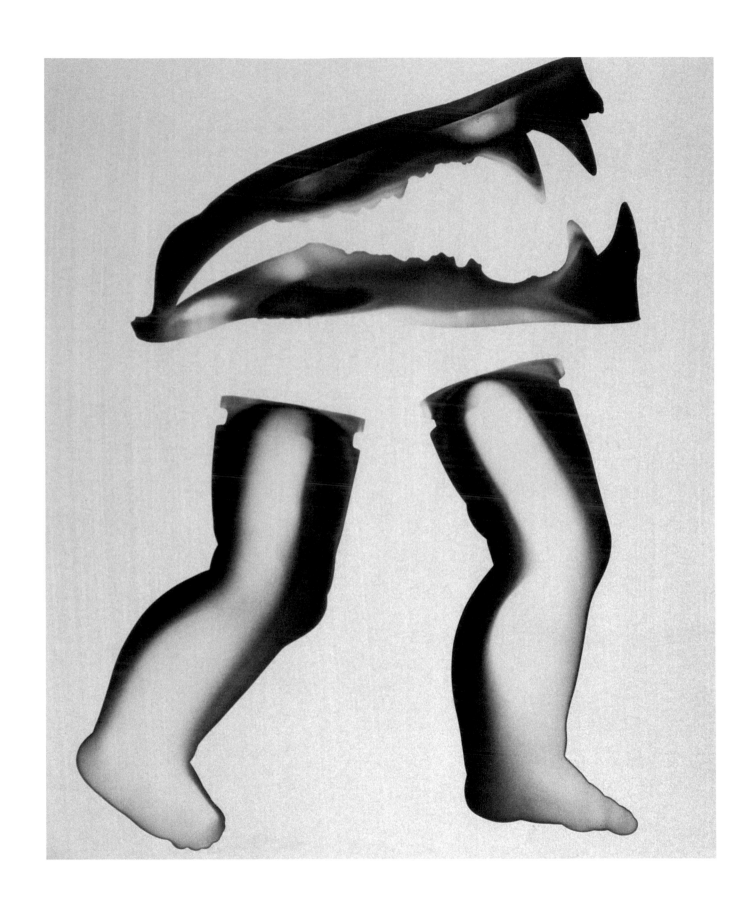

52. John Metoyer. *Innocence: Jaws and Legs*. Cyanotype.
Collection of Raúl Peschiera.

53. John Metoyer. *The Angel of Melrose.* Cyanotype. Collection of Dr. Joe Cash.

54. John Metoyer. *Self Portrait as Azrael*. Cyanotype. Collection of Sarah Love.

55. John Metoyer. *The Altar Boy with Death and Tree.* Cyanotype.
Collection of Genie Byone.

56. John Metoyer. *Push*. Cyanotype. Collection of Michael Downey.

57. John Metoyer. *Fiddlehead 1*. Cyanotype. Collection of Pam Breaux.

58. John Metoyer. *The Angel Heron*. Cyanotype. Collection of the artist.

59. Harry Rubincam. *The Horseman*. Pigment print.

60. John F. Collins. *Morning Fog*. Bromide print.

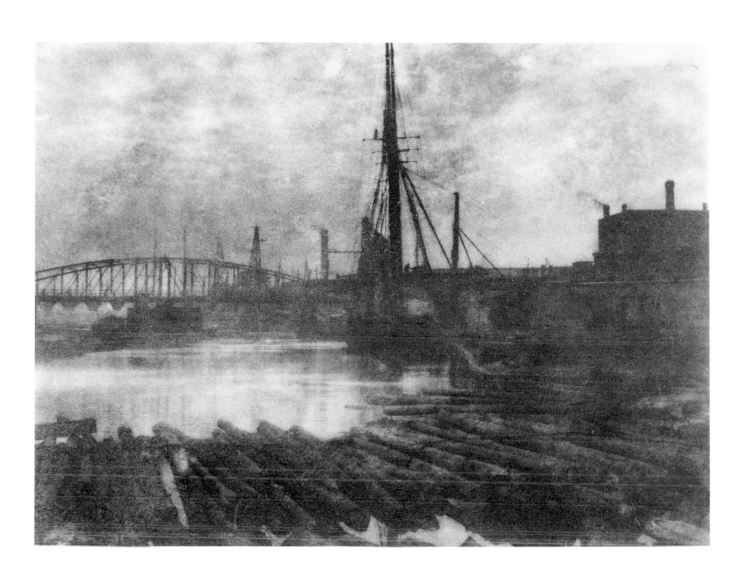

61. Albert Schaaf. *The South Bay*. Oil-pigment print.

62. Edward Steichen. *Late Afternoon—Venice.*
Photogravure from *Camera Work* 42/43.

63. Alvin Langdon Coburn. *Lombardy Poplars*. Gray-pigment gum bichromate print.

64. Albert Schaaf. *Market — Strasbourg*. Oil-pigment print.

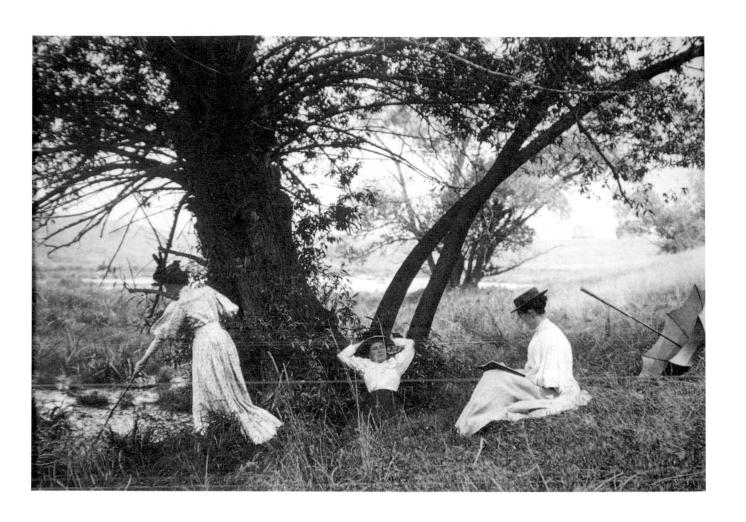

65. Albert Schaaf. *Idyllic Scene*. Platinum print.

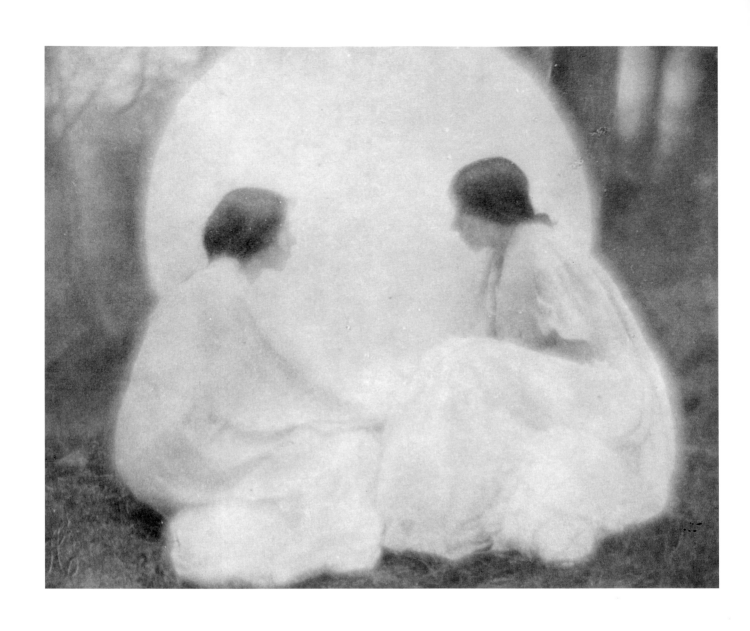

66. Alvin Langdon Coburn. *Lillian and Laura Seeley*. Platinum print.

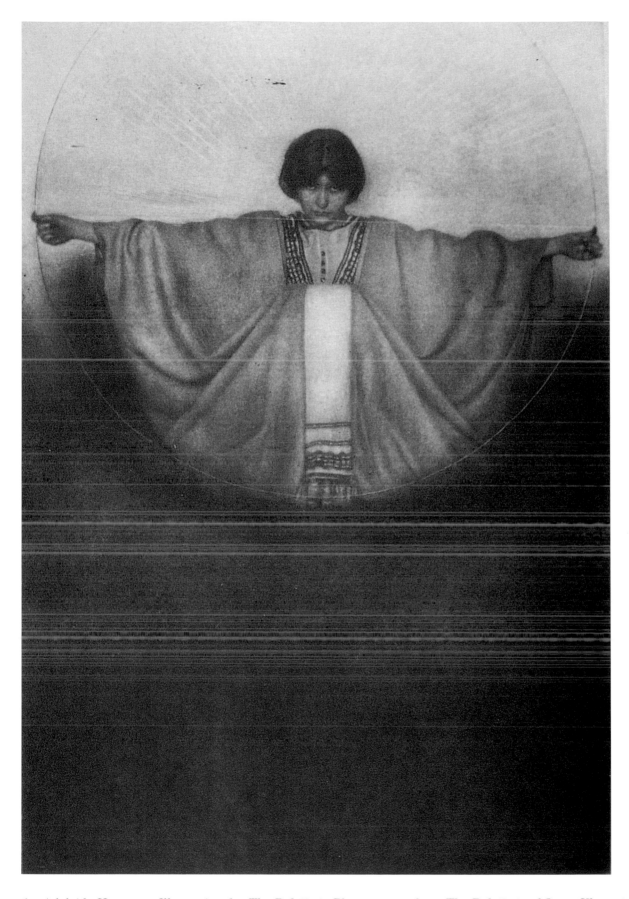

67. Adelaide Hanscom. Illustration for *The Rubáiyát*. Photogravure from *The Rubáiyát of Omar Khayyám*.

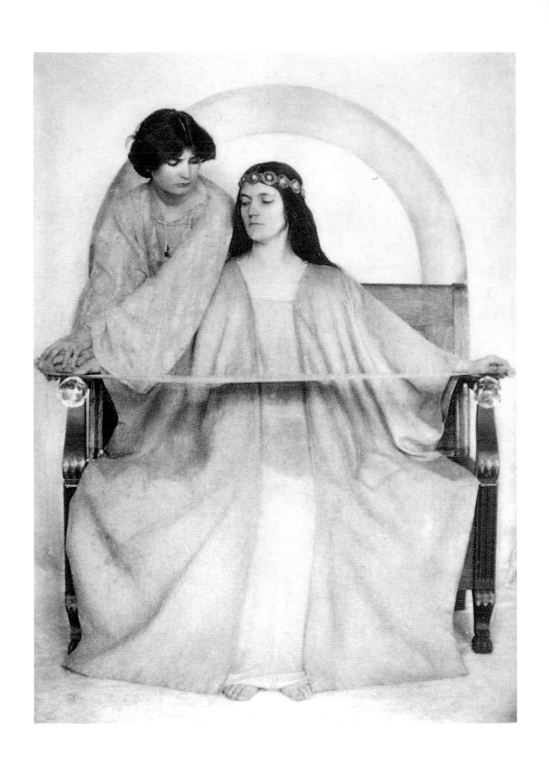

68. Adelaide Hanscom. Illustration for *The Rubáiyát*.
Photogravure from *The Rubáiyát of Omar Khayyám*.

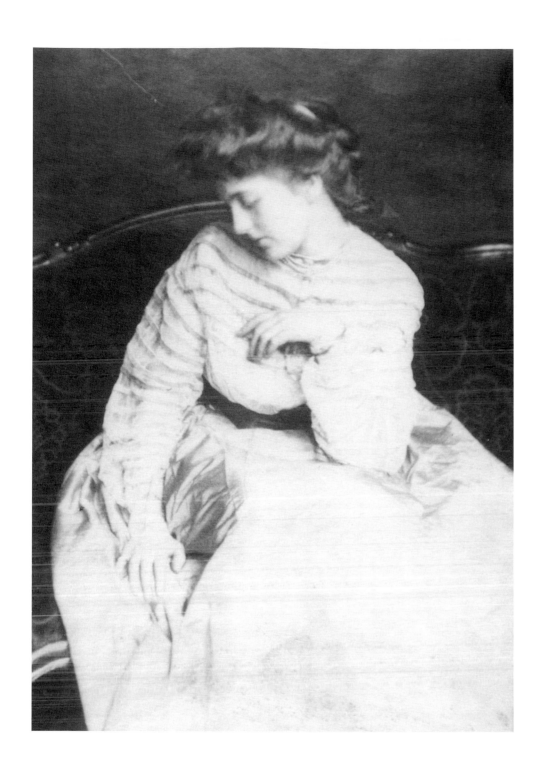

69. Arthur E. Becher. *Untitled*. Platinum print.

70. Alvin Langdon Coburn. *Classical Study*. Platinum print.

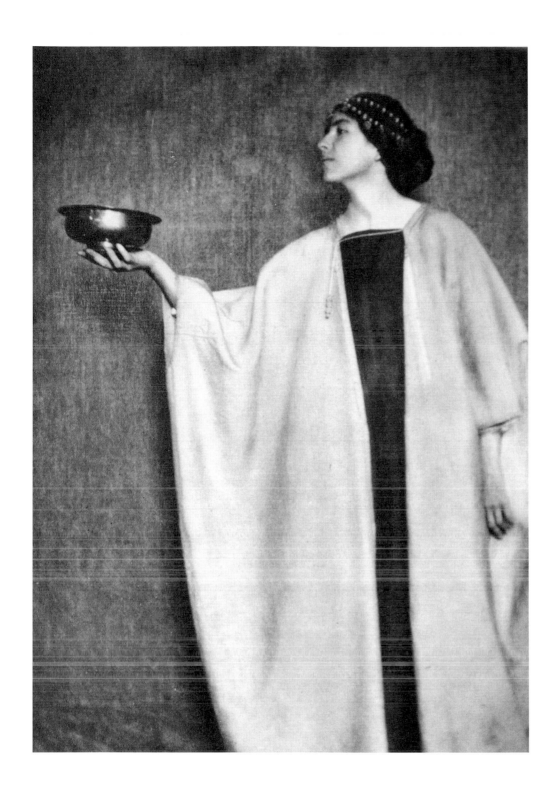

71. Adelaide Hanscom. Illustration for *The Rubáiyát*. Photogravure from *The Rubáiyát of Omar Khayyám*.

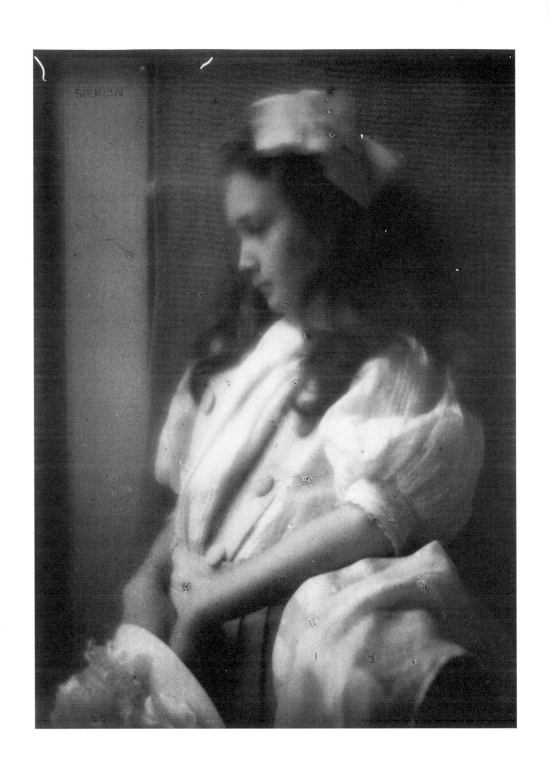

72. Edward Steichen. *Jean Simpson*. Autochrome.

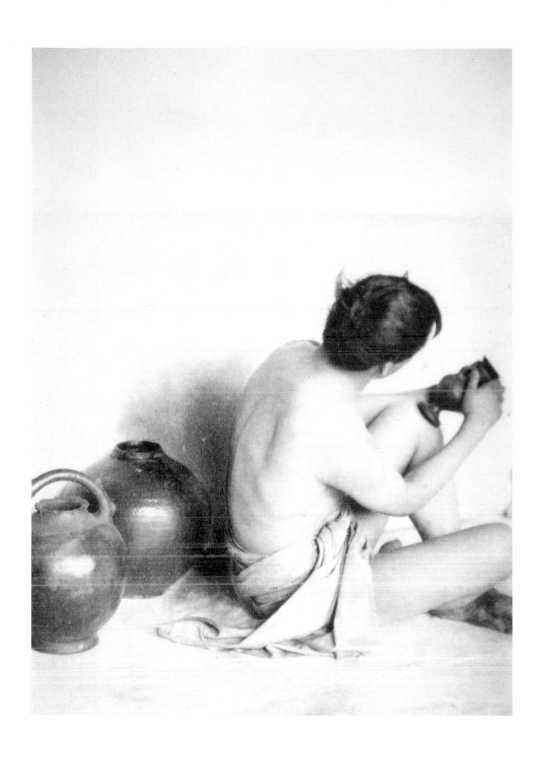

73. Adelaide Hanscom. Illustration for *The Rubáiyát*. Photogravure from *The Rubáiyát of Omar Khayyám*.

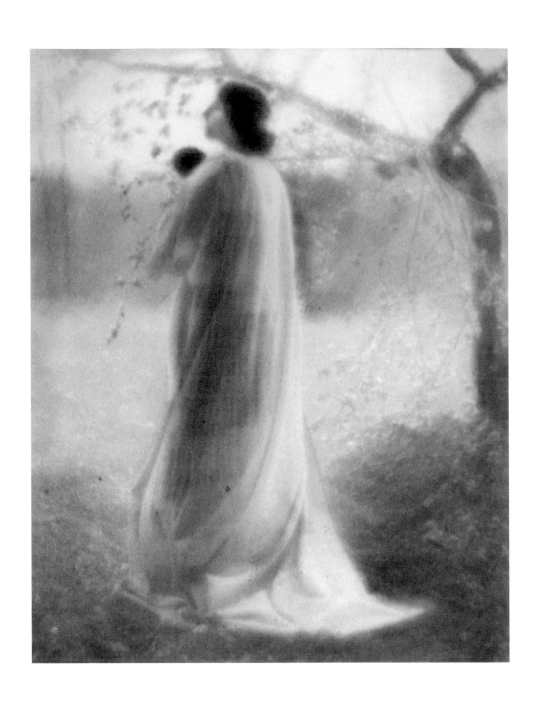

74. George Seeley. *Golden Dawn*. Platinum print.

75. Edouard Hannon. *Forest Light*. Photogravure from *Die Kunst in der Photographie* I (1897), no. 4.

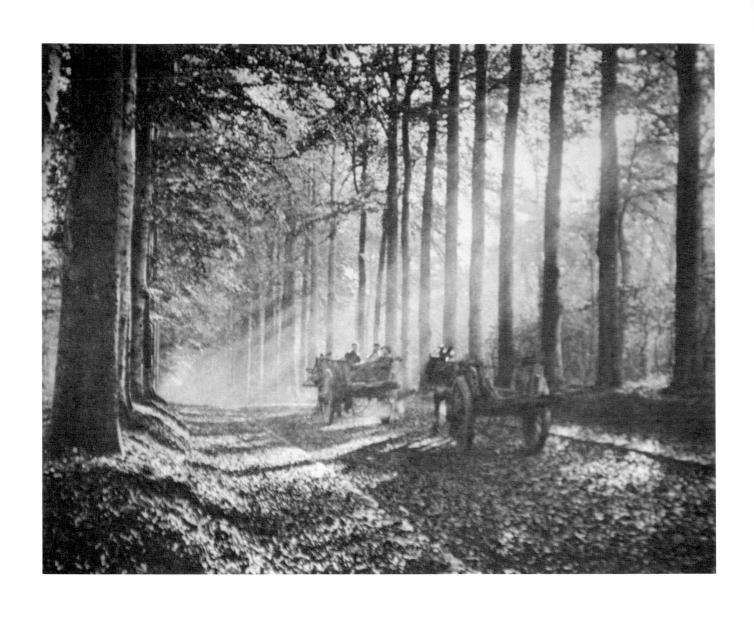

76. Edouard Hannon. *Sunbeams.*
Photogravure from *Photographische Rundschau*, 1897.

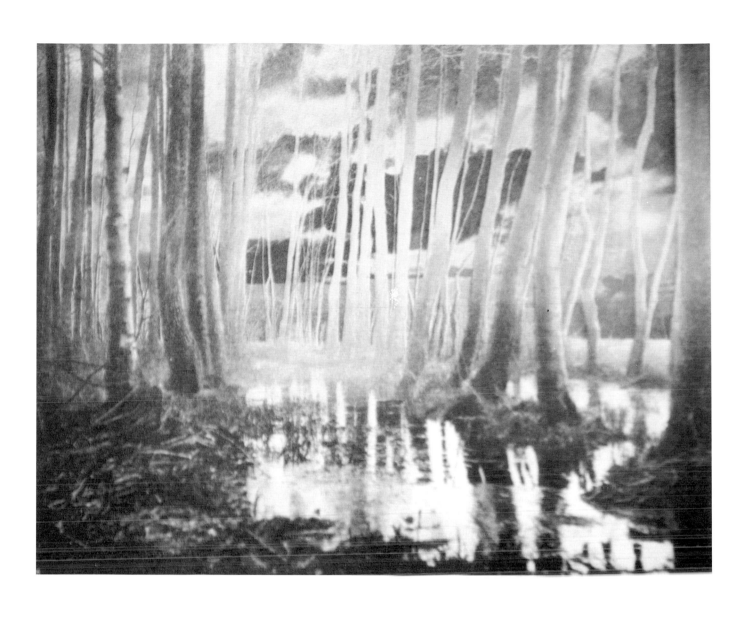

77. Edouard Hannon. *After the Storm*. Halftone from *Photographische Rundschau*, 1897.

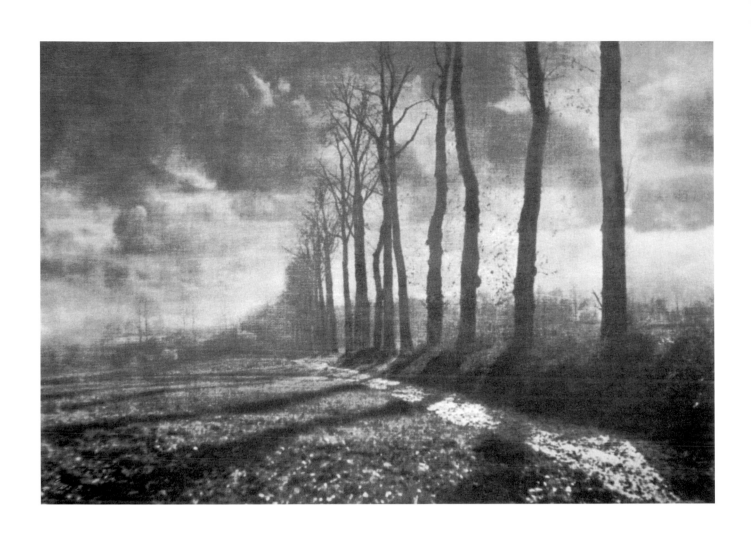

78. Alexandre (Alexandre Edouard Drains). *Landscape Study*.
Photogravure from *Die Kunst in der Photographie* III (1899), no. 1.

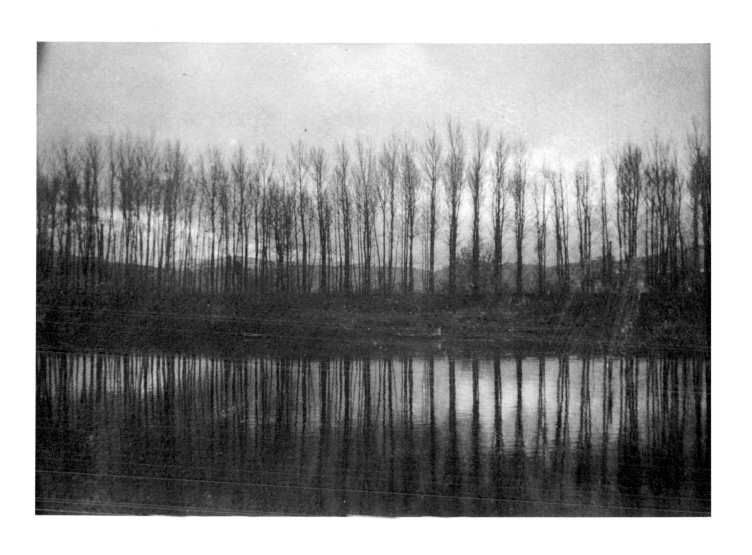

79. Aldo Pompejani. *Untitled*. Silver print.

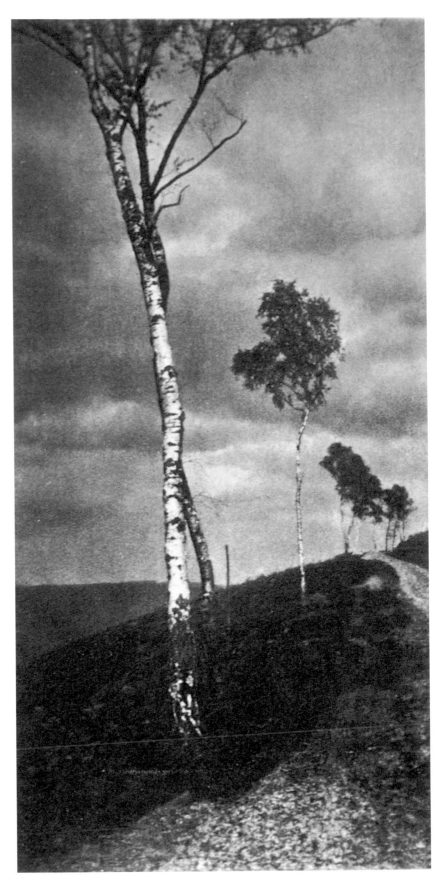

80. Eduard Arning. *Untitled*. Photogravure from *Photographische Rundschau*, 1900.

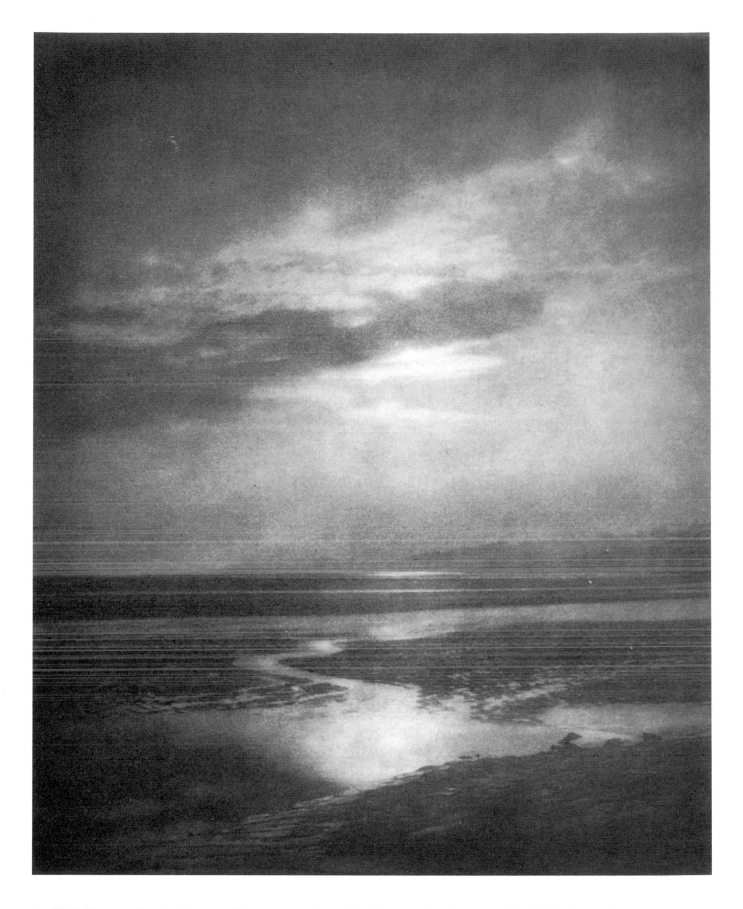

81. W. J. Warren. *On the Estuary*. Photogravure from *Die Kunst in der Photographie* II (1898), no. 6.

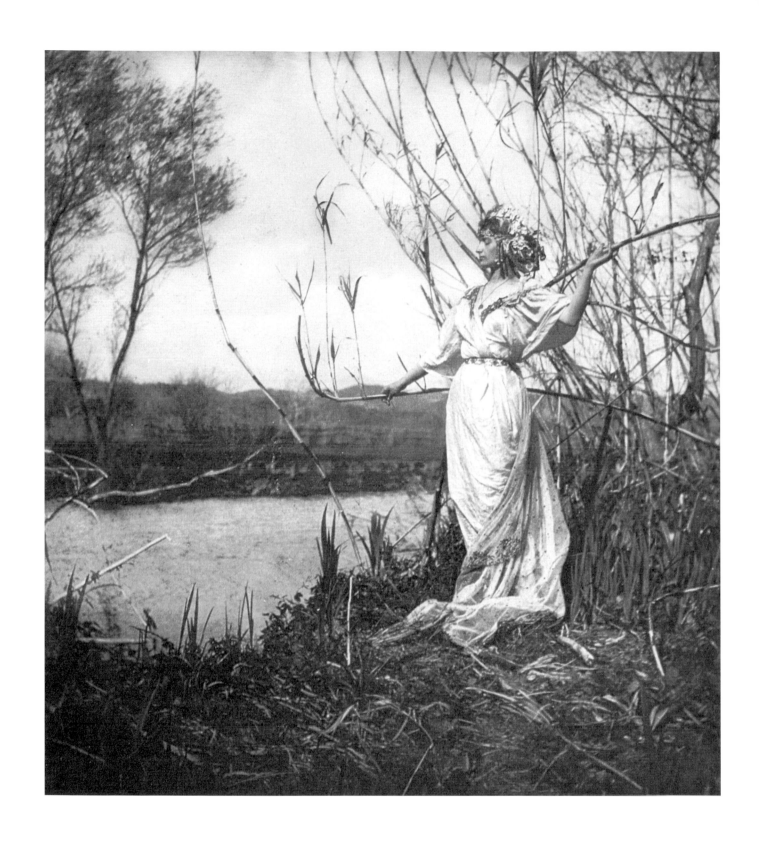

84. Paul Bergon. *The King's Daughter.*
Photogravure from *Die Kunst in der Photographie* II (1898), no. 5.

85. Alexandre (Alexandre Edouard Drains). *Fisherman.*
Photogravure from *Die Kunst in der Photographie* III (1899), no. 3.

86. Gatti Casazza. *Evening, Lake Como.*
Photogravure from *Art in Photography*, London, 1905.

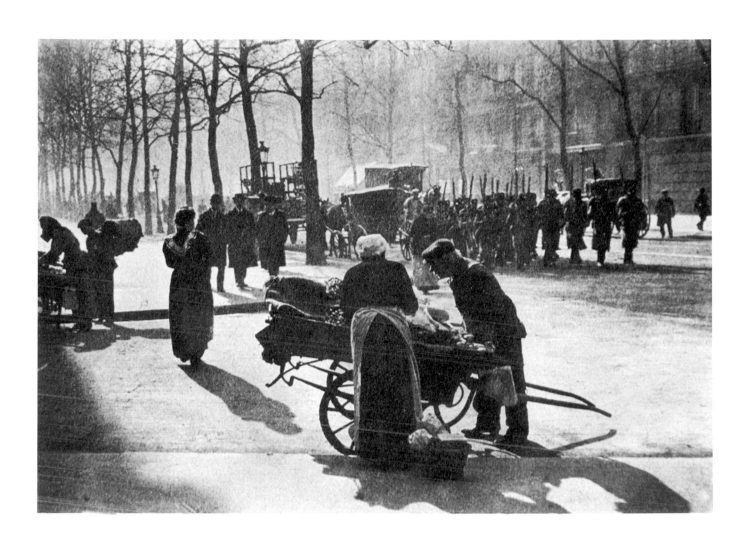

87. Maurice Bucquet. *Paris.* Photogravure from *Photographische Rundschau,* 1900.

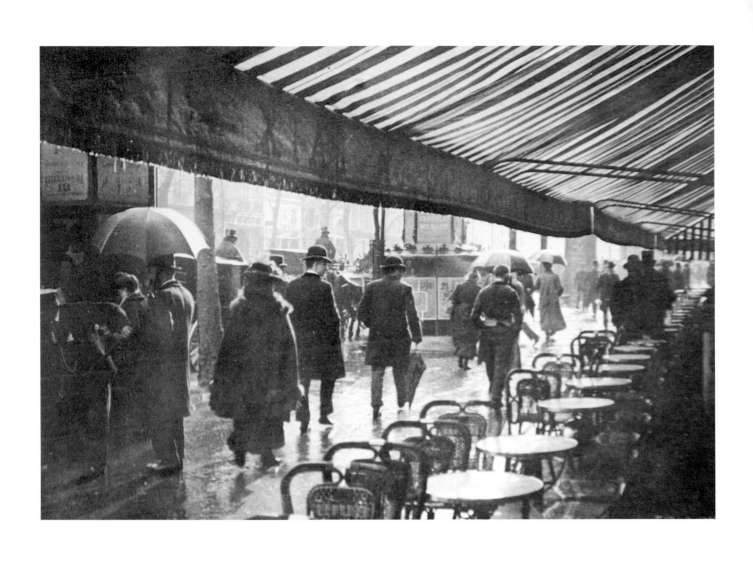

88. Maurice Bucquet. *The Effect of Rain.*
Halftone from *Esthétique de la Photographie*, Paris, 1900.

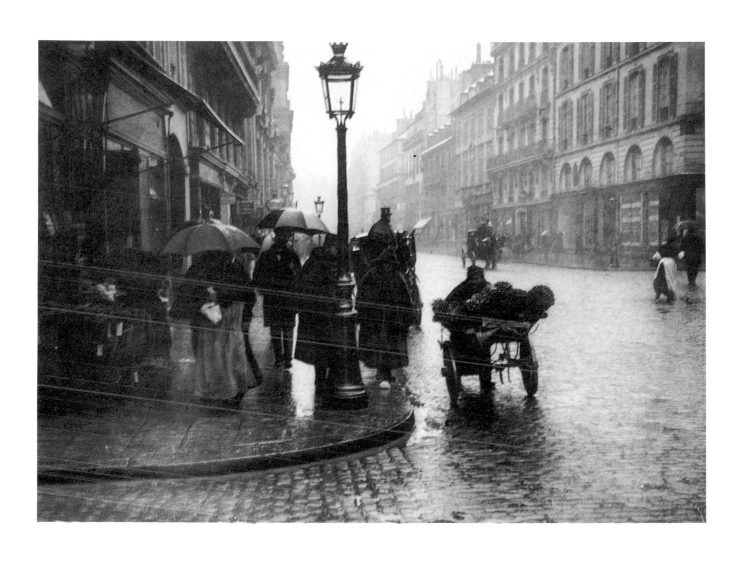

89. Maurice Bucquet. *A Rainy Day in Paris*.
Photogravure from *Die Kunst in der Photographie* II (1898), no. 5.

90. Otto Scharf. *Rainy Street in Krefeld at Twilight.*
Photogravure from *Photographische Rundschau*, 1900.

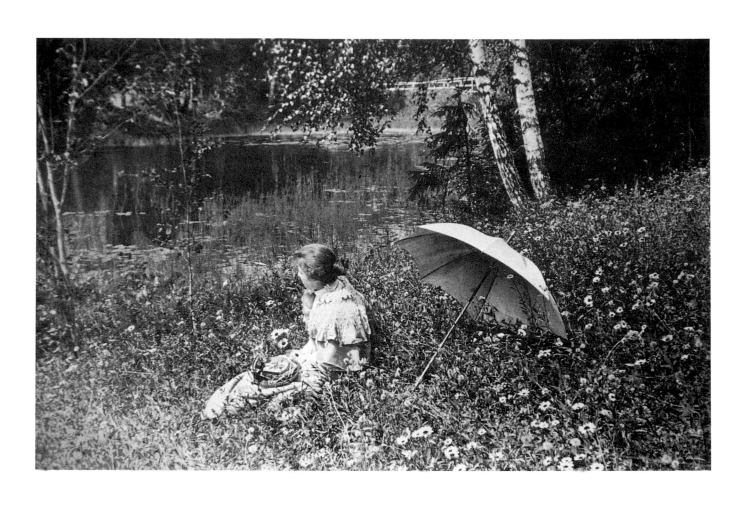

91. Alexis Mazourine. *In Summer.*
Photogravure from *Die Kunst in der Photographie* II (1898), no. 4.

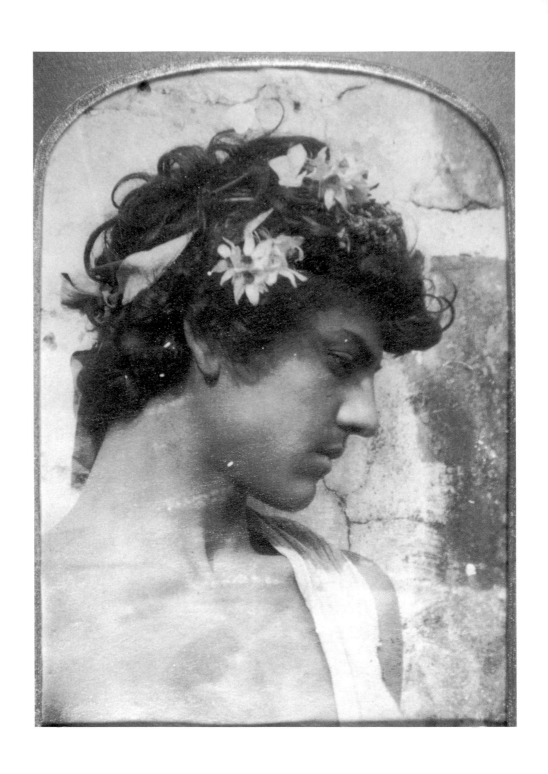

92. Wilhelm von Gloeden. *Portrait*. Albumen print.

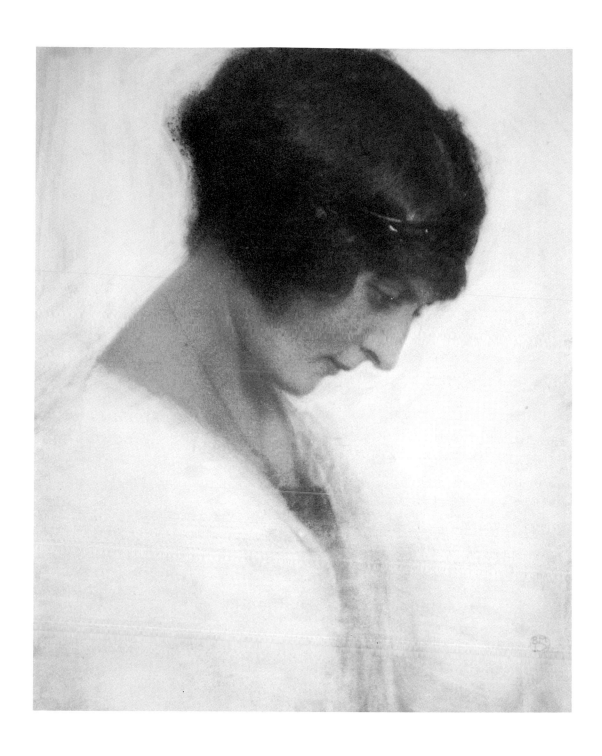

93. Rudolph and Minya Dührkoop. *Portrait*. Gum bichromate print.

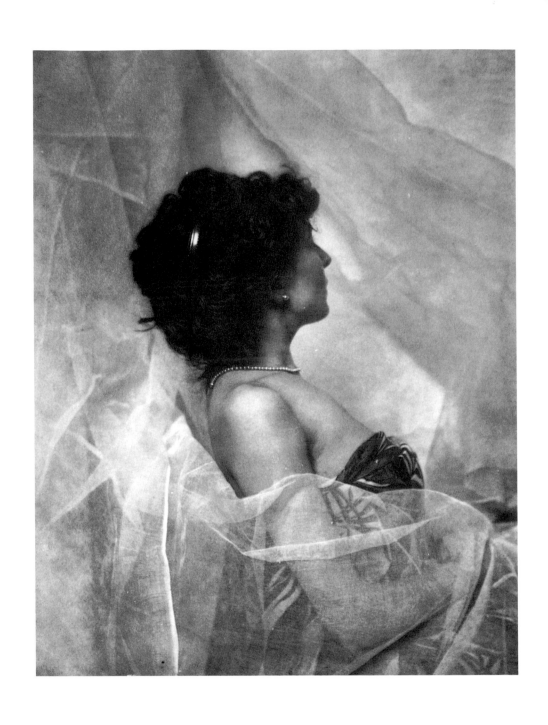

94. Maurice Brémard. *Study*.

Photogravure from *Die Kunst in der Photographie* I (1897), no. 3.

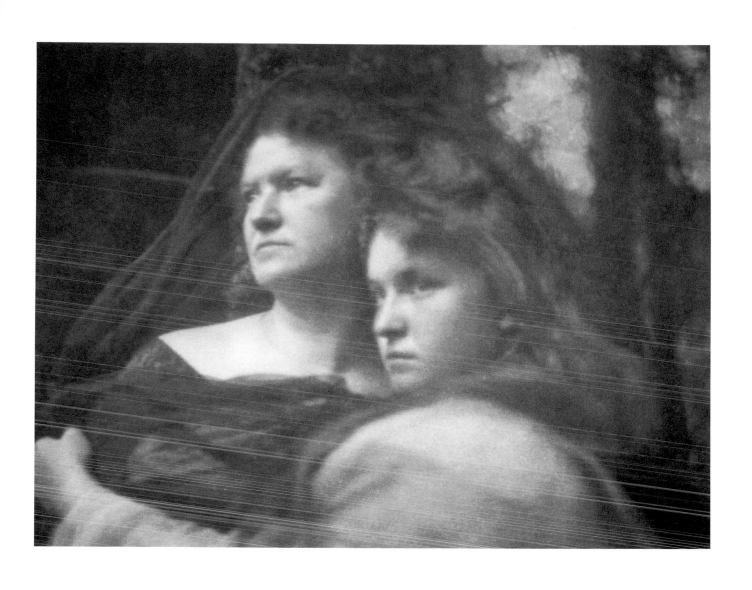

95. Betty Diesler. *Study*.
Photogravure from *Die Kunst in der Photographie* III (1899), no. 6.

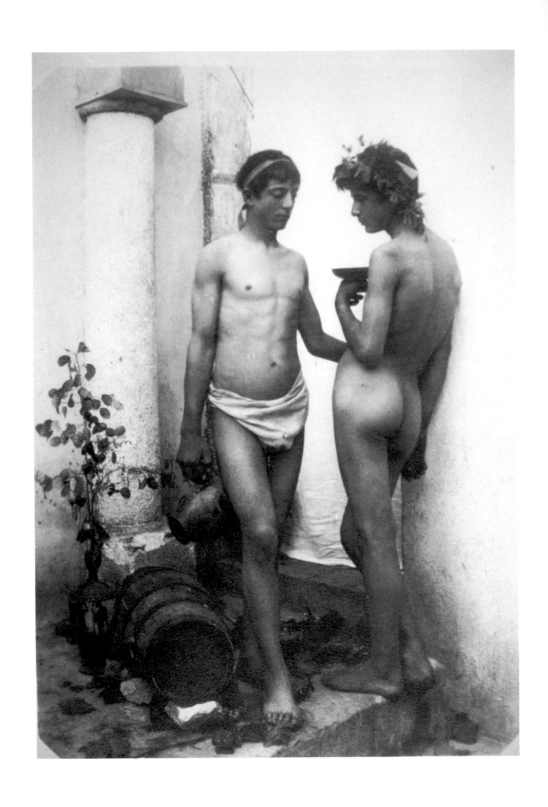

96. Wilhelm von Gloeden. *Untitled*. Platinum print.

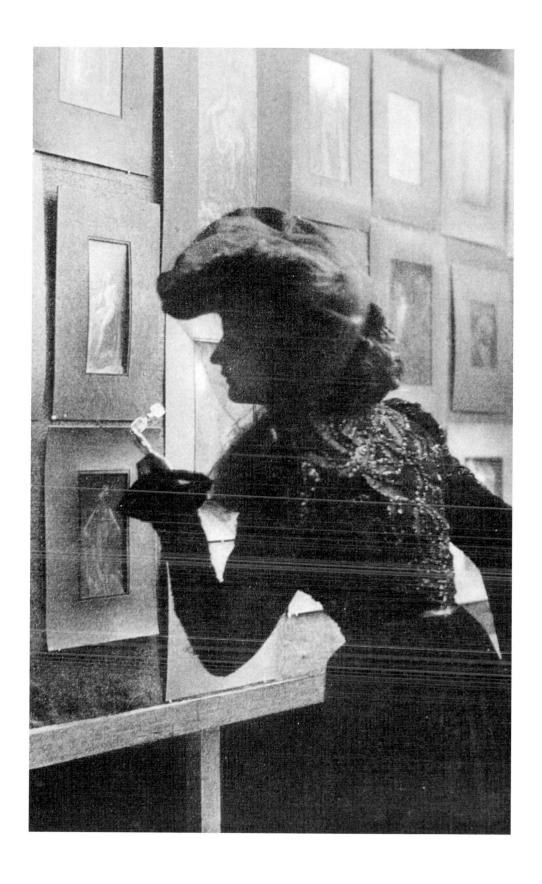

97. Paul Bergon. *At the Exhibition.* Halftone from *La Revue de Photographie*, 1903.

98. Jerry Spagnoli. *Panorama*. Seven half plate daguerreotypes.
Collection of the artist.

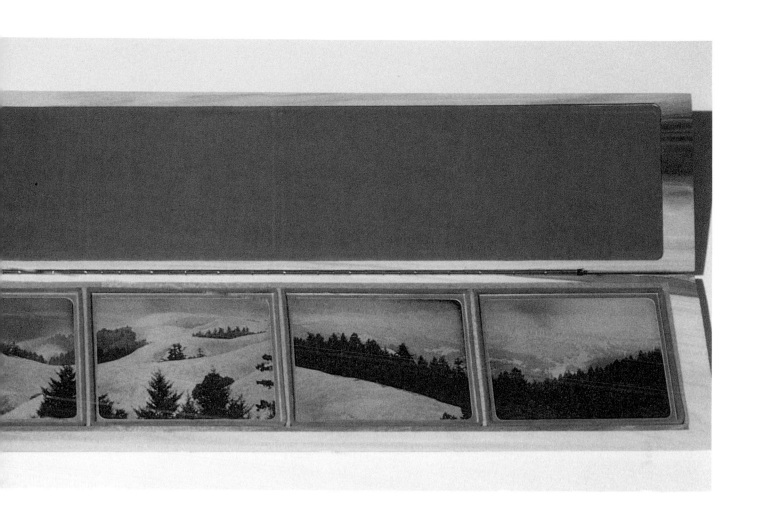

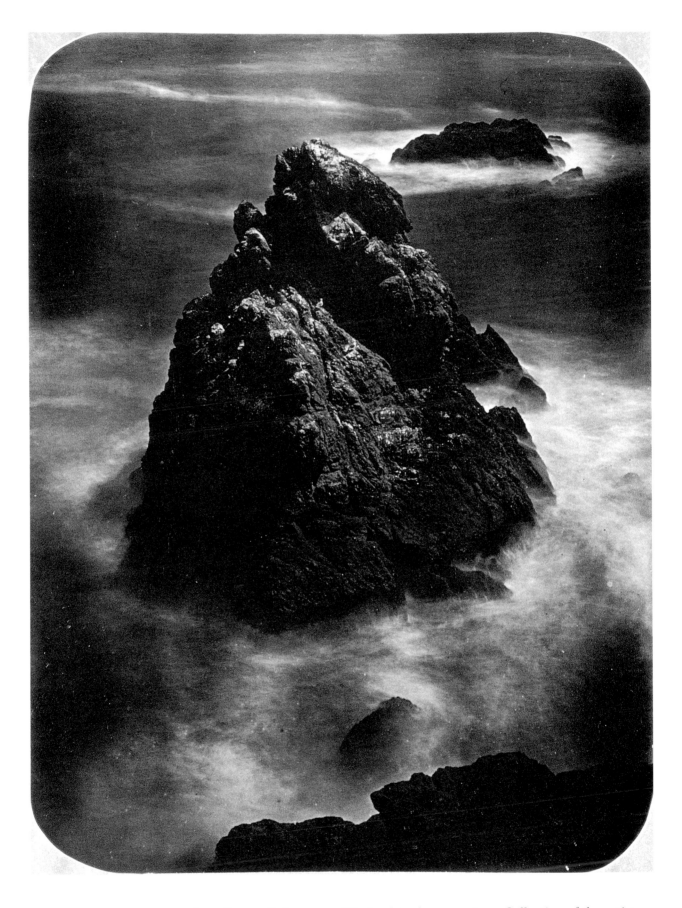

99. Jerry Spagnoli. *Seascape*. Whole plate daguerreotype. Collection of the artist.

100. Jerry Spagnoli. *Reliquary*. Daguerreotype; sculpture; construction.
Collection of the artist.

101. Jerry Spagnoli. *Explosion*. Daguerreotype; sculpture; construction.
Collection of the artist.

102. Jerry Spagnoli. *Habitat: Icon / Text*. Half plate daguerreotype.
Collection of the artist.

103. Jerry Spagnoli. From *The Vanished World*. Half plate daguerreotype.
Collection of the artist.

Selected Bibliography

AMERICAN DESTINY OR MANIFEST MYTHOLOGY

Baldwin, Joseph Glover. *The Flush Times of California*, ed. Richard E. Amacher and George W. Polhemus. Athens, Ga.: University of Georgia Press, 1966.

Barry, T. A., and B. A. Patten. *Men and Memories of San Francisco in the Spring of '50*. San Francisco: A. L. Bancroft & Co., 1873.

Boller, Henry A. *Among the Indians: Eight Years in the Far West, 1858–1866*, ed. Milo Milton Quaife. Chicago: R. R. Donnelley & Sons Co., 1959.

Crosby, Elisha Oscar. *Memoirs: Reminiscences of California and Guatemala from 1849 to 1864*, ed. Charles Albro Barker. San Marino, Calif.: Huntington Library, 1945.

Derbec, Étienne. *A French Journalist in the California Gold Rush*, ed. A. P. Nasatir. Georgetown, Calif.: Talisman Press, 1964.

Dornin, George D. *Thirty Years Ago: Gold Rush Memories of a Daguerreotype Artist*, ed. Peter Palmquist. Nevada City: Carl Mautz Publishing, 1995.

Doten, Alfred. *The Journals of Alfred Doten, 1849–1903*, ed. Walter Van Tilbury Clark, Reno: University of Nevada Press, 1973.

Evans, George W. B. *Mexican Gold Trail: The Journal of a Forty-Niner*, ed. Glenn S. Dumke. San Marino, Calif.: Huntington Library, 1945.

Field, Richard S., and Robin Jaffee Frank. *American Daguerreotypes from the Matthew R. Isenburg Collection*. New Haven: Yale University Art Gallery, 1989.

Foresta, Merry, and John Wood. *Secrets of the Dark Chamber: The Art of the American Daguerreotype*. Washington: Smithsonian Institution Press and National Museum of American Art, 1995.

Geiger, Vincent, and Wakeman Bryarly. *Trail to California: The Overland Journal of Vincent Geiger and Wakeman Bryarly*, ed. David Morris Potter. New Haven: Yale University Press, 1945.

Heyman, Therese Thau. *Mirror of California*. Oakland: Oakland Museum, 1973.

Drew Heath Johnson. "Silver & Gold: A Preview of Cased Images from Northern California Collections," in *The Daguerreian Annual* 6 (1995): 75–113.

Journals of Forty-Niners: Salt Lake to Los Angeles with Diaries and Contemporary Records of Sheldon Young, James S. Brown, Jacob Y. Stover, Charles C. Rich, Addison Pratt, Howard Egan, Henry W. Bigler, and others, ed. LeRoy R. Hafen and Ann W. Hafen. Glendale, Calif.: Arthur H. Clark Company, 1954.

Larkin, Thomas Oliver. *The Larkin Papers*, ed. George P. Hammond. Berkeley and Los Angeles: University of California Press, 1962.

Original Journals of the Lewis and Clark Expedition, 1804–1806, ed. Reuben Gold Thwaites. New York: Arno Press, 1969.

Palmquist, Peter. "The Daguerreotype in San Francisco," *History of Photography* 4, no. 3 (July 1980): 207–38.

Pictures of Gold Rush California, ed. Milo Milton Quaife. Chicago: R. R. Donnelley & Sons Co., 1949

Shaw, Reuben Cole. *Across the Plains in Forty-nine*, ed. Milo Milton Quaife. Chicago: R. R. Donnelley & Sons Co., 1948.

Rudisill, Richard. *Mirror Image: The Influence of the Daguerreotype on American Society*. Albuquerque: University of New Mexico Press, 1971.

Taft, Robert. *Photography and the American Scene*. New York: Dover, 1964.

Taylor, Bayard. *Eldorado or Adventures in the Path of Empire*. New York: Alfred A. Knopf, 1949.

Wilson, Luzena Stanley. *Luzena Stanley Wilson '49er: Memories Recalled*. Mills College, Calif.: Eucalyptus Press, 1937.

Wood, John, ed. *America and the Daguerreotype*. Iowa City: University of Iowa Press, 1991.

Altender, J. V. "Paper Prints from Autochromes." *American Annual of Photography for 1911*, vol. 25 (1910): 128. Also published in *British Journal of Photography* 53 (January 1911), Colour Photography Supplement: 7.

"The Autochrome Process in a Nutshell." *Photographic News* 52 (September 1907): 304. Also published in *Wilson's Photographic Magazine* 44, no. 611 (November 1907): 487 – 89.

Autochromes: Color Photography Comes of Age. Washington: Library of Congress, 1980.

The Autochromes of Charles C. Zoller, 1909 – 1930: Rochester in Color. Rochester: IMP/GEH, 1988.

Belden, Charles J. "Making Autochromes by Artificial Light." *American Annual of Photography for 1918*, vol. 32 (1917): 88 – 92. Also published in *British Journal of Photography* 66 (July 1919), Colour Photography Supplement: 25 – 26.

Biermann, E. A. "Autochromy Up to Date." *American Annual of Photography for 1916*, vol. 30 (1915): 170 – 73.

——. "Individualised Autochromy." *Amateur Photography & Photographic News* 60 (July 1914): 56.

Burnham, J. Appleton. "Observations on the Autochrome Process." *Photo-Era* 24 (May 1910): 197 – 201.

Carter, Charles M. "Painting and Color Photography." *American Annual of Photography for 1909*, vol. 23 (1908): 41 – 42.

Fred Payne Clatworthy: Early Color Photography of the West. Riverside: California Museum of Photography, 1984.

Cooper, James. "Amateurs and the Autochrome." *Photo-Era* 31 (August 1913): 80 – 85.

Coote, Jack. "First Colour." *Amateur Photographer* (June 23, 1990): 54 – 56.

Deisch, Noel. "Illumination of the Subject in Determining the Colour Quality of Autochromes." *Photographic Journal of America* 54 (November 1917): 467 – 69. Also published in *British Journal of Photography* 65 (August 1918), Colour Photography Supplement: 30 – 31; abstracted in *Camera Craft* 25 (1918): 244 – 46.

Downes, William Howe. "Influence of the Autochrome Process upon Art." *Photo-Era* 20 (January 1908): 41 – 42.

Falk, B. F. "The Autochrome Process – A New Era." *Wilson's Photographic Magazine* 44, no. 611 (November 1907): 484 – 86.

Fitzsimons, R. J. [firm]. *Color Photography with Autochrom Plates* (New York: R. J. Fitzsimons, 1916).

Fraprie, Frank. "Simple Color Photography Achieved." *American Photography* 1 (August 1907): 59 – 64.

Gray, Edward. "An Amateur's First Experience with Autochrome Plates." *Camera Craft* 15 (April 1908): 132 – 34.

Hamburger, W. S. "Autochrome Flashlight Portraiture." *American Photography* 8 (August 1914): 514 – 16. Also published in *British Journal of Photography* 61 (September 1914), Colour Photography Supplement: 34 – 35.

Hartmann, Sadakichi. "Lumière's 'Autochrome.'" *The Stylus* 1 (January 1910): 13 – 18.

Hovey, Clarissa. "Color Photography." *Photographic Times* 64, no. 9 (September 1912): 354 – 59. Originally given as a paper to the Women's Federation of Photography at Philadelphia; a variant appeared in *Wilson's Photographic Magazine* (August 1912): 340 – 44.

Howard, April. "Autochromes: The First Color Photography." *Darkroom Photography* (July 1989): 42 – 48, 57 – 58.

"Intensifying Autochromes." *Photo-Era* 31 (August 1913): 105.

Jacobs, Mark. "Postcard Country: Early Autochromes of the Rockies." *Rocky Mountain Magazine* (July-August 1980): 47 – 51.

Klein, Henry Oscar. "My Experience with the Autochrome Plate." *American Annual of Photography for 1910*, vol. 24 (1909): 130 – 33.

Knott, Franklin Price. "Artist Adventures on the Island of Bali." *National Geographic Magazine* 53, no. 3 (March 1928): 326 – 47.

Knowles, Hugh C. "Progress in Screen Plate Photography." *American Annual of Photography for 1911*, vol. 25 (1910): 140 – 42.

——. "Screen Plate Color Photography." *American Annual of Photography for 1910*, vol. 24 (1909): 38 – 41.

Laurvik, John Nilsen. "The New Color Photography." *International Studio* 34 (1908): xxi-xxiii.

Lester, Peter. "Travel and Early Colour." *Photography* (March 1992): 24 – 27.

Lewis, Alfred Holmes. "The Autochrome in Winter." *Photo-Era* 28 (January 1912): 10 – 12.

Longly, W. H., and Charles Martin, "The First Autochromes from the Ocean Bottom." *National Geographic Magazine* 51, no. 1 (January 1927): 56.

Lumière, Auguste, and Louis Lumière. "A New Method for Developing Autochrome Plates." *American Photography* 2 (July 1908): 361 – 66.

"The Lumière Autochrome Color Process." *Wilson's Photographic Magazine* 44, no. 610 (October 1907): 433.

McCord, Bennet. "Why Not the Autochrome?" *The Camera* 18 (1914): 679 – 82.

Miller, Malcolm Dean. "The Autochrome Process." *American Annual of Photography for 1909*, vol. 23 (1908): 77 – 78.

Montminy, M. A. "The Autochrome Process." *Wilson's Photographic Magazine* 44, no. 611 (November 1907): 486.

Paddock, Eric. "Colorado's Scenic Views Highlight Photography Exhibition." *Colorado Heritage News* (May 1987): 9 – 10.

Penrose, Frank. "The Use of Autochromes in Bird Photography with Examples of Protective Coloration." *Photographic Journal* 29 (June 1915): 215 – 18. Also published in *British Journal of Photography* 62 (July 1915), Colour Photography Supplement: 27 – 28.

Power, H. D'Arcy. "Autochrome Notes." *Camera Craft* 15 (1908): 31 – 33.

——. "Color Photography." *Camera Craft* 15 (1908): 311, 353; 16 (1909): 29, 73 – 74, 186 – 87, 321, 369. Regards his ongoing progress.

——. "The Lumière Autochrome Plate." *Camera Craft* 15 (1908): 20 – 23.

——. "A New Color Plate." *Camera Craft* 15 (1908): 229 – 30.

——. "A New Method of Developing Autochrome Plates." *Camera Craft* 15 (1908): 353 – 54.

——. "Progress in Autochrome Color Work." *Camera Craft* 15 (1908): 353 – 54.

——. "Screen-Plate Color Photography." *Camera Craft* 15 (1908): 110 – 11. Opinions on development of autochromes.

——. "Simplified Development of Autochromes." *Camera Craft* 15 (1908): 215 – 16. Also published in *British Journal of Photography* 56 (January 1909), Colour Photography Supplement: 5 – 6.

Rimmer, John Brown. "Simplified Autochrome Work." *American Photography* 14 (September 1920): 516 – 19.

Rypenski, M. C. "Color Photography." *American Annual of Photography for 1914*, vol. 28 (1913): 116 – 26. Also published in *Illuminating Engineering Society. Transactions* 9 (1914): 579 – 92, *Scientific American Supplement* 79 (February 1915): 134 – 35.

Sheahan, David J. "The Autochrome. Possibilities of Its Use as a Pictorial Medium." *American Annual of Photography for 1916*, vol. 30 (1915): 188 – 96.

——. "A Few Words about Autochromes." *American Annual of Photography for 1917*, vol. 31 (1916): 104 – 106.

——. "The Making of Autochromes." *American Annual of Photography for 1915*, vol. 29 (1914): 284 – 86.

Smillie, Thomas W. "Recent Progress in Color Photography." *Smithsonian Institution. Annual Report 1907* (1908): 231 – 37.

Starr, William Ireland. "Why Not Make Color Photographs?" *American Annual of Photography for 1912*, vol. 26 (1911): 228 – 34.

Steadman, Frank Morris. "Color Photography with Lumière Autochrome Plate." *Camera Craft* 14 (1907): 395 – 400.

Steichen, Eduard J. "Color Photography." *Camera Work* 22 (April 1908): 13 – 24. Also published in an abridged version as "Colour Photography with the Autochrome Plates" in *British Journal of Photography* 55 (April 1908): 300 – 302.

Stieglitz, Alfred. "Formalin for Obviating the Frilling of Autochrome Plates." *British Journal of Photography* 55 (July 1908), Colour Photography Supplement: 53 – 54.

——. "The New Color Photography – A Bit of History." *Camera Work* 20 (October 1907): 20 – 25. Reprinted in Jonathan Green, ed. *Camera Work: A Critical Anthology* (Millerton, N.Y.: Aperture, 1973), pp. 124 – 29.

"The Success of Color Photography." *The Craftsman* (March 1912): 687. Discusses major autochrome exhibition, including work by Genthe, Falk, A. H. Lewis, H. H. Pierce, S. L. Stein, Frances B. Johnston, and F. J. Sipprell.

[Tennant, R. Dixon.] "Exhibition of 'Autochrome' Photographs." *Wilson's Photographic Magazine* 44, no. 611 (November 1907): 483 – 84.

Toch, Maximilian. "The Lumière Color Process Simplified." *American Photography* 3 (May 1909): 274 – 78. Also published in *Photo-Era* 23 (July 1909): 20 – 23.

——. "The Simplified Autochrome Process." *American Annual of Photography for 1910*, vol. 24 (1909): 245 – 46.

Wallace, Robert James. "The Autochrome Plate." *Popular Astronomy* 16 (1908): 83 – 91.

Wentzel, Volkmar K. *Autochrome: The Vanishing Pioneer of Color.* Washington: National Geographic Society, 1980.

Williams, A. D. "Developing Autochromes." *Camera Craft* 23 (January 1916): 19 – 22. Also published in *British Journal of Photography* 63 (March 1916), Colour Photography Supplement: 12.

Wood, John. *The Art of the Autochrome.* Iowa City: University of Iowa Press, 1993.

——. *The Art of the Autochrome Address Book.* New York: Galison Books, 1995.

THE ART OF THE CYANOTYPE AND THE VANDALOUS DREAMS OF JOHN METOYER

Herschel, John. "On the action of the rays of the solar spectrum on vegetable colours, and on some new photographic processes." *Philosophical Transactions* 132, pt. 1 (1842): 181 – 214.

Janis, Eugenia Parry. "Her Geometry." In Constance Sullivan, ed., *Women Photographers.* New York: Harry N. Abrams, 1990.

—— and Josiane Sartre. *Henri Le Secq Photographe de 1850 à 1860.* Paris: Musée des Arts Décoratifs / Flammarion, 1986.

Schaaf, Larry. *Sun Gardens: Victorian Photograms by Anna Atkins.* New York: Aperture, 1985.

AMERICAN SYMBOLISM

Bunnell, Peter C. *The Art of Pictorial Photography, 1890 – 1925.* Princeton: The Art Museum, 1992.

Clair, Jean, et al. *Lost Paradise: Symbolist Europe.* Montreal: Montreal Museum of Fine Arts, 1995.

Crump, James. *F. Holland Day: Suffering the Ideal.* Santa Fe: Twin Palms, 1995.

Dimock, George. *Intimations & Imaginings: The Photographs of George H. Seeley.* Pittsfield: The Berkshire Museum, 1986.

Ehrens, Susan. *A Poetic Vision: The Photographs of Anne Brigman.* Santa Barbara: Santa Barbara Museum of Art, 1995.

Green, Jonathan. *Camera Work: A Critical Anthology.* Millerton, N.Y.: Aperture, Inc., 1973.

Jussim, Estelle. *Slave to Beauty: The Eccentric Life and Controversial Career of F. Holland Day.* Boston: Godine, 1981.

Longwell, Dennis. *Steichen, The Master Prints, 1895 – 1914: The Symbolist Period.* New York: Museum of Modern Art, 1978.

Naef, Weston J. *The Collection of Alfred Stieglitz.* New York: Metropolitan Museum of Art / Viking Press, 1978.

Peterson, Christian A. *Alfred Stieglitz's Camera Notes.* Minneapolis: Minneapolis Institute of Arts, 1993.

Pohlmann, Ulrich, et al. *Frank Eugene: The Dream of Beauty.* Munich: Nazraeli Press and Fotomuseum im Münchner Stadtmuseum, 1995.

Weaver, Mike. *Alvin Langdon Coburn: Symbolist Photographer, 1882–1966.* New York: Aperture, 1986.

Wilson, Michael G., and Dennis Reed. *Pictorialism in California: Photographs, 1900–1940.* Malibu and San Marino: J. Paul Getty Museum and Henry E. Huntington Library and Art Gallery, 1994.

Wood, John. *The Art of the Autochrome.* Iowa City: University of Iowa Press, 1993.

MASTERS OF EUROPEAN PICTORIALISM AND THE PROBLEM OF ALFRED STIEGLITZ

Andries, Pool, et al. *Rétrospective Edouard Hannon.* Brussels: Contretype, 1986.

Buerger, Janet E. "Art Photography in Dresden, 1899–1900: An Eye on the German Avant-Garde at the Turn of the Century." *Image* 27, no. 2: 1–24.

Buerger, Janet E. *The Last Decade: The Emergence of Art Photography in the 1890s.* Rochester: IMP/GEH, 1984.

Debanterlé, René. *Autour de Leonard Misonne.* Charleroi: Musée de la Photographie, 1990. Also includes Marissiaux, Chavepeyer, Populaire, Ickx, and Lemaire.

Duliere, Cécile, and Françoise Dierkens, *Edouard Hannon, Photos 1900.* Brussels: Musée Horta, 1977.

Fleischmann, Kaspar Manuel. *Jasienski.* Zürich: Galerie Zur Stockeregg, 1981.

Gautrand, Jean-Claude, et al. *I Pittorialisti: fotografie francesi, 1896–1930.* Florence: Alinari, 1989.

Harker, Margaret. *The Linked Ring: The Secession Movement in Photography in Britain, 1892–1910.* London: Heinemann, 1979.

Harker, Margaret, et al. *La Photographie d'Art vers 1900.* Brussels: Crédit Communal, 1983.

Kaufhold, Enno, et al. *Kunstphotographie um 1900: Die Sammlung Ernst Juhl.* Hamburg: Museum für Kunst und Gewerbe, 1989.

Kempe, Erika, and Fritz Kempe. *Die Kunst der Camera im Jugendstil.* Frankfurt: Umschau, 1986.

Kempe, Fritz. *La Photographie Artistique vers 1900.* Stuttgart: Institute pour les Relations Culturelles avec l'Etrager, 1980.

Kunstphotographie in Belgien um 1900. Evenepoel, Hannon, Misonne. Cologne: n.p., 1976.

Mayeur, Catherine. *Emile Chavepeyer, 1893–1959.* Barbençon: Musée de la Photographie, Archives de Wallonie, 1987.

Miraglia, Marina. *Fotografia Pittorica, 1889/1911.* Milan and Florence: Electa and Alinari, 1979.

Naef, Weston, *The Painterly Photograph, 1890–1914.* New York: Metropolitan Museum of Art, 1973.

Pinet, Hélène, and Michel Poivert. *Le Salon de Photographie: Les écoles pictorialistes en Europe et aux Etats-Unis vers 1900.* Paris: Musée Rodin, 1993.

Poivert, Michel. *Le Pictorialisme en France.* Paris: Hoëbeke, 1992.

Steinert, Otto, et al. *Kunstphotographie um 1900.* Hamburg: Museum für Kunst und Gewerbe, 1964.

Taylor, John. *Pictorial Photography in Britain, 1900–1920.* London: Arts Council of Great Britain, 1978.

Tillmanns, Urs. *Pictorialismus in der Photographie.* Zürich: Galerie für Kunstphotographie Zur Stockeregg, 1984.

Weaver, Mike, ed. *British Photography in the Nineteenth Century.* Cambridge: Cambridge University Press, 1989.

PAST, PASSING, OR TO COME

Wood, John. *The Scenic Daguerreotype: Romanticism and Early Photography.* Iowa City: University of Iowa Press, 1995.

Pohlmann, Ulrich, et al. *Frank Eugene: The Dream of Beauty*. Munich: Nazraeli Press and Fotomuseum im Münchner Stadtmuseum, 1995.

Weaver, Mike. *Alvin Langdon Coburn: Symbolist Photographer, 1882–1966*. New York: Aperture, 1986.

Wilson, Michael G., and Dennis Reed. *Pictorialism in California: Photographs, 1900–1940*. Malibu and San Marino: J. Paul Getty Museum and Henry E. Huntington Library and Art Gallery, 1994.

Wood, John. *The Art of the Autochrome*. Iowa City: University of Iowa Press, 1993.

MASTERS OF EUROPEAN PICTORIALISM AND THE PROBLEM OF ALFRED STIEGLITZ

Andries, Pool, et al. *Rétrospective Edouard Hannon*. Brussels: Contretype, 1986.

Buerger, Janet E. "Art Photography in Dresden, 1899–1900: An Eye on the German Avant-Garde at the Turn of the Century." *Image* 27, no. 2: 1–24.

Buerger, Janet E. *The Last Decade: The Emergence of Art Photography in the 1890s*. Rochester: IMP/GEH, 1984.

Debanterlé, René. *Autour de Leonard Misonne*. Charleroi: Musée de la Photographie, 1990. Also includes Marissiaux, Chavepeyer, Populaire, Ickx, and Lemaire.

Duliere, Cécile, and Françoise Dierkens, *Edouard Hannon, Photos 1900*. Brussels: Musée Horta, 1977.

Fleischmann, Kaspar Manuel. *Jasienski*. Zürich: Galerie Zur Stockeregg, 1981.

Gautrand, Jean-Claude, et al. *I Pittorialisti: fotografie francesi, 1896–1930*. Florence: Alinari, 1989.

Harker, Margaret. *The Linked Ring: The Secession Movement in Photography in Britain, 1892–1910*. London: Heinemann, 1979.

Harker, Margaret, et al. *La Photographie d'Art vers 1900*. Brussels: Crédit Communal, 1983.

Kaufhold, Enno, et al. *Kunstphotographie um 1900; Die Sammlung Ernst Juhl*. Hamburg: Museum für Kunst und Gewerbe, 1989.

Kempe, Erika, and Fritz Kempe. *Die Kunst der Camera im Jugendstil*. Frankfurt: Umschau, 1986.

Kempe, Fritz. *La Photographie Artistique vers 1900*. Stuttgart: Institute pour les Relations Culturelles avec l'Etrager, 1980.

Kunstphotographie in Belgien um 1900: Evenepoel, Hannon, Misonne. Cologne: n p, 1976.

Mayeur, Catherine. *Emile Chavepeyer, 1893–1959*. Barbençon: Musée de la Photographie, Archives de Wallonie, 1987.

Miraglia, Marina. *Fotografia Pittorica, 1889/1911*. Milan and Florence: Electa and Alinari, 1979.

Naef, Weston. *The Painterly Photograph, 1890–1914*. New York: Metropolitan Museum of Art, 1973.

Pinet, Hélène, and Michel Poivert. *Le Salon de Photographie: Les ecoles pictorialistes en Europe et aux Etats-Unis vers 1900*. Paris: Musée Rodin, 1993.

Poivert, Michel. *Le Pictorialisme en France*. Paris: Hoëbeke, 1992.

Steinert, Otto, et al. *Kunstphotographie um 1900*. Hamburg: Museum für Kunst und Gewerbe, 1964.

Taylor, John. *Pictorial Photography in Britain, 1900–1920*. London: Arts Council of Great Britain, 1978.

Tillmanns, Urs. *Pictorialismus in der Photographie*. Zürich: Galerie für Kunstphotographie Zur Stockeregg, 1984.

Weaver, Mike, ed. *British Photography in the Nineteenth Century*. Cambridge: Cambridge University Press, 1989.

PAST, PASSING, OR TO COME

Wood, John. *The Scenic Daguerreotype: Romanticism and Early Photography*. Iowa City: University of Iowa Press, 1995.